Sports Illustrated™

THE STORY OF
Football
IN 100 PHOTOGRAPHS

CONTENTS

INTRODUCTION

EVERY PICTURE TELLS A STORY

by CRAIG ELLENPORT

I'VE ALWAYS HAD tremendous respect for sports photographers. In my first job out of college, as editor for a weekly football magazine, one of my regular responsibilities during the season was securing game passes for our freelance photographers. The successful ones traveled every week during the season. The smart ones studied the college and pro schedules in advance—the ideal scenario might be a weekend in South Florida where the University of Miami was hosting a big game on Saturday and the Dolphins were at home Sunday. Or USC-UCLA the day before a Rams home game.

I worked closely with Bob Rosato, a very talented photographer based in Miami. So talented that he eventually reached the pinnacle of his profession—becoming a staff photographer for *Sports Illustrated*.

I'm proud to have helped Bob along the way. When he was still a freelancer, I used to give him cheat sheets for the games he covered. If it was a college game,

I'd give him names of the up-and-coming players whose photos would be in demand when the NFL draft rolled around. For NFL games, Bob knew the obvious players to shoot, but I'd toss him the names of a few rookies I thought he should add to his portfolio.

In the winter of 1990, Bob rewarded me with an invitation to be his assistant on the sidelines at a Bills-Giants game. This was a big deal, because both teams were 11–2 at the time. Could this be a Super Bowl preview? Who knows (wink, wink)?

Never mind that the weather was miserable. Freezing rain was the order of the day. My job was to lug around a heavy bag of photo equipment—and for God's sake, keep it dry!—and follow Bob as he made his way up and down the sidelines following the action. By the end of the day, I was cold and wet, and the Giants—my favorite team—had lost. But it was still a boatload of fun.

It took me a couple of days to thaw out. Back in the office, I wondered when my next photojournalism adventure might take place—and my boss delivered some shocking news: We were approved for a Super Bowl XXV photo credential, and he was sending me to Tampa. We already had Bob Rosato shooting the game for us, so this wouldn't really be work for me. Just a front row seat for the Big Game.

Who knew that I was about to take a picture that would one day be included in a book of some of the sport's greatest photography?

Sure enough, the Bills and Giants met in Super Bowl XXV. The Gulf War was going on, and we had to go through metal detectors to get into the stadium. (Not unusual these days but a new phenomenon back then.) Unlike the December game at Giants Stadium, the weather was perfect for Super Bowl Sunday, and I made my way to the field about an hour before kickoff. I met up with Bob, who had some equipment for me. He had an all-access credential that allowed him to go anywhere around the field. My pass was limited—I was on the Giants sideline and could only move between the goal line and the 10-yard line, no farther. Bob handed me two cameras, one with a 35-millimeter lens and the other with a telephoto lens. New roll of film in each camera.

"Have fun," Bob said. "See you after the game."

One roll of film in each camera. For those of you not old enough to remember life before iPhones, that meant I had a limited number of shots—24 with each camera.

I could have run out of film before the game started if I wasn't careful. There was Bill Parcells roaming the sidelines during pregame warmups. There was Giants quarterback Phil Simms, in street clothes and walking with crutches. (He suffered a season-ending knee injury in that regular-season loss to the Bills; if the Giants were going to win Super Bowl XXV, they would have to do it with backup quarterback Jeff Hostetler.) I could have taken a bunch of pictures of Whitney Houston singing the national anthem.

I didn't take any shots of Whitney. I was afraid people would think it was disrespectful to take pictures while the anthem was being sung. In retrospect, that was silly.

Then again, I'm sure any photos I took would have been the worst pictures of Whitney Houston ever taken. What I'm saying is, I am a bad photographer. Maybe it's my bad eyes, maybe my shaky hands, probably a little of both. I had those pictures developed as soon as I could when I got home after the game … and they were terrible. Some were out of focus, some were taken just after the action took place. Out of the 48 pictures I took, I'd say just one came out good.

But, oh, was it good.

The best thing I did that night was conserve my shots. And it wasn't easy. The Bills and Giants played a classic back-and-forth game. Midway through the second quarter, Bills all-world defensive end Bruce Smith sacked Hostetler in the end zone to give Buffalo a 12–3 lead. I was standing at the 1-yard line on that side of the field—the play happened right in front of me. I did not get a shot of that play. I was just standing there with my jaw on the ground, trying to figure out how Hostetler managed to hold onto that football when Smith locked his massive claw of a hand around Hostetler's right wrist. If the ball came loose and Buffalo scored a touchdown instead of a safety, history might have been different. Hostetler holding onto that ball as he was tackled might be one of the most underappreciated plays in NFL history.

The Giants scored a touchdown at the end of the half and another in the third quarter to take a 17–12 lead. The Bills scored early in the fourth to go up 19–17 and then the Giants kicked a field goal midway through the fourth to take a 20–19 lead. Amazingly, I still had a few shots left as the Bills began their final possession. They were driving toward the end zone on the other side of the field from

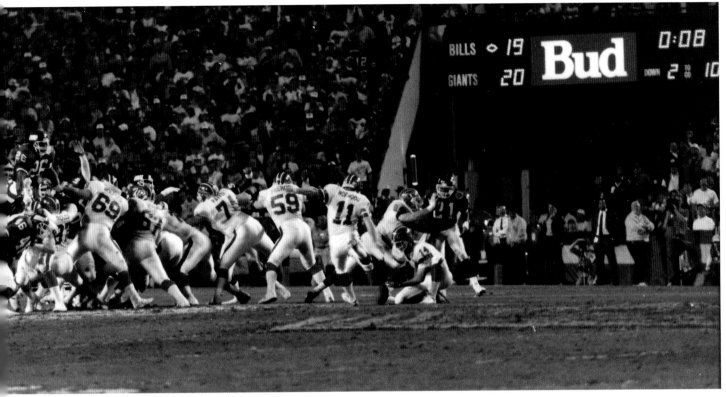

Out of the 48 pictures I took at Super Bowl XXV, one came out good. But, oh, was it good.

where I was. I don't remember how many shots I had left in either camera, but I waited for the right moment.

There it was. Second-and-10 at the Giants' 29-yard line. Bills kicker Scott Norwood trots out for the potential Super Bowl–winning kick. The ball is snapped.

Click.

And there it is. I'd love to say I intended to frame the photo the way it turned out, with the scoreboard perfectly situated in the upper right, giving the score, down-and-distance and time remaining. There's Norwood leaning into the kick. Giants special teams Pro Bowl player Reyna Thompson desperately coming around the end. Thompson didn't get there, but Norwood's kick famously (or infamously, depending on your rooting interest) sailed wide right. The Giants were victorious in what many consider the greatest Super Bowl ever played. And I ended up with the luckiest photo I could have taken.

It's the only good photo I took that night … and I treasure it.

Every picture tells a story. As a Giants fan, I love the story that my picture tells. As a football fan, I love all the photographs you'll find in this book. Whether they are action shots taken on the field or posed photographs featuring players and coaches and executives who left their mark on the history of professional football, there are two things you can say about the 100 photos you are about to see:

They were taken by photographers who have more talent in their pinkies than I have in my entire body.

They tell the rich history of professional football.

CRAIG ELLENPORT *is the senior fantasy editor at* Sports Illustrated. *A veteran sportswriter who has covered the NFL for more than 30 years, he oversaw production of all NFL publications during his 12 years as senior editor at NFL.com and director of NFL Publishing, serving as co-editor for* The Super Bowl: An Official Retrospective.

1925 to 1966

Beginnings

THE GALLOPING GHOST

CUBS PARK, CHICAGO | *November 26, 1925*

RED GRANGE, A THREE-TIME All-American at the University of Illinois, was widely considered one of the greatest players in the history of college football. To be sure, he was the sport's biggest draw. His final college game, at Ohio State, drew a then-record crowd of nearly 85,000 fans. By contrast, pro football games in those days drew crowds in the hundreds. Then the Chicago Bears signed Grange, and everything changed.

Wrote John Underwood in a story for the September 4, 1985, issue of SI:

> "Could it be that Grange really was the greatest ever? Damon Runyon wrote about him, as did Westbrook Pegler and Paul Gallico. It was the Golden Age of Sport, and those three supplied much of the burnish. When Runyon saw Grange play for the first time, he said he was 'three or four men and a horse rolled into one. He is Jack Dempsey, Babe Ruth, Al Jolson, Paavo Nurmi and Man o' War.' Gallico called him a 'touchdown factory.'"

Five days after that game at Ohio State, Grange (far right) made his NFL debut as the Bears hosted the Chicago Cardinals on Thanksgiving Day in 1924. Bears owner/coach George Halas went a bit crazy and had 20,000 tickets printed. Turns out it wasn't enough. A crowd of 39,000 watched Grange's NFL debut. That would be the beginning of an insane schedule—Grange and the Bears played 10 games in 18 days, including a win over the New York Giants that drew 68,000 fans at the Polo Grounds. Giants owner Tim Mara credits that game as putting pro football on the map in New York.

A year later, the Bears went on a barnstorming tour around the country, playing in cities that didn't even have an NFL team. In Underwood's SI story, the writer caught up with a then-82-year-old Grange and asked him about the tour. Grange acknowledged that the NFL barely got mentioned in the newspapers back then:

> "Pro ball in the early days got two or three inches on the third page. After we made those tours, it was getting top headlines. We spread the NFL across the country, taking it to towns that never saw a pro game, doing anything to push the product. We played in Memphis one year, and after the game started, we were driving for a touchdown when the promoter came running on the field and told everybody we'd have to start over. The backer of the game was the founder of the Piggly Wiggly stores, Clarence Saunders, and he'd gotten caught in traffic and missed the kickoff. So we started over."

Photograph by GEORGE RINHART/CORBIS

THE SNEAKERS GAME

POLO GROUNDS, NEW YORK | *December 9, 1934*

THE FIRST OFFICIAL NFL Championship Game occurred in 1933, with the Chicago Bears defeating the New York Giants, 23–21. The same two teams met again for the 1934 title at the Polo Grounds in New York. This time, the biggest challenge for both teams was a frozen field that made it extremely difficult for players to get any footing. Bears Hall of Famer Bronko Nagurski, while gang-tackled on this play, did manage a 1-yard touchdown run that helped give Chicago a 10–3 lead at halftime.

It was then an unusual equipment decision that made history.

Giants captain Ray Flaherty is the man who hatched the plan before the game even began. Seeing how bad the field conditions would be, he recalled a college game in which playing with basketball sneakers instead of cleats made for better footing on the ice. Giants head coach Steve Owen dispatched a locker room attendant named Abe Cohen to Manhattan College to borrow sneakers from the school's basketball team. Cohen made it back to the Polo Grounds after the game began. At halftime, Owen ordered the switch in footwear. The Bears kicked a third-quarter field goal to make it 13–3, but the momentum eventually shifted to the Giants, who were having a much easier time handling the icy turf. New York scored four fourth-quarter touchdowns and came away with a 30–13 win.

"We immediately said something was wrong, because they suddenly had good footing and we didn't," Nagurski said after the game. "They just out-smarted us."

Photograph by BETTMANN

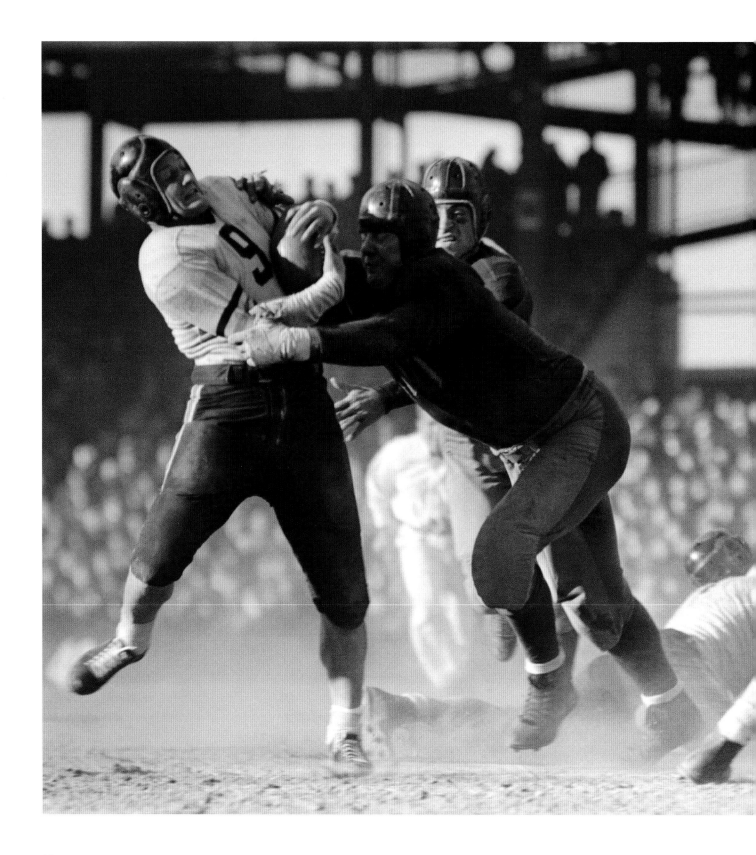

73–0

GRIFFITH STADIUM, WASHINGTON, D.C. | *December 8, 1940*

CHICAGO BEARS RUNNING back Bill Osmanski was brought down by Washington's Willie Wilkin after a short gain here in the 1940 NFL Championship Game. That would be a rare stop for the Redskins. On Chicago's second play from scrimmage, Osmanski ran 68 yards for the game's first touchdown. That was all the points the Bears needed, but they scored just a few more after that. The final score that day at Washington's Griffith Stadium: Bears 73, Redskins 0.

Chicago's offense kept Washington thoroughly confused with its T formation attack. Three running backs lined up behind Hall of Fame quarterback Sid Luckman, with one back in motion before just about every play. The Bears rushed for 381 yards and amassed 519 yards of total offense. Ten different players scored for the Bears—not all of them on the offense. In the third quarter alone, Chicago defenders returned three interceptions for scores.

What's really amazing about the final score is that Washington had defeated Chicago, 7–3, just three weeks prior to the championship game. How did the Bears turn the tables so quickly? Several of the Bears players said they were highly motivated by Redskins owner George Preston Marshall telling reporters after that first meeting that the Bears were crybabies and quitters. Perhaps the first example of "bulletin board material," Chicago owner and coach George Halas did not stop reminding his team of Marshall's remarks in the weeks leading up to the rematch.

That Bears-Redskins grudge match was one of the top rivalries in the early days of the NFL. In a seven-year span (1937–43), these teams played for the NFL championship four times, with each team winning twice.

Photograph by BETTMANN

BREAKING THE COLOR BARRIER

WISCONSIN STATE FAIR PARK, WEST ALLIS, WISC. |
October 6, 1946

WHILE THERE WERE some Black players in the earliest days of professional football, by 1933 they were gone from the game completely. Some coaches offered the sad excuse that it was for their own good, because of the horrible way they were treated by white teammates. But clearly there were owners who didn't want them, either. It was a regrettable period in the league's history. Finally, on March 21, 1946, halfback Kenny Washington signed with the Los Angeles Rams, becoming the first Black player in the modern era. Washington had starred at UCLA and graduated in 1939. The NFL draft was 22 rounds that year, yet Washington, and every other Black player, went undrafted.

Wrote Alexander Wolff in the October 12, 2009, issue of SI:

"The snubbing of Kenny Washington indicts the football establishment more than any other exclusion. Though he led the nation in total offense as a senior in 1939, and played 580 of a possible 600 minutes by doubling as the anchor of the defensive secondary, Washington was relegated to second-team All-America by Hearst, the AP, the UP and Grantland Rice, while the East-West Shrine Game passed him over entirely. Yet when *Liberty* magazine polled more than 1,600 collegians on the best player they had faced on the field, Washington was the lone man named on the ballot of everyone he played against."

As a condition for allowing the Rams to relocate to Los Angeles before the 1946 season, the city demanded that the league integrate. Washington had been a popular semi-pro player in the area, so the Rams immediately signed him. He already had bad knees by then—though he does still own the Rams' record for the longest run from scrimmage, 92 yards. The team would also sign Washington's former UCLA teammate, Woody Strode. He played just one season, but then enjoyed a successful acting career, which included a Golden Globe nomination for a supporting role in *Spartacus*.

Photograph by PRO FOOTBALL HALL OF FAME/AP PHOTOS

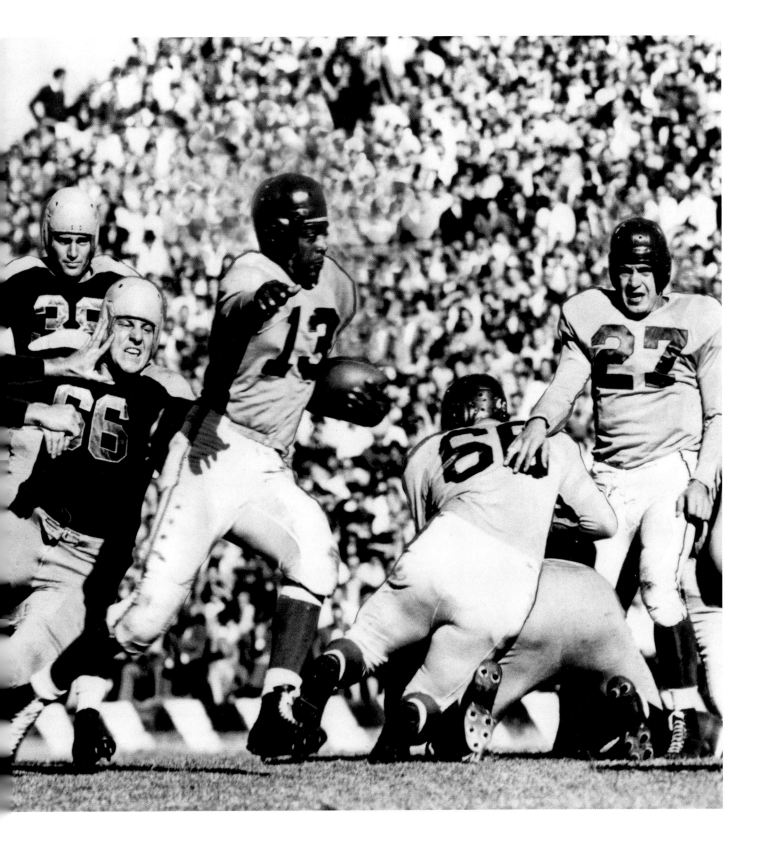

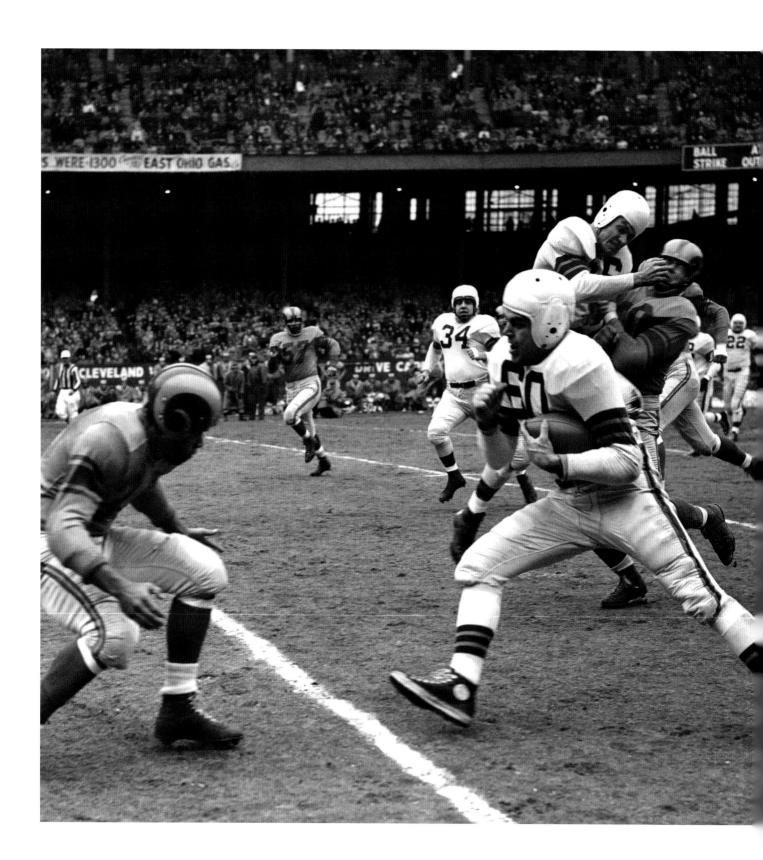

AUTOMATIC OTTO

CLEVELAND STADIUM, CLEVELAND | *December 24, 1950*

IT'S NOT EASY comparing quarterbacks from different eras, but there's really one piece of information about Otto Graham that automatically puts him in the conversation for greatest quarterback of all time: From 1946 to 1955, Graham led the Cleveland Browns to 10 straight championship games, winning seven of them. Even if he was surrounded by amazing talent, there's no denying Graham's greatness. After he died on December 17, 2003, Paul Zimmerman penned this tribute for SI:

"Watching Graham and his Browns in the All-America Football Conference was to see a brand of football that was way ahead of its time. The NFL, in the late 1940s, was shaking off the traces of the single wing. The T formation was still a learning experience. Pass protection was primitive, and quarterbacks completed less than 50% of their passes. But the Browns, whose offensive line employed Paul Brown's technique of cup blocking and chanted 'Nobody touches Graham' as they broke the huddle, helped make Otto the most precise and meticulous passer the game had ever seen. In 1953 he connected on 64.7% of his throws.

"Cleveland breezed through four AAFC titles before joining the NFL in 1950. That year, at one of the keynote games in league history, the Browns played the two-time NFL champion Eagles in Philadelphia. I sat in the end zone and watched Graham play the defenders like violins, working the corners with comeback routes off quick, timed squareouts and, when they loosened up, hitting them up the middle with 238-pound fullback Marion Motley. The final score was 35–10. 'It was those comebacks off the quick outs that killed 'em,' Graham told me years later. 'They were something I worked out with my receivers, Dante Lavelli and Mac Speedie. Throw the timed pattern, but have them break back toward me at the end of it. Defensive backs couldn't react to that.'

"What he didn't mention was that it took utmost accuracy to make the whole thing work, and until John Unitas and Joe Montana arrived no one was as accurate as Graham. One story was about how one of his teammates bent a wire coat hanger into a diamond shape one day and challenged Graham to throw a football through it from 15 feet away. He went 10 for 10.

"He played in the NFL for six years and reached the championship game in each one, and his effect on his teammates was electric. They just never felt they could lose a game he was quarterbacking. How would I rate him, alltime? Top five, along with Montana, Unitas, Sammy Baugh, Sid Luckman and John Elway. But no one was as great a winner as Graham."

Photograph by BETTMANN

THE GREATEST GAME EVER PLAYED

YANKEE STADIUM, BRONX, N.Y. | *December 28, 1958*

WAS THE 1958 NFL Championship Game between the Baltimore Colts and New York Giants really the greatest game ever played? Like most everything else in sports, that's up for debate. No one can argue, however, that it was—and still is—the most important.

In terms of popularity in the United States, football was still far behind baseball at that time. The '58 championship was just the fourth NFL title game to be televised nationally. And the 45 million fans who watched the contest saw something that had never happened before in any NFL game: sudden-death overtime.

The game featured 12 players, six on each team, who would end up in the Pro Football Hall of Fame—names such as Johnny Unitas and Ray Berry for the Colts, Frank Gifford and Sam Huff for the Giants. The Colts marched the length of the field in the closing minutes of regulation to set up the game-tying field goal. Midway through the first overtime period, Colts running back Alan Ameche scored on a 1-yard run to win the title.

Here's how Tex Maule described the scene in the January 5, 1959, issue of *Sports Illustrated*:

"The Baltimore Colts needed all their varied and impressive talent to get the 17–17 tie at the end of the regular four quarters. Then, for eight and one quarter minutes of the sudden-death extra period, in which victory would go to the first team to score, all of the pressure and all of the frenzy of an entire season of play was concentrated on the misty football field at Yankee Stadium. The fans kept up a steady, high roar. Tension grew and grew until it was nearly unbearable. But on the field itself, where the two teams now staked the pro championship and a personal winner's share of $4,700 on each play, coldly precise football prevailed. With each team playing as well as it was possible for it to play, the better team finally won. The Colts, ticking off the yards with sure strength under the magnificent direction of quarterback Johnny Unitas, scored the touchdown that brought sudden death to New York and the first championship to hungry Baltimore."

The buzz this game created sparked a new era of professional football and led directly to the sport's incredible growth in the '60s.

Photograph by NEIL LEIFER

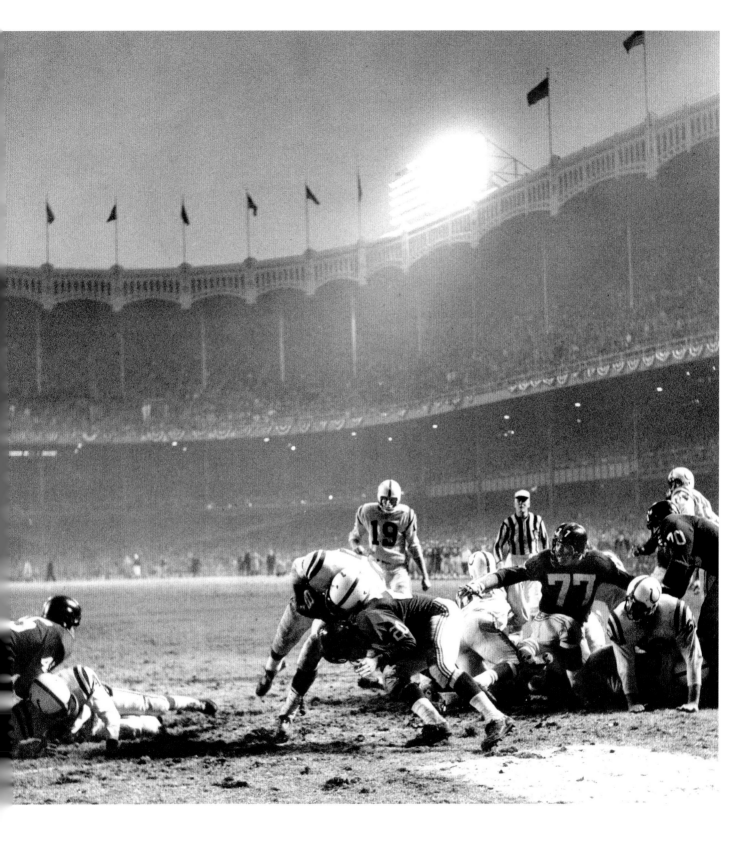

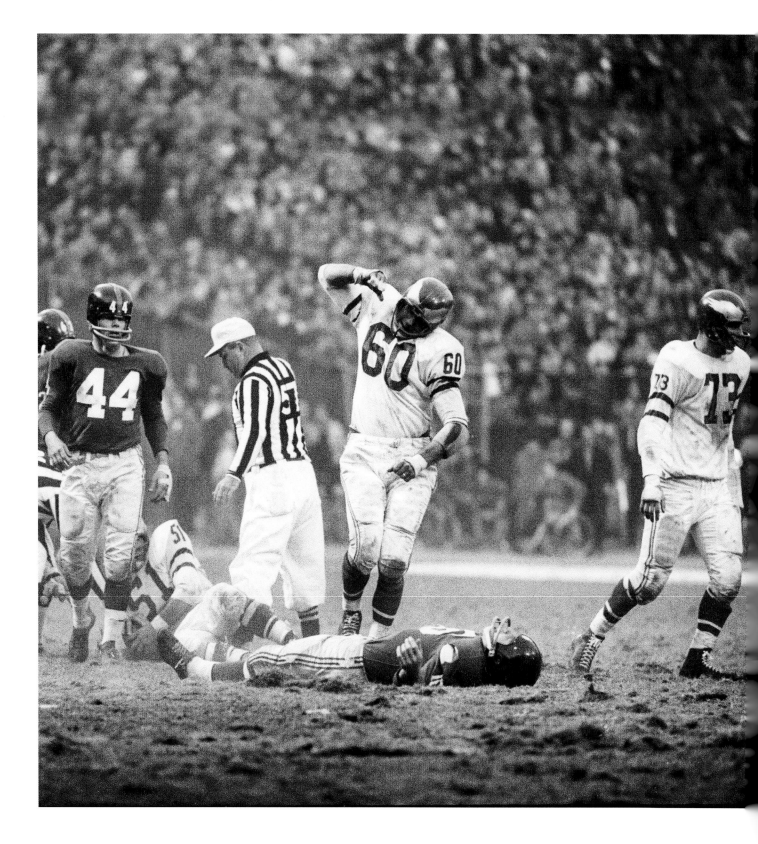

LAST OF THE 60-MINUTE MEN

YANKEE STADIUM, BRONX, N.Y. | *November 20, 1960*

CHUCK BEDNARIK—A.K.A. CONCRETE Charlie—is perhaps the most symbolic "old-school" football player there ever was. His name was perfect for a hard-nosed, hard-hitting tackler. And, of course, he played all 14 of his NFL seasons with the blue-collar Philadelphia Eagles. A few days after he died at age 89, this was the obituary penned by Tim Layden for the March 30, 2015, issue of SI:

"The Hall of Fame center/linebacker Chuck Bednarik, who died last Saturday at 89, didn't simply live and play football in another time; he was wholly and unmistakably of that time—a Greatest Generation soldier, a 60-minute man and an unrepentant defender of the era that he defined and which in turn defined him.

"Born in Bethlehem, Pa., Bednarik enlisted in the Army before finishing high school. Between August 1944 and April '45, he flew 30 bombing missions over Germany, manning a .50 caliber machine gun, and each safe landing was a fresh lease on life. In a '93 *Sports Illustrated* profile of Bednarik, John Schulian wrote, '... he did what he did after every mission, good or bad. He lit a cigarette and headed for the briefing room, where there was always a bottle on the table. "I was 18, 19 years old," he says, "and I was drinking that damn whiskey straight."

"Bednarik went from the war to Penn, where he was a two-time All-American, and then spent 14 seasons with the Eagles, playing both ways—center and middle linebacker—for the first seven and parts of the last seven, making All-Pro eight times as a linebacker.

"But Bednarik's influence can't be reduced to biographical records. At 6'3" and 235 pounds, he was quick-footed and powerful in the era that preceded weight training (and steroids), and earned a reputation for crushing hits and intimidation. He is best remembered for two plays from Philadelphia's 1960 NFL championship season. On November 20 he took down Giants halfback Frank Gifford with a hit to the chest that left Gifford concussed and caused him to miss the entire 1961 season. A month later in the NFL title game at Franklin Field, Bednarik tackled Jim Taylor of the Packers in the closing seconds, then lay on top of Taylor until time expired before saying, 'You can get up now, the game's over.'

"The game was never really over for Bednarik. Into his 80s he remained the go-to source for criticism of the modern, pampered athlete. It was a role he earned with his body and soul, speaking in the voice of his generation."

Photograph by JOHN G. ZIMMERMAN

PAPA BEAR

FRANKLIN FIELD, PHILADELPHIA | *November 5, 1961*

NO LIST OF the most important figures in professional football is complete without the inclusion of George "Papa Bear" Halas. He belongs on the Mount Rushmore of coaches *and* the Mount Rushmore of owners. As a player, he was merely good. But you could forgive him if he wasn't a superstar. In addition to playing wide receiver and defensive end for the Decatur Staleys, soon to be renamed the Chicago Bears, he also coached the team and handled ticket sales. Overall, Halas coached the Bears for 40 years. He won six NFL championships and retired from coaching with 324 wins, a league record that stood until Don Shula broke it in 1993.

His last year on the sidelines was 1967—47 years after he was part of the group that founded what would become the National Football League. In 1977, at the age of 82, Halas was still working five and a half days a week. SI's Frank Deford caught up with him in his office at Bears headquarters for a story that ran in the December 5, 1977, issue:

> "It is easy to forget that this man across the desk is a certified institution. Papa Bear was tackled by Jim Thorpe and struck out by Walter Johnson. He played six games in right field for the Yankees in 1919 (the Babe settled in that very realty the next season), and Halas was also there in Canton,

Ohio, sitting on a running board in a Hupmobile showroom on Sept. 17, 1920 when pro football was created. It was a Friday, one of the last things to be created in just one day. And this fellow across the desk was right there, live. Then Papa Bear won 326 games, 12 more than Stagg, more than anyone in the history of the pros or the colleges. He is the only man Vince Lombardi would embrace and one of the few he would call Coach.

"Coach, what makes a good coach?

"'Complete dedication,' Papa Bear declares straightaway. And another surprise: 'He must know football.' Hmmm. 'And he must apply himself. And he must have the right temperament.'

"Which is what?

"'I don't know. I just knew my own.'

"Which was what?

"'I liked to win and I fought for everything in the book. Nothing else mattered.' Pause. 'That's all.'"

Photograph by NEIL LEIFER

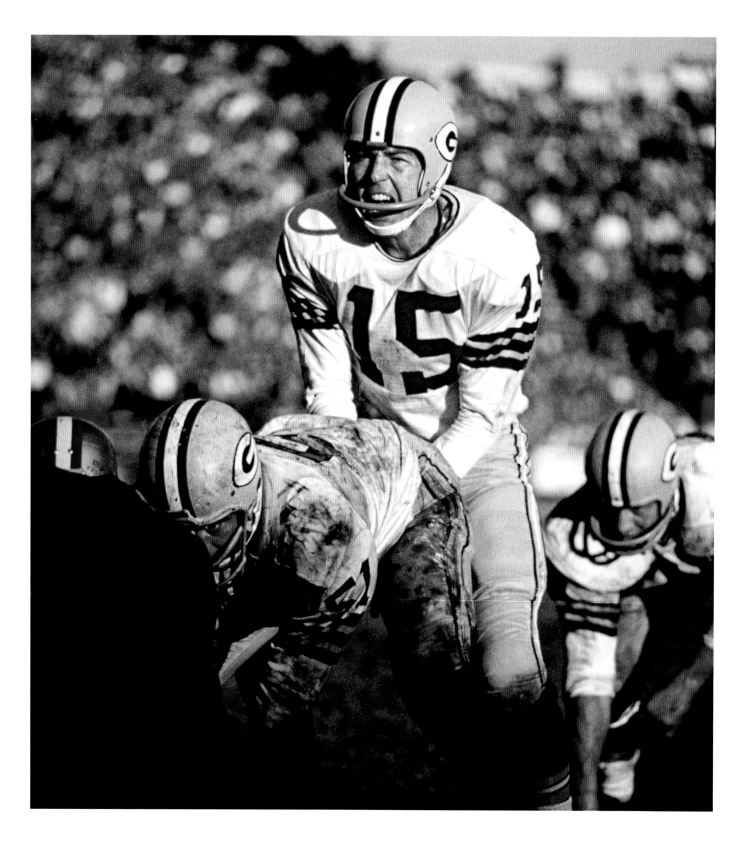

THE FIELD GENERAL

KEZAR STADIUM, SAN FRANCISCO | *December 9, 1962*

BART STARR WAS never the flashiest quarterback in the NFL and he didn't put up incredible passing numbers, even by the more modest standards of the 1960s. All Bart Starr did was win.

As captured in this photo late in the 1962 season, the Green Bay Packers quarterback was the quintessential field general. A 17th-round draft pick out of Alabama in 1956, Starr only started a handful of games for the Packers in his first few seasons. But when Vince Lombardi took over as head coach in 1959, he felt Starr had the right combination of intelligence and ability to be his starter. In 1960, Starr led the Packers to the NFL Championship Game against Philadelphia. The Eagles won—it would be the only postseason loss of Starr's career.

A year later, Starr and the Packers won the first of back-to-back NFL titles. Green Bay's offense was fueled by a powerful running game that featured Jim Taylor and Paul Hornung, but it was Starr who called the plays and was a model of efficiency. As Taylor and Hornung slowed

a bit in the mid-1960s, Starr called his own number more and made the passing game more of a focus. He threw 16 touchdown passes in 1965, a season that culminated with his third NFL title. In 1966, he was named NFL MVP after throwing for 14 touchdowns and just three interceptions, leading the league with a passer rating of 105. After throwing four TD passes in Green Bay's NFL title game win over the Cowboys, Starr and the Packers represented the NFL in the first-ever AFL-NFL Championship Game—which would later be known as Super Bowl I. Not only was Starr MVP of that game, he went on to be Super Bowl II MVP as well.

All in all, Starr was 9–1 in playoff games, with 15 touchdown passes and three interceptions. His career postseason passer rating of 104.8 remains third all time. He had been first for 50 years until Josh Allen and Patrick Mahomes recently passed him.

Photograph by NEIL LEIFER

THE AGONY OF DEFEAT

PITT STADIUM, PITTSBURGH | *September 20, 1964*

YELBERTON ABRAHAM TITTLE JR. played quarterback in the NFL and AAFC for 17 years. After three seasons with the Baltimore Colts and 10 more with the San Francisco 49ers, he was traded to the New York Giants and led them to the NFL title game three years in a row (1961–63). He passed for over 28,000 yards and led the NFL in TD passes three times on his way to being enshrined in the Pro Football Hall of Fame. Yet for all his positive accomplishments on the football field, Y.A. Tittle will forever be best known for this photograph, taken near the end of an otherwise unimportant game in 1964.

The picture was taken by Morris Berman, a photographer for the *Pittsburgh Post-Gazette*. Playing the Pittsburgh Steelers at Pitt Stadium in Week 2 of the season, the Giants had a 14–0 lead when Tittle attempted a screen pass deep in his own territory. The pass was intercepted and returned for a touchdown, but Tittle never saw that. After releasing the pass, Tittle was hit square in the chest by a Steelers defensive lineman and slammed to the turf.

In addition to the bloody head seen in the photo, Tittle suffered bruised ribs. Tittle was a month shy of 38 when that game was played—plenty old for a pro football player, though he looked even older. He continued to play through the season, but he was never the same. When the '64 season ended, Tittle retired. The Steelers game wasn't his last in the NFL, but it feels like a symbolic finish.

"That was the end of my dance," Tittle told *Smithsonian Magazine* in 2007, 10 years before he died. "A whole lifetime was over."

Adding to the legend of this photo: Berman's picture never actually ran in the *Post-Gazette*'s game story. Berman's editor preferred to use an action shot. The photo didn't really get noticed until Berman entered it in several contests. It won for best sports photograph in the National Headliner Award contest later that year.

Photograph by MORRIS BERMAN/AP PHOTOS

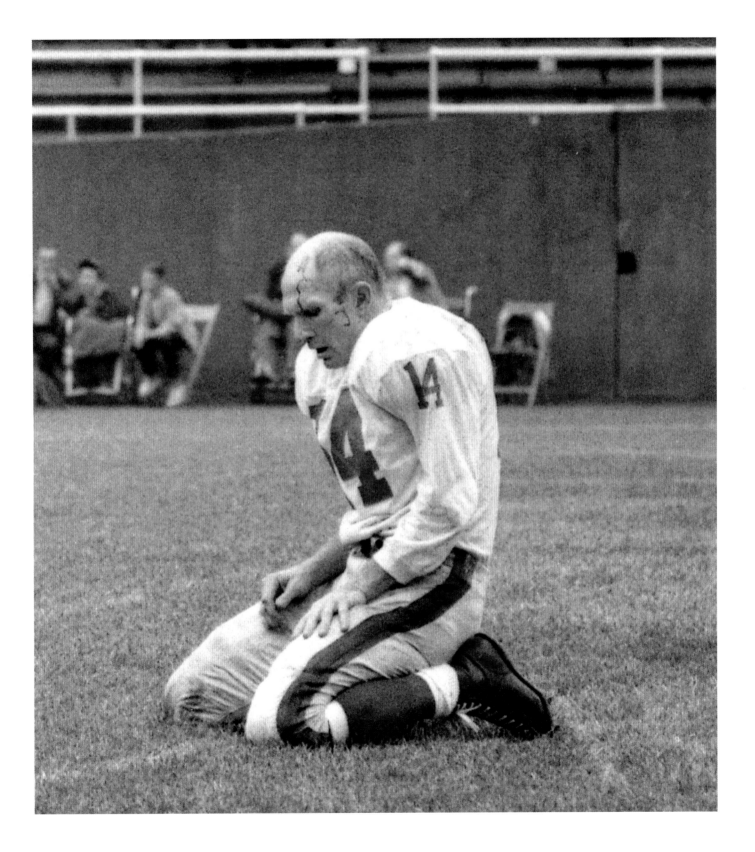

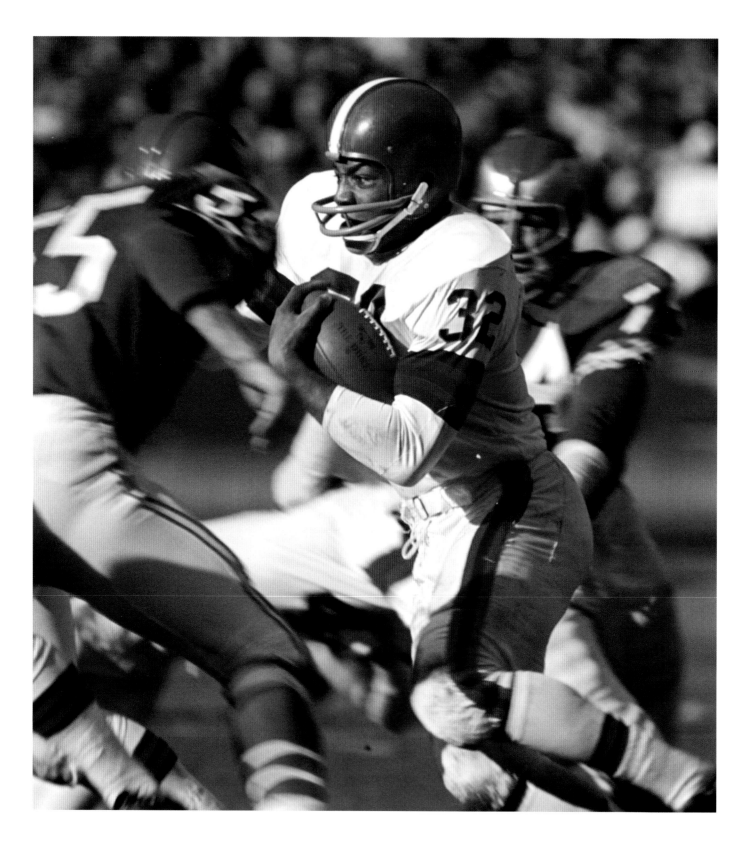

GOODBYE, CLEVELAND. HELLO, HOLLYWOOD

CLEVELAND STADIUM, CLEVELAND | *November 29, 1964*

"The Cleveland Browns probably lost the championship of the Eastern Conference of the National Football League on the playing fields of Beechwood Park School for Boys near London last week. That is where Jim Brown, the best running back in the game for the past nine years, announced his retirement."

That was the beginning of Tex Maule's story in the July 25, 1966, issue of *Sports Illustrated*. To be clear, Brown wasn't just the best running back of the previous nine years; he was perhaps the greatest running back of all time.

Possessing a breathtaking combination of speed and toughness, Brown was the NFL's all-time rushing leader when he retired, rushing for 12,312 yards in his nine seasons. The record stood for 18 years before Walter Payton passed him. Ten players currently rank ahead of Brown, though none played fewer than 11 seasons and all of them played after the NFL season schedule was expanded from 14 to 16 games. Brown was just 30 years old when he retired, fresh off a 1965 season in which he rushed for 1,544 yards—the eighth single-season rushing title of his career.

So why did Brown retire? The reason he was in London at the time of his retirement announcement was because he was on a movie set, playing a role in the war epic, *The Dirty Dozen*. Filming was behind schedule, and it was clear Brown wouldn't be done before Cleveland players had to report for training camp. Browns owner Art Modell threatened to fine him for the days he missed … so Brown just decided to call it quits and focus on his acting career.

"I think the Browns will be all right," Brown told Maule in that SI story. "They may be even better without me because they will have a more diversified attack."

Brown's acting career was successful—he appeared in more than 50 movies or TV shows—though nowhere near the level of his football career. As for the Browns, their former star's prediction couldn't have been more wrong. After reaching the NFL Championship Game in Brown's final two seasons, winning in 1964, Cleveland missed the playoffs in their first season without Brown. And they haven't been back to a title game since.

Photograph by NEIL LEIFER

A WINNING FORMULA

PHOTO SHOOT, BALTIMORE | *December 4, 1964*

WHEN THE MIAMI Dolphins defeated the Philadelphia Eagles on November 14, 1993, Don Shula became the winningest coach in NFL history. His 325th career victory surpassed the legendary George Halas. When Shula retired two years later, he closed the book on a legendary career of his own. In 33 seasons as a head coach—seven with the Baltimore Colts (pictured here with Johnny Unitas) and then 26 in Miami—Shula *averaged* 10 regular-season wins a year. He had all of two losing seasons and made the postseason 20 times, winning two Super Bowls with Miami and an NFL championship with the Colts.

While some coaches are known for a certain style, Shula remained a consistent winner despite making perhaps the greatest coaching pivot in football history. The Dolphins of the 1970s were a ground-and-pound team, winning with defense and a conservative offense led by the running game. In 1983, the Dolphins drafted quarterback Dan Marino and everything changed. Well, almost everything. With Marino under center, Shula's offense was now a pass-happy unit posting record offensive statistics. It was an entirely different approach, but Shula kept on winning.

When Shula retired after the 1995 season, rival head coach Marv Levy, who would later join Shula in the Pro Football Hall of Fame, penned a guest column in the January 15, 1996, issue of *Sports Illustrated* paying tribute:

"I am going to miss Don Shula. I like him and I admire him. I'm going to miss looking those 53 yards across the field and thinking, There is a coaching legend. I remember when I was a special teams coach with the Redskins in 1972. We played the Dolphins in Super Bowl VII in the Los Angeles Coliseum. I was just an assistant, but I felt a real sense of pride being on the same field with Shula. Whenever I think of baseball, the first name that comes to mind is Babe Ruth. What the Babe was to baseball, Shula is to football coaching. There are certain figures in sports who are larger than the games they play or coach, and Don Shula is one of those.

"Over the years we became friendly rivals, but I never stopped admiring him. People sometimes ask me to name the greatest coach in NFL history. George Halas may have set the standard, but Don Shula has won more games than anyone, and he has done it in the most competitive era. He had an incomparable ability to evaluate players, to motivate them and to teach them the game of football. Above all else, he was honest. His teams played clean, hard, by-the-rules football. He was the keenest of competitors from the day he entered the league until the day he retired, and he respected those who competed so hard against him.

"I don't think we'll see the likes of Don Shula again, in this era or perhaps ever."

Photograph by NEIL LEIFER

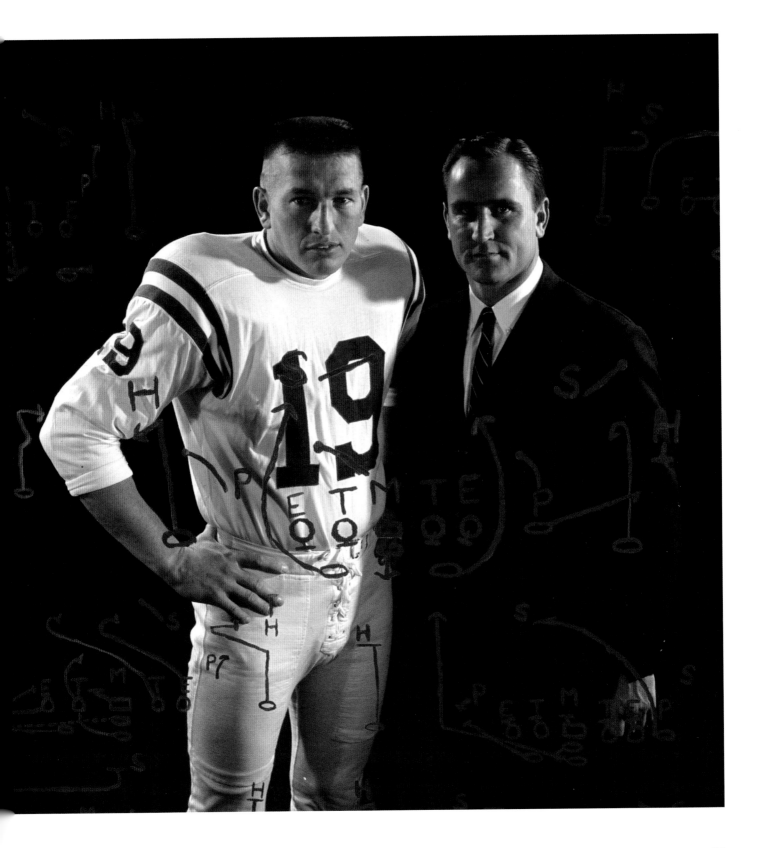

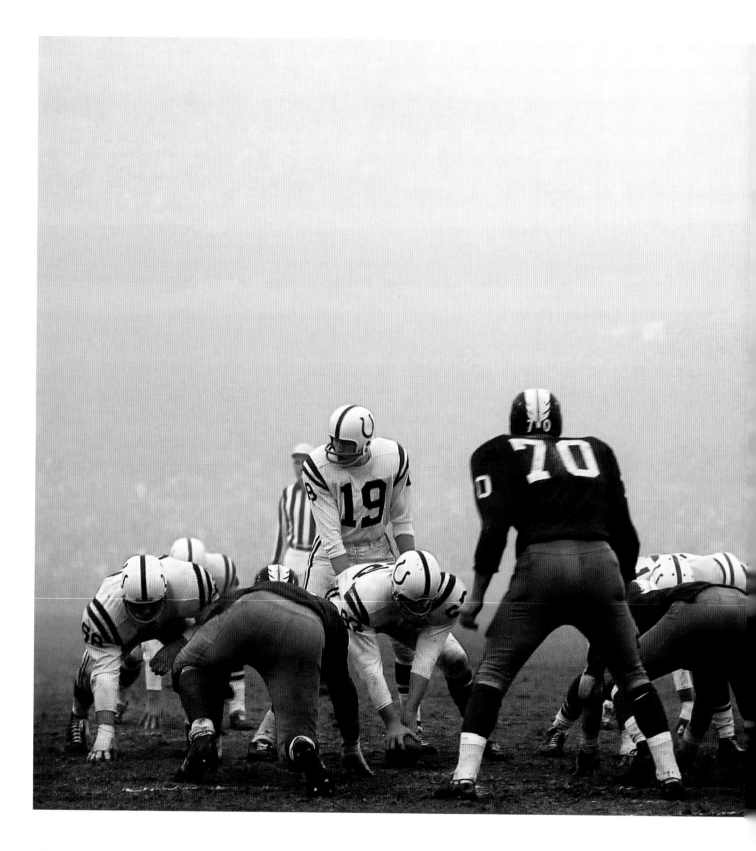

THE BEST THERE EVER WAS

MEMORIAL STADIUM, BALTIMORE | *December 13, 1964*

HALL OF FAME quarterback Johnny Unitas graced the cover of SI on September 23, 2002—12 days after his death at age 69. The story, penned by award-winning writer and lifelong Baltimore Colts fan Frank Deford, had a simple headline: "The Best There Ever Was."

An excerpt:

"Sometimes, you just had to be there.

"That was the way it was with Johnny Unitas in the prime of his life, when he played for the Baltimore Colts and changed a team and a city and a league. Johnny U was an American original, a piece of work like none other, excepting maybe Paul Bunyan and Horatio Alger.

"Part of it was that he came out of nowhere, like Athena springing forth full-grown from the brow of Zeus, or like Shoeless Joe Hardy from Hannibal, Mo., magically joining the Senators, compliments of the devil. But that was myth, and that was fiction. Johnny U was real, before our eyes.

"Nowadays, of course, flesh peddlers and scouting services identify the best athletes when they are still in junior high. Prospects are not allowed to sneak up on us. But back then, 1956, was a quaint time when we still could be pleasantly surprised. Unitas just surfaced there on the roster, showing up one day after a tryout. The new number 19 was identified as 'YOU-ni-tass' when he first appeared in an exhibition, and only later did we learn that he had played, somewhere between obscurity and anonymity, at Louisville and then, for six bucks a game, on the dusty Pittsburgh sandlots. His was a story out of legend, if not, indeed, out of religious tradition: the unlikely savior come out of nowhere."

The Colts had been building a strong team, with future Hall of Famer players like Lenny Moore, Gino Marchetti and Art Donovan. They drafted quarterback George Shaw in the first round in 1955 with the hopes he would lead the team to greatness. That would not be the case. During the fourth game of the 1956 season, Shaw broke his leg. In came Unitas, and a legend was born. Two years later, Unitas led the Colts to the NFL championship in the overtime win over the New York Giants known as "the Greatest Game Ever Played." It was the first of three NFL titles he won with Baltimore. He also helped the Colts win Super Bowl V, connecting with John Mackey on a 75-yard touchdown pass.

Playing in an era long before the NFL's passing explosion, Unitas was ahead of his time. A three-time NFL MVP, he led the league in passing yards four times and led the league in touchdown passes four years in a row. His record streak of 47 consecutive games with at least one TD pass stood for 52 years until Drew Brees broke it in 2012.

Photograph by NEIL LEIFER

THE KANSAS COMET

WRIGLEY FIELD, CHICAGO | *December 12, 1965*

GALE SAYERS EARNED his nickname during his days at the University of Kansas, but the shifty running back from Omaha, Neb., truly embodied that moniker in the professional ranks. Like a comet, Sayers shined brilliantly as he flew past everyone and everything in his universe seemingly at light speed. And like a comet, Sayers unfortunately burned out quicker than any other star in the NFL galaxy.

It didn't take long for Sayers to make an impact after the Chicago Bears made him a first-round draft pick in 1965. Sayers played sparingly in Chicago's first three games, all losses. The Bears turned it around from there, winning nine of their next 10 games—and Sayers was the catalyst. After the team's Week 11 win over the Giants at Yankee Stadium, Sayers had 14 total touchdowns, which tied an NFL rookie record. In his recap of the Bears-Giants game for the December 6, 1965, issue of SI, Tex Maule declared "there is now no argument about who will be the Rookie of the Year. That man is Gale Sayers, the marvelously exciting running back of the Chicago Bears."

With three games left, there was little doubt Sayers would break the rookie touchdown record. But what he did two weeks later was astonishing. In a 61–20 win over the San Francisco 49ers, Sayers tied another NFL record by scoring *six* touchdowns in one game. And it wasn't just that he scored six touchdowns, it was *how* he scored. He opened the game's scoring with an 80-yard screen pass. One of his four TD runs went for 50 yards. For good measure, he scored the game's final touchdown on an 85-yard punt return. He finished with 336 all-purpose yards, averaging 21 yards every time he touched the football.

Sayers indeed won Rookie of the Year honors in 1965, and he continued to blaze a trail. He led the NFL in all-purpose yards in each of his first three seasons and led the league in rushing twice. But knee injuries cut his career short. After playing just two games each in 1970 and '71, Sayers retired. Despite only playing five full seasons in the NFL, Sayers's brilliance on the field was undeniable. In 1977, he was elected to the Pro Football Hall of Fame.

Photograph by NEIL LEIFER

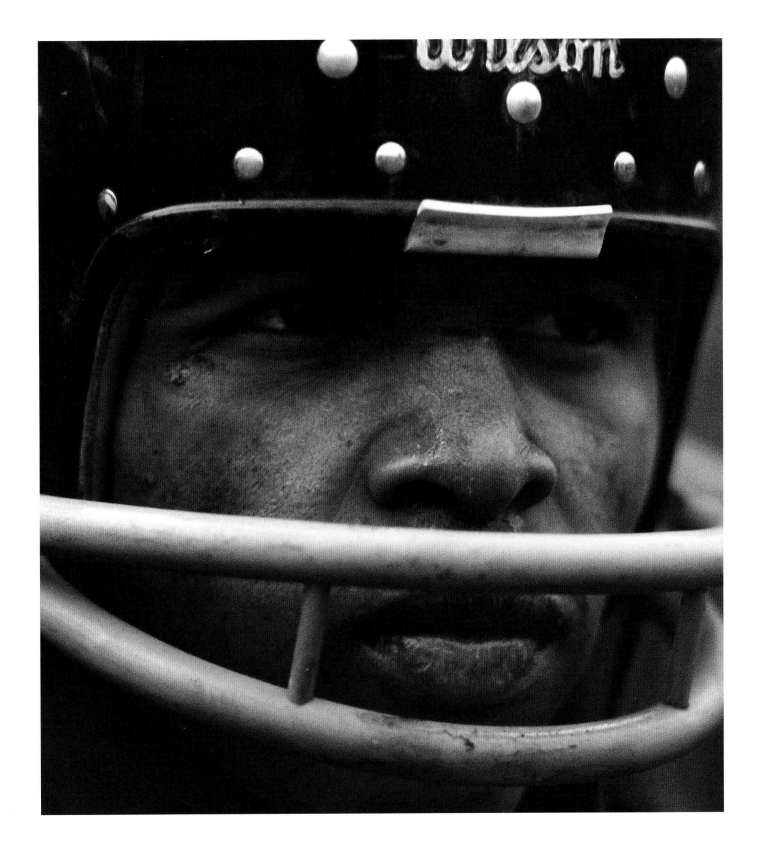

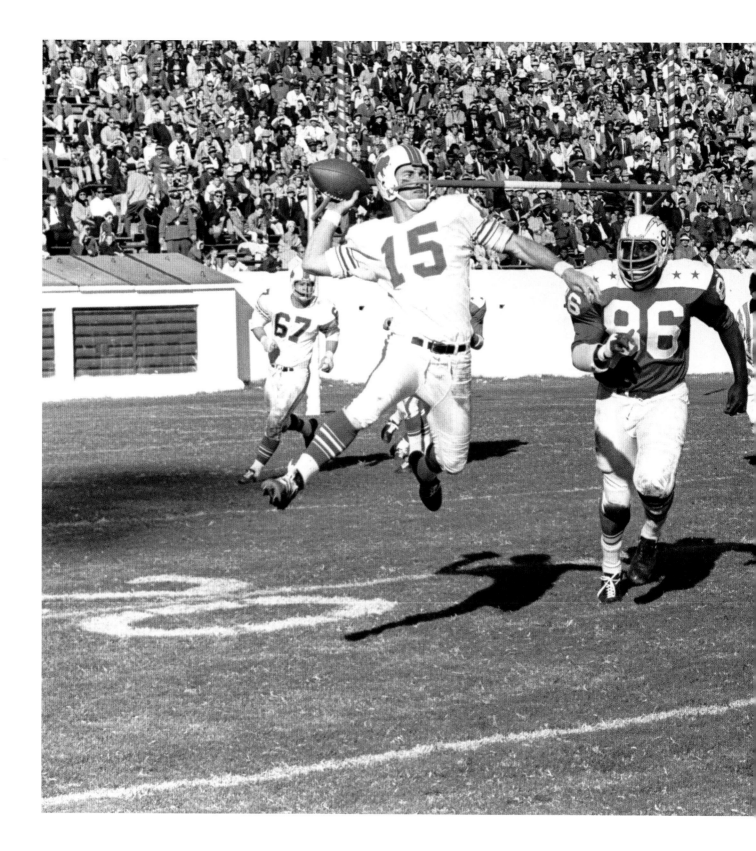

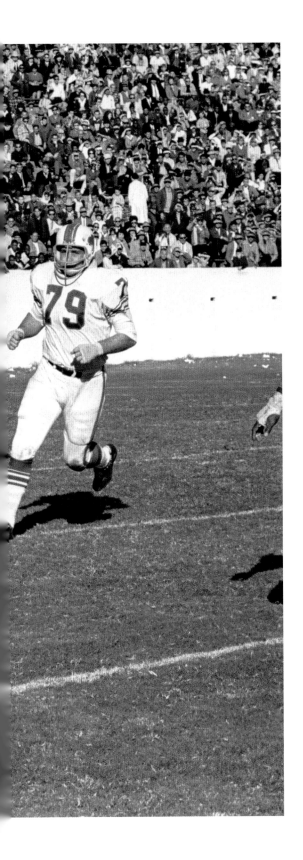

THE POLITICIAN

RICE STADIUM, HOUSTON | *January 15, 1966*

JACK KEMP, A vocal conservative Republican long before he went into politics, struggled for a couple of seasons in the NFL before making a name for himself in the fledgling AFL. This was the beginning of Kemp's obituary, which ran in the May 11, 2009, issue of SI:

"In 1964 a rumor swept Buffalo that Bills running back Cookie Gilchrist was getting fewer carries because quarterback Jack Kemp, a staunch Republican, refused to hand the ball off to an unabashed lefty. It turned out to be a sportswriter's joke, but Gilchrist still saw fit to angrily refute the notion that Kemp, who died last Saturday at age 73 of cancer, could be so narrow-minded. 'Jack is a pro,' Gilchrist snapped, 'and a pro would hand off to Castro.'

"Kemp's conservatism was no secret. Before joining the Bills in 1962, he played two seasons with the Chargers and moonlighted as a columnist for *The San Diego Union*, a right-leaning paper.… Kemp read William F. Buckley and Ayn Rand on team flights. He campaigned for Republican candidates. He befriended Richard Nixon and was a liaison to college campuses for the Republican National Committee. A foray into politics seemed inevitable, but not before the end of his football career."

And what a career it was. Kemp helped the Bills win back-to-back AFL championships in 1964 and '65, and he was the MVP of both title games. When he retired after the 1969 season, he ended his career as the AFL's all-time leader in passing yards.

Kemp followed his 10-year AFL career with a 19-year run in the United States House of Representatives. In 1989, he was appointed Housing Secretary under President George H.W. Bush.

Kemp is certainly one of the most prominent former pro football players to hold a high-ranking place in government, but he is not alone. Hall of Fame wide receiver Steve Largent was an Oklahoma congressman for nine years. Former Saints and Raiders quarterback Heath Shuler was a U.S. representative for North Carolina from 2007 to 2013. Former Colts and Patriots receiver Anthony Gonzalez has been a congressman for Ohio since 2019.

Photograph by BETTMANN

THE GUARANTEE

PHOTO SHOOT | *July 23, 1966*

"BROADWAY JOE NAMATH is the folk hero of the new generation."

Those were the words of Tex Maule from the January 20, 1969, issue of SI, recounting what remains one of the greatest upsets in all of sports. The New York Jets were 17-point underdogs to the Baltimore Colts in Super Bowl III, the third championship game between the NFL and the upstart American Football League. After the Packers had won the first two Super Bowls handily, many fans believed an AFL team could *never* win a Super Bowl.

Enter Namath.

"Namath reminds you a bit of Dean Martin in his relaxed confidence and in the droop of his heavy-lidded eyes," Maule wrote. "He is a man of self-assurance and, as he showed early in the week, a man of startling honesty."

Earlier in the week, despite the long odds against them, Namath publicly and famously said his Jets were going to win the game. "I guarantee it," he added. But he didn't stop there. He said there were five or six AFL quarterbacks better than Colts quarterback Earl Morrall. Both Namath and Jets head coach Weeb Ewbank instilled a confidence in the team that picked up steam throughout the week and ultimately stifled the Colts on gameday.

Matt Snell rushed for 121 yards and a touchdown. The defense intercepted Morrall three times and when aging Hall of Famer Johnny Unitas, who missed almost the entire season with an arm injury, came off the bench in the third quarter, they intercepted him too.

The Jets won, 16–7. In addition to cementing the legend of Joe Namath, who was the game's MVP, it also gave the AFL instant credibility.

Perhaps lost in the shadow of Namath was the legend of Ewbank. It's hard to call a member of the Hall of Fame underrated, but Ewbank has never been considered for anyone's Mount Rushmore of coaches. But consider: Ewbank was the Colts head coach when they defeated the Giants in the 1958 NFL Championship Game. In other words, Ewbank was the winning coach in perhaps the two most important football games ever played.

Photograph by NEIL LEIFER

THE PASS-CATCHER

MUNICIPAL STADIUM, KANSAS CITY, MO. | *November 6, 1966*

LAUNCHED IN 1960, the American Football League produced its fair share of superstar players before eventually merging with the NFL at the end of the decade. Few stars shined as bright as San Diego Chargers wide receiver Lance Alworth.

Nicknamed "Bambi" for his speed and grace, Alworth simply could not be covered. After an injury-shortened rookie season in 1962, he rattled off seven straight 1,000-yard seasons, leading the AFL in receiving yards and touchdowns three times each. In 1965, he caught 69 passes for 1,602 yards and 14 touchdowns—averaging an incredible 114.4 yards per game.

Alworth finished his career with 542 receptions for 10,266 yards (18.9 yards per catch) and 85 touchdowns. Playing for the Dallas Cowboys the last two years of his career, Alworth caught a touchdown from Roger Staubach in Super Bowl VI. Alworth was the first AFL player ever elected to the Pro Football Hall of Fame.

A proud member of the AFL, Alworth was not shy about singing the league's praises. Years before Joe Namath famously guaranteed an AFL victory in Super Bowl III, Alworth was saying the AFL was the better league. As the receiver told Edwin Shrake in the December 13, 1965, issue of SI:

"Any athlete with pride wants to compete against the ones who are supposed to be the best. The fact is, I don't believe the NFL is the best. I watch plenty of NFL films. Their defenses are not as complex and advanced as ours have become in the AFL. Most NFL teams use the old 4-3 defense, with red dogs coming off of it. Hardly anybody ever does anything that simple in our league anymore, which is why our games don't have as much scoring as theirs. And their cornerbacks are just people. The only edge the NFL has over us is three experienced quarterbacks—Johnny Unitas, Frank Ryan and Sonny Jurgensen. Our top four teams and the NFL's top seven are not far apart. I hope we get to play against them someday and shut them up."

Photograph by JOHN VAWTER COLLECTION/DIAMOND IMAGES/GETTY IMAGES

AMERICA'S TEAM IS BORN

NAVAL BASE, SOUTH VIETNAM | *November 13, 1966*

THE DALLAS COWBOYS didn't officially become known as "America's Team" until six years after their victory in Super Bowl VI, but their 24–3 win over the Dolphins set a decade of dominance in motion. It was the team's second of five Super Bowl appearances in the 1970s and the first of their two championships. The Cowboys had reached Super Bowl V a year earlier, losing a close game to the Colts, but their quarterback that season was Craig Morton. The '71 season was the first as a full-time starter for Roger Staubach, who was the face of America's Team. He was already a football hero, having won the 1963 Heisman Trophy playing for Navy. And after graduating from the Naval Academy in 1965, he *volunteered* for a tour of duty in Vietnam.

After serving his country for three years in Vietnam, Staubach returned to the States for his final two years of service before joining the Cowboys—who had drafted him in 1964 as a "futures" pick—as a 27-year-old rookie in 1969.

Despite the late start to his career, Staubach flourished. He threw two touchdown passes in Super Bowl VI and was named MVP. He led Dallas to another title with a win in Super Bowl XII and when he retired in 1980, he had the highest career passer rating in NFL history. Staubach was elected to the Pro Football Hall of Fame in 1985.

As for the "America's Team" nickname, that was the brainchild of NFL Films producer Bob Ryan. As he was putting together the team's official 1978 highlight reel, Ryan noticed how Dallas fans always showed up no matter where the team was playing. Thus, he named the highlight reel "America's Team."

Now, he did need the team to sign off on the title. Hall of Fame head coach Tom Landry did not approve, as he feared it would put a target on his team. But general manager Tex Schramm loved the idea, and gave his approval. The name stuck, and soon enough, 50 percent of NFL products being sold were Cowboys merchandise.

Photograph by BETTMANN

1967
to
1999

The
Super Bowl
Era

SUPER BOWL I

LOS ANGELES MEMORIAL COLISEUM, LOS ANGELES | *January 15, 1967*

SUPER BOWL I wasn't really known as Super Bowl I at the time it was played. Just seven months after the NFL and AFL agreed to a merger, the NFL's Packers played the AFL's Chiefs in the first meeting between the two leagues. It was originally called the AFL-NFL World Championship Game. Played before a crowd of 61,946 at Los Angeles Memorial Coliseum, Green Bay prevailed, 35–10. Many observers expected a big win for the Packers, but it wasn't as easy as the final score indicated.

From Tex Maule's game story in the January 23, 1967, issue of SI:

> "For two quarters it seemed that the Kansas City Chiefs might turn the Super Bowl into a Super Upset. The AFL champions, 7-year-old babes in the jungle of professional football, had played the merciless machine that is Vince Lombardi's NFL champion Green Bay Packers to a virtual standstill, blunting the famed running attack, harassing the game's best passer, moving the ball down the field to trail only 14–10. Then the superdream came to a nightmarish end. The Packers stormed out of the weeds, where they had been lurking for a half, and suddenly the first game between the two long-feuding leagues became a rout."

It might not have been a matter of the Packers "lurking." Rather, it might have been the weight of an entire league sitting on their shoulders. For years, NFL owners and coaches and players and league executives had been selling the narrative that the AFL was the minor leagues compared to the older, more established product. As time passed, it became well documented that Lombardi and his players received many calls and telegrams reminding them how critical it was that they win this game.

But the Chiefs were a worthy opponent. The fierce Green Bay defense was not used to seeing the play-action passes being perpetrated by Chiefs quarterback Len Dawson. Thus, the Packers decided at halftime to start blitzing more. The decision paid off. Four plays into the third quarter, Dawson rushed a pass to avoid a blitzing linebacker and Willie Wood picked him off, returning the interception 50 yards to the Chiefs' 5-yard line. Elijah Pitts scored on the next play and the Packers never looked back.

"You could practically hear the giant sigh of relief in the dressing room," said Wood. "Then we started celebrating."

Photograph by NEIL LEIFER

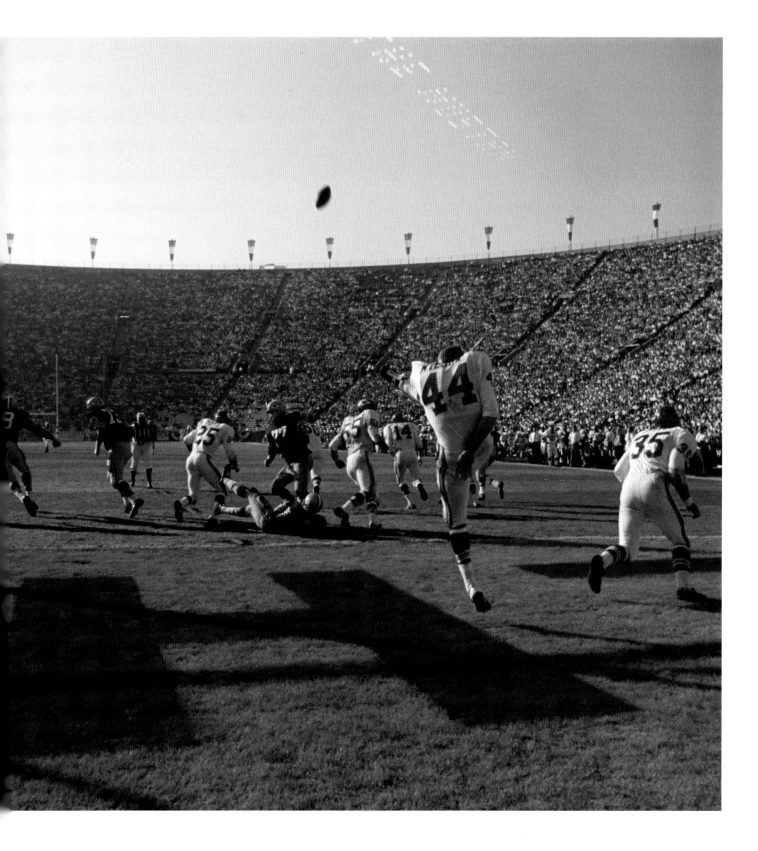

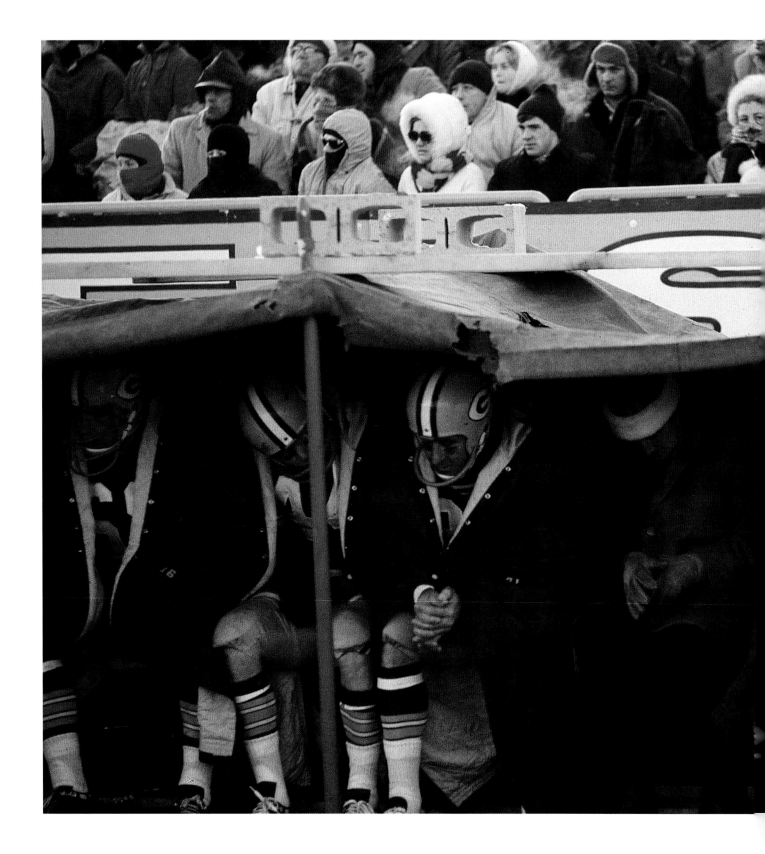

THE ICE BOWL

LAMBEAU FIELD, GREEN BAY, WISC. | *December 31, 1967*

GREEN BAY'S LAMBEAU FIELD first opened in 1957, but it was another 10 years before it rightfully earned its nickname, "the Frozen Tundra." It wasn't just bitter cold the day the Packers hosted the Dallas Cowboys for the 1967 NFL Championship Game. Not only was it 13 degrees below zero. Not only did the wind chill make it feel like minus-38. On top of that, the stadium's underground heating system had malfunctioned. At kickoff time, the field was a sheet of ice.

It was under those conditions that two storied franchises staged a legendary performance.

The elements didn't stop the defending champion Packers from scoring on their opening drive and soon taking a 14–0 lead. The visiting Cowboys, perhaps taking longer to deal with the cold, slowly got back into the game. After closing to within 14–10 early in the fourth quarter, Dallas running back Dan Reeves threw a halfback option pass and hit Lance Rentzel for a 50-yard touchdown. Dallas 17, Green Bay 14.

Green Bay eventually started its final possession at the Dallas 32 with less than five minutes remaining.

"For the first time I had doubts," Packers offensive tackle Jerry Kramer told SI's Tex Maule after the game. "I thought, well, maybe the time has come for us to lose. But I had a second thought immediately. I thought that if we went, we'd go swinging."

Swing they did, marching 67 yards to the Cowboys' 1-yard line. On third-and-goal from the 1, with 16 seconds left and no timeouts, Starr called his own number and followed a block from Kramer into the end zone for the winning score.

From Maule's SI story on January 8, 1968:

"Marshaled into something resembling a hot streak by quarterback Bart Starr, the Packers shook off more than two quarters of almost total ineffectiveness and in the final frozen moments toiled 68 yards in four minutes and 37 seconds to score on the brave Dallas defenders. Thus, with only 13 seconds left to play, Green Bay won 21–17 to take the National Football League championship for the third straight year. No other team has been able to do that since the NFL was split into divisions."

Instead of taking the chance that Starr might be stopped on third down and the clock would run out, why didn't Hall of Fame head coach Vince Lombardi opt for an easy field goal that would have tied the game and force overtime? Maule posed the question after the game.

"I was thinking of the fans," Lombardi said, facetiously. "I couldn't stand to think of them sitting in those cold stands for an overtime period."

The win earned the Packers a trip to sunny South Florida, where they dispatched the Oakland Raiders in Super Bowl II.

Photograph by NEIL LEIFER

LEADER OF THE PACK

MIAMI ORANGE BOWL, MIAMI | *January 14, 1968*

AFTER THE GREEN BAY PACKERS finished 1–10–1 in 1958, the once proud and now floundering franchise fired Scooter McLean and brought in a 45-year-old offensive coordinator from the New York Giants to be their new head coach. The Packers' return to prominence was immediate. After Green Bay started the 1959 season 3–0, Tex Maule introduced Vince Lombardi to the football world in the October 19, 1959, issue of SI:

"Vince Lombardi started out to be a lawyer. He had all the talent needed: a cold, analytical mind and a streak of sentiment which, in moments of stress, brought tears to his liquid brown Italian eyes. He was, too, a brilliant student. When he finished at Fordham University, he coached St. Cecelia High School in New Jersey in order to earn enough money to pay for his expenses at law school.

"The talents which fitted him so well for a career as an attorney proved equally fitting for a head coach. Lombardi analyzed offenses and defenses and, coldly and impersonally, judged the capabilities of the youngsters at St. Cecelia. His half-time exhortations were so sincere and deeply felt that now and then they moved Lombardi himself to tears. This combination of steely football acumen and arrant sentimentalism worked so well with the St. Cecelia boys that Lombardi's teams won 36 games in a row. In the meantime, Vince acquired a law degree, but he never used it. He had become so thoroughly infected with the madness which infects all football coaches that he stowed his law degree in a dresser drawer and went on to coach the freshman team at Fordham, where he had been a member of the famous seven blocks of granite.

"That was in 1947. He moved to West Point in 1949, installing an effective T attack for the Cadets. In 1954 he came to the New York Giants to operate the attack of that team and, after last season, he moved into the difficult and demanding job of head coach of the Green Bay Packers."

The Packers finished 7–5 in 1959—their first winning record in 12 years. It also happened to be Lombardi's *worst* record in nine years as coach of the team. From 1961 to 1967, Lombardi won five NFL titles in seven years. Lombardi resigned as Packers coach after the 1967 season. A year later he became head coach and general manager of the Washington Redskins. The team finished 7–5–2 in its only season under Lombardi—the team's first winning record in 14 years. Lombardi died of cancer on September 3, 1970. The NFL made the decision that year that the trophy awarded to the Super Bowl champion each year would forever be known as the Lombardi Trophy.

Photograph by NEIL LEIFER

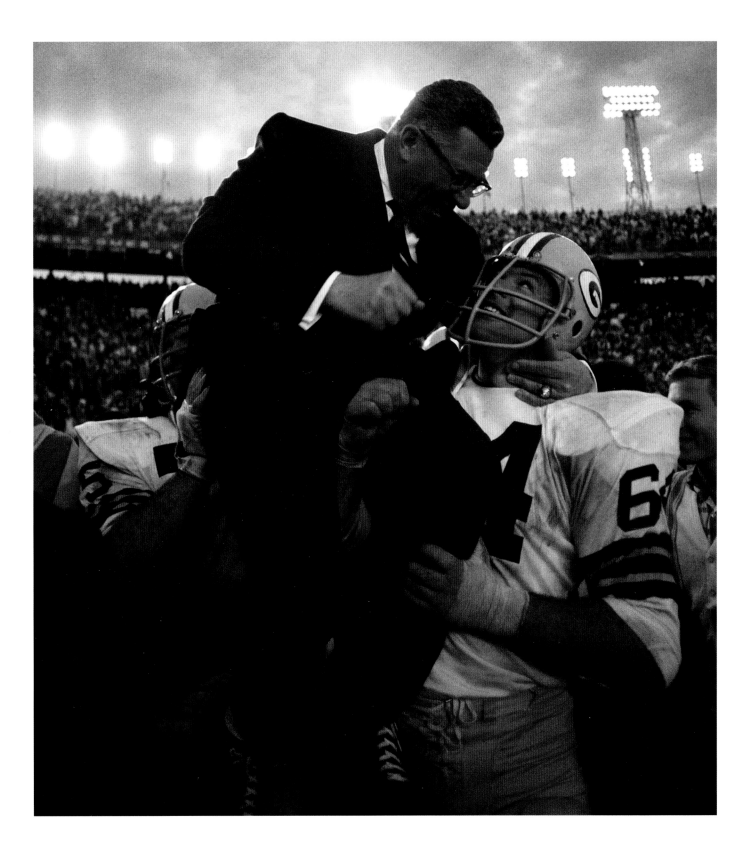

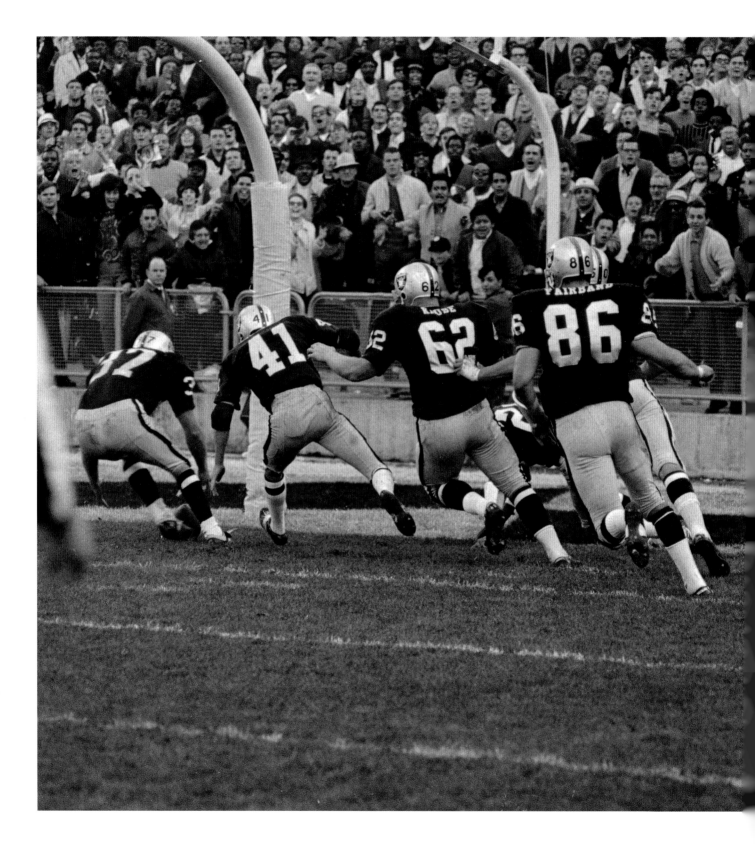

YOU HAD TO BE THERE (REALLY)

OAKLAND–ALAMEDA COUNTY STADIUM, OAKLAND | *November 17, 1968*

THE FOLLOWING WAS a blurb in the "Scorecard" section of the November 25, 1968, issue of *Sports Illustrated*, under the subhead, "Breaks of the Game":

"As the Oakland Raiders scored twice in the last minute to beat the New York Jets last Sunday, NBC-TV cut to two commercials and then a children's special. (Later, as a little crippled girl was crawling and struggling to walk, a bulletin showing the final score crept by just below her.) We were reminded that while there are hardships involved in going to a football game in person, at least it never plunges you into *Heidi*."

Historically, "the Heidi Game" became so much more significant over time. For starters, it was one of the most exciting regular-season games in AFL—or NFL—history. The Raiders and Jets were bitter AFL rivals and this late-season contest went back and forth. The Raiders had tied the game at 29–29 with less than four minutes left before the Jets drove for a go-ahead field goal that made it 32–29 with just over a minute to play.

That's when the clock struck 7 p.m. Eastern time, when NBC was scheduled to air *Heidi*. The plan was to delay the start of the movie if the game was still in progress … but the execs who made that plan could not get through to the control room because calls were coming in asking about when the movie would begin. So viewers in the Eastern time zone were switched to *Heidi*.

Typical situation for frustrated Jets fans. The last thing they saw was their team taking the lead with time running out. What they missed was Raiders quarterback Daryle Lamonica throwing a 43-yard touchdown pass to give the Raiders the lead. And they missed the ensuing kickoff, which the Jets fumbled and allowed the Raiders to return for a touchdown that made the final score 43–32.

As a result of the outrage that followed, there was good news for football fans. With the Heidi Game in mind, the NFL ensured in all future TV negotiations that games would air in their entirety in the visiting team's TV market.

As for the result of the game, maybe it was a good thing the Jets lost. Maybe that gave them extra motivation when the two teams met a month later in the AFL title game. The Jets won that game, sending them to Super Bowl III and a date with history.

Photograph by BETTMANN

THE MONSTER OF THE MIDWAY

WRIGLEY FIELD, CHICAGO | *December 14, 1969*

IN THE OCTOBER 29, 2001, issue of SI, Paul Zimmerman ranked Dick Butkus the No. 1 middle linebacker of all time. Here was Zimmerman's scouting report:

"Never had the luxury of two big tackles to keep offensive linemen off him. He was the best at shedding blockers and gathering himself quickly to deliver a thundering hit on the ballcarrier. He was oversized for his era (6'3", 245 pounds), and his pass coverage skills, based on intelligence and a feel for angles, have always been underrated."

Butkus was a first-round pick of the Chicago Bears in 1965, taken third overall—the Bears had the fourth overall pick as well, and used that one to select fellow Hall of Fame member Gale Sayers. Butkus played for Chicago from 1965 to 1973, and he epitomized the franchise nickname: "Monsters of the Midway."

The Bears had long been known for their defense, but few defensive players in the history of the sport have evoked the kind of ferocity that Butkus did. NFL Films could fill a movie with the imagery that Butkus created—

bloody knuckles, cold air shooting out of his facemask as he prepared to attack. It wasn't uncommon to see Butkus effortlessly lift a running back off the ground—his legs still pedaling, not realizing how fast it was all happening—and then slam him to the turf.

Butkus made the Pro Bowl the first eight of his nine NFL seasons. He was a five-time All-Pro and twice was named NFL Defensive Player of the Year. He was named to the All-Decade Team for both the '60s and '70s.

Butkus was featured on the cover of SI's 1970 NFL preview issue, released on September 21 of that year, with the headline: "The Most Feared Man in the Game." In fact, Butkus was on SI's radar long before that. An All-American linebacker at the University of Illinois who not once but twice finished in the top six voting for the Heisman Trophy, Butkus was also featured on an SI cover in 1964 as a collegian. In his cover story, Dan Jenkins wrote, "If every college football team had a linebacker like Dick Butkus of Illinois, all fullbacks soon would be three feet tall and sing soprano."

Photograph by NEIL LEIFER

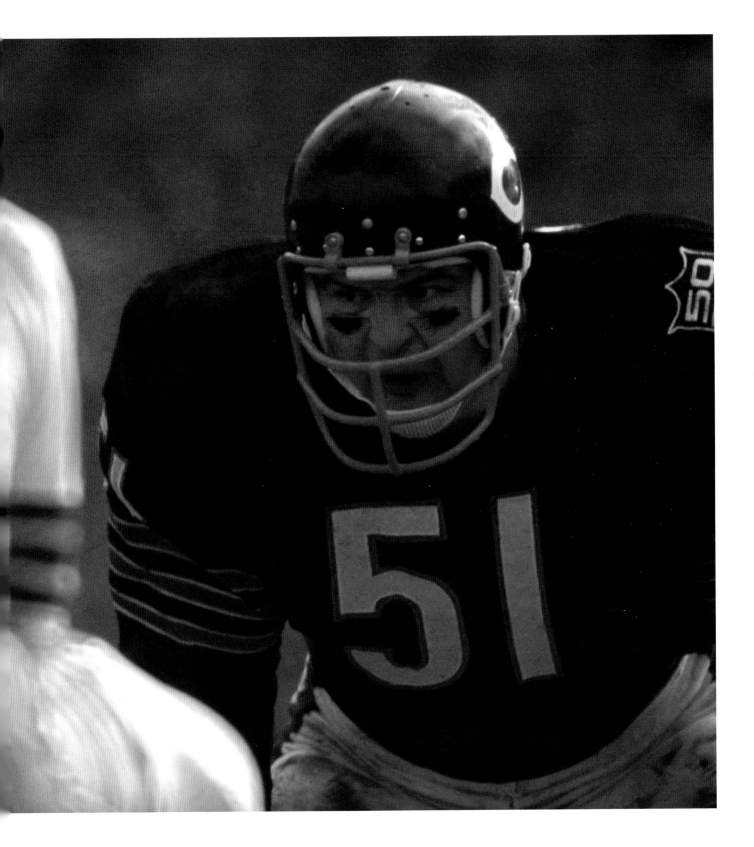

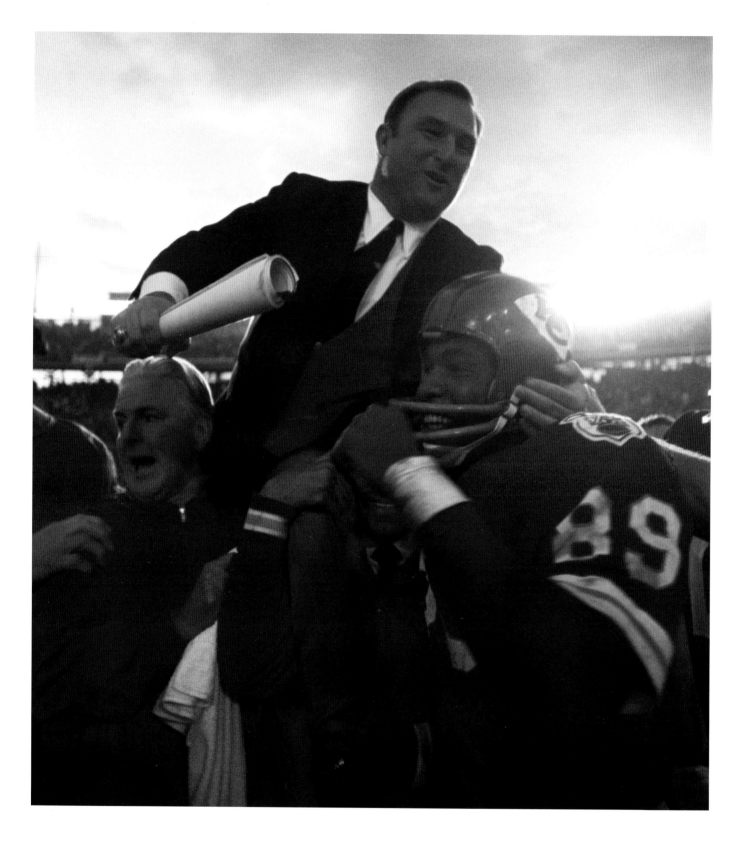

SUPER BOWL IV

TULANE STADIUM, NEW ORLEANS | *January 11, 1970*

WHEN JOE NAMATH and the New York Jets took down the big, bad Baltimore Colts in Super Bowl III, it showed the world that the American Football League could compete with the more established NFL. One year later, the Kansas City Chiefs' victory in Super Bowl IV proved to the world that Super Bowl III wasn't a fluke.

The NFL's Minnesota Vikings were an expansion team in 1961, meaning they hadn't even been around as long as the Kansas City Chiefs, who started in the AFL as the Dallas Texans when that league formed in 1960. Still, the Vikings were established as a 12-point favorite in Super Bowl IV. They had a veteran quarterback in Joe Kapp and the famed "Purple People Eater" defense, led by Hall of Famers Alan Page, Carl Eller and Paul Krause. Minnesota allowed an average of 9.5 points per game in 1969, with an average margin of victory of 17.6 points.

But they were no match for the Chiefs. In front of more than 80,000 fans at Tulane Stadium in New Orleans, the Chiefs took Super Bowl IV with a resounding 23–7 victory.

The maestro of that Chiefs squad, head coach Hank Stram, spoke proudly about his stacked defense and an offensive playbook that featured more than 300 plays run off 18 different offensive sets. "I think football teams reflect the personality of coaches, and I like to think my personality is reflected in the variety of the Chiefs' attack and defense," Stram said.

Quarterback Len Dawson was the MVP of Super Bowl IV, completing a modest 12 of 17 passes for 142 yards and one touchdown. It was really the defense that stood out, holding Minnesota to 67 rushing yards and forcing five turnovers. While the "Purple People Eaters" nickname drew more attention, the Chiefs' starting defense in Super Bowl IV featured six future members of the Pro Football Hall of Fame: Curley Culp, Buck Buchanan, Bobby Bell, Willie Lanier, Emmitt Thomas and Johnny Robinson.

Photograph by NEIL LEIFER

APPOINTMENT TELEVISION

PHOTO SHOOT | *September 1, 1971*

THANKS TO A TV executive and a polarizing announcer, *Monday Night Football* became an American tradition. By 1969, the NFL had played a grand total of six televised games on Monday nights—and the ratings were never great. So when legendary television exec Roone Arledge approached NFL commissioner Pete Rozelle with the idea of playing a game every Monday night starting in 1970, the idea was really part desperation. With CBS and NBC being the NFL's two main broadcast partners, Arledge and ABC wanted to find a way in.

Rozelle had been interested in adding more night games anyway, so he was intrigued. Of course, he took the idea back to CBS and NBC to give them first dibs. CBS took a pass because they aired the popular TV show *Mayberry RFD* on Monday. NBC aired its *Movie of the Week*, so they declined as well. ABC got its way, and by 1971 featured the trio of (pictured) Howard Cosell, Frank Gifford and Don Meredith.

Here's how Steve Rushin recounted the birth of *Monday Night Football* in a profile of Arledge that ran in the August 16, 1994, issue of SI:

"So ABC had football for the fall of 1970 with one condition: Arledge insisted that he be able to choose his own announcers without interference from the NFL. Television contracts in that day called for approval of network announcers by the leagues; indeed, it was only four years earlier that CBS broadcaster Jack Whitaker was thrown off the Masters' telecast by tournament officials for impudently calling the Augusta National gallery a 'mob.' But Rozelle agreed to give a free hand to Arledge, and the first person Arledge hired for his new *Monday Night Football* was Howard Cosell.

"A few years earlier Arledge had signed Cosell to appear as a boxing analyst on *Wide World* and to cover the sport at the 1968 Olympics. Cosell instantly seized a high profile with his interviews of Muhammad Ali, whom Cosell insisted on calling ... Muhammad Ali. This was deemed outrageous and deliberately provocative, even though Muhammad Ali was the man's legal name and had been for four years. 'We've forgotten how weird some people's opinions were,' says Arledge. Indeed, when ABC asked Ali—who had been stripped of his heavyweight title for resisting the Vietnam draft—to commentate on its boxing coverage, it did so despite warnings against the idea from the U.S. State Department.

"In those first giddy days following those first Monday nights, Arledge had to dance a conga to his desk, sidestepping bushels of letters and telegrams tottering in piles throughout his office. He could peel one off a stack at random and invariably the missive would read, 'Get him off the air!' Of course, 'him' was Cosell, who later estimated that half of his mail began with the cheery salutation 'You n-----loving Jew bastard….'

"The essence of the outcry was clear. 'We were desecrating something,' says Arledge. 'CBS had Ray Scott, and now we had this loudmouthed Howard on TV questioning everything, yelling about what a dumb trade that was, and asking, 'Don't football players have rights?' And a lot of the owners just couldn't deal with it.'

"It was clear, too, that television could create a collective national experience, could unite a country in something, if only in its distaste for this toupeed boor spouting polysyllables in a broadcast booth. By the fall of 1971, 30 million viewers were tuning into ABC on Monday nights."

Photograph by BETTMANN

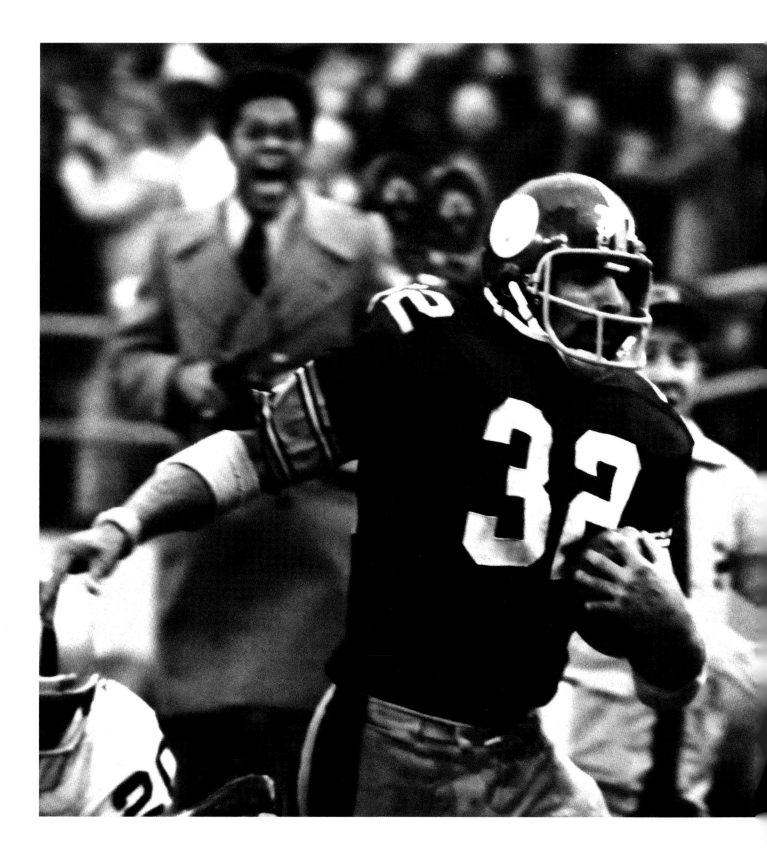

64

THE IMMACULATE RECEPTION

THREE RIVERS STADIUM, PITTSBURGH | *December 23, 1972*

WHEN PETER KING ranked the 10 greatest games in NFL history for *Sports Illustrated*, he had the Immaculate Reception at No. 10. Here was his recap:

> "Only Frenchy Fuqua knows the truth about the Immaculate Reception, and he's not telling. With 22 seconds left in this AFC playoff, the Steelers were trailing 7–6 and were down to one last play, from their 40-yard line. Quarterback Terry Bradshaw took the snap, and with Raiders clawing at him, threw a bullet 20 yards downfield in the direction of running back Fuqua. The ball, Fuqua and Oakland safety Jack Tatum all arrived at the same spot at the same instant. The ball bounced backward into the hands of fullback Franco Harris, who ran for the apparent winning TD. But, back then, a pass caroming off an offensive player to a teammate was an incompletion. Tatum swore he never touched the ball. Fuqua, of course, was mum. And did the ball touch the turf before Harris grabbed it and ran for the touchdown? After a long, tense delay the play was ruled a touchdown. A generation later, we're still dying to know if it really was."

The Immaculate Reception is one of the most enduring images of the Pittsburgh Steelers dynasty of the 1970s—yet it occurred two years *before* they won their first title. The Miami Dolphins—on their way to completing a perfect season—defeated Pittsburgh in the AFC Championship Game one week later. Still, this game was significant for the Steelers. Believe it or not, it was the first playoff victory in the franchise's 40-year history.

Said veteran NFL writer Ray Didinger: "That was the day the Steelers came out of the shadows." Indeed, while the Raiders did get revenge with a playoff win over the Steelers in 1973, Pittsburgh's postseason record in the '70s was a remarkable 14–4, including four Super Bowl victories.

Photograph by HARRY CABLUCK/AP PHOTOS

PERFECTION

LOS ANGELES MEMORIAL COLISEUM, LOS ANGELES |
January 14, 1973

"It was not always easy, and far less dramatic than it might
have been, but the Miami Dolphins finally demonstrated
rather conclusively that they are the biggest fish in the pro
football pond. In the seventh Super Bowl they defeated the
Washington Redskins 14–7 before 81,706 sweltering and
smog-beset fans in the Los Angeles Memorial Coliseum....
No other NFL team has ever gone undefeated for a season,
and no other club is likely to do it again soon, either. On the
record, then, Miami is the best club in pro football history."

That's how Tex Maule began his Super Bowl VII game story in
the January 22, 1973, issue of SI. Indeed, no team has matched
Miami's perfection in the 50 years since that magical 1972 season.
Famously, several players from that team still pop a bottle of
champagne every year when the last undefeated team goes down.

Under head coach Don Shula, the '72 Dolphins were a blue-
collar bunch. With a trio of productive runners in Hall of Famer
Larry Csonka, Jim Kiick and Mercury Morris, Hall of Fame
quarterback Bob Griese didn't need to do a whole lot. He
attempted only 11 passes in Super Bowl VI (completing eight,
one for a touchdown). The "No-Name Defense," featuring
Hall of Fame linebacker Nick Buoniconti, held 11 of 14 regular-
season opponents to 14 points or less.

It's ironic that the most famous play from the game that
clinched their perfection was actually a blooper. Miami led
Washington 14–0 with just over two minutes left when
Garo Yepremian lined up for a field goal as the Dolphins looked
to record the first shutout in Super Bowl history. Instead, the kick
was blocked. The ball bounced back to Yepremian, who picked
it up and scrambled awkwardly before essentially tossing the ball
up for grabs. Washington's Mike Bass recovered the fumble and
ran it back 49 yards for a score. The game ended soon after, an
imperfect end to a perfect season.

Photograph by NEIL LEIFER

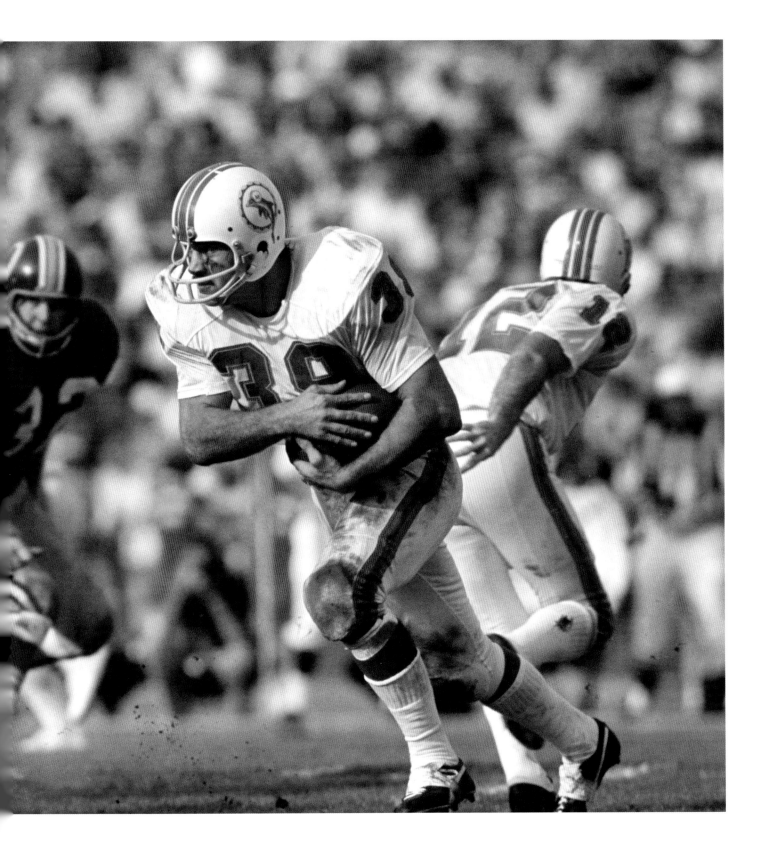

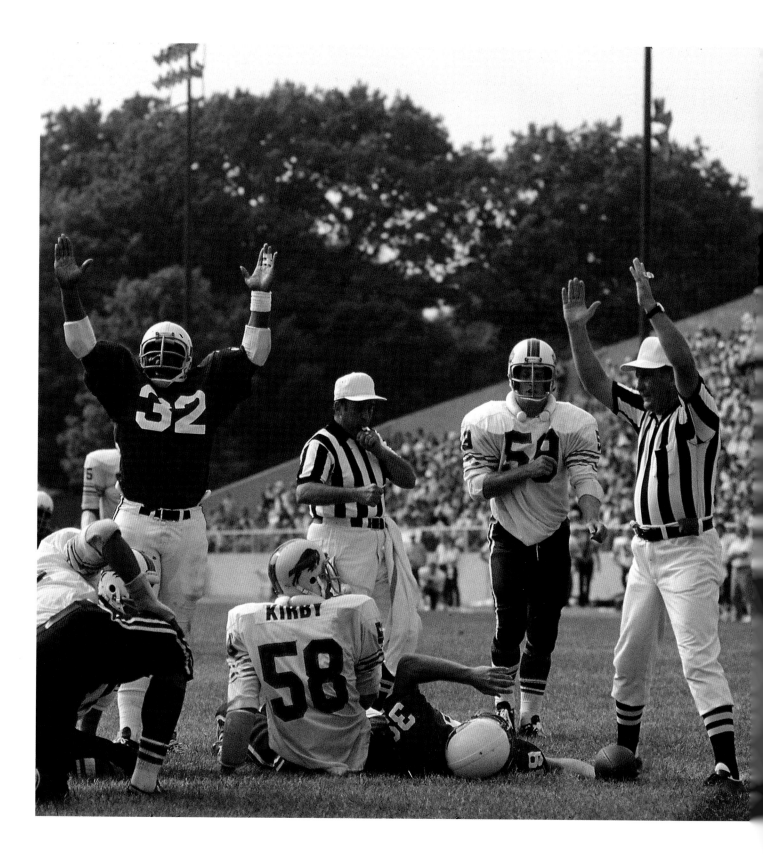

THE REPLACEMENTS

FAWCETT STADIUM, CANTON, O. | *July 27, 1974*

FOR THE RECORD, this picture shows the St. Louis Cardinals celebrating a touchdown against the Buffalo Bills in the 1974 Hall of Fame Game, traditionally the NFL's preseason opener every year. What was more notable about this game is that the *real* NFL players were outside the stadium, picketing. The players were a month into a strike against the league. They reached an agreement with the NFL in mid-August and the regular season proceeded as normal, but it was tough to get past this ugly scene.

An excerpt from Ray Kennedy's story in the August 5, 1974, issue of *Sports Illustrated*:

"In the surprisingly spirited game that followed, the St. Louis Nobodies defeated the Buffalo Unknowns 21–13—but the biggest winner of the afternoon was the crafty old Management Council. More than paranoia, the owners' fail-safe system for beating the picket line was indicative of the intensity of their desire to show the striking players that they can put on games that people will pay to see; attendance at the Hall of Fame game was 17,286, only about 2,400 fewer than the previous year.

"For their part, the striking players remain confident that despite the relative success of the Hall of Fame no-name game, they will win out in the long run. While organizing the pickets. Players Association President Bill Curry observed, 'Most of those guys playing out there today know they are never going to play in the NFL. If they can get a picture of themselves in an NFL uniform to hang over their bar, well, that's enough.'"

Thirteen years later, an in-season labor dispute forced the league to use replacement players in games that counted. Players went on strike after Week 2 of the 1987 regular season. Week 3 games were canceled but the league played the next three weeks with replacement players before the union agreed to end the strike. About 15 percent of the established players crossed the picket lines to play—including some big names such as Joe Montana, Randy White and Steve Largent.

The Washington Redskins—one of only two teams that did not have any players cross the picket line to play—went 3–0 during the strike. Washington would then go on to win the Super Bowl that season.

Photograph by NEIL LEIFER

THE SEA OF HANDS

OAKLAND–ALAMEDA COUNTY COLISEUM, OAKLAND |
December 21, 1974

WHEN THE NFL ranked the greatest games in honor of the league's
100th anniversary, the "Sea of Hands" game came in at No. 23,
but it is much higher among Raiders fans. The Silver & Black
have played in many games worthy of a nickname—"Holy Roller"
and "Ghost to the Post" come to mind—but "Sea of Hands" was
the most significant of the bunch.

The Miami Dolphins were in quest of their third consecutive
Super Bowl title. Leading the Raiders 26–21 with 35 seconds left
in this playoff game, they needed one more stop in order to clinch
a trip to the AFC Championship Game against Pittsburgh. On
first-and-goal from the Miami 8-yard line, Raiders quarterback
Kenny "the Snake" Stabler dropped back to pass. Trying to escape
heavy pressure, Stabler took a few steps up to about the 15-yard
line. Dolphins defensive lineman Vern Den Herder lunged at his
feet and as Stabler was falling forward, he managed to launch a
desperation pass into the end zone.

"I got very little on the ball," Stabler said in the postgame
interview. "It was kind of a dying duck, end-over-end deal, back
into a sea of hands in the end zone."

Most of those hands belonged to Miami defenders. Somehow,
in the middle of that pack, Raiders running back Clarence
Davis came down with the football to score the game-winning
touchdown.

"Of all the people on the team that were eligible receivers,
the one guy you would never want to throw the ball to is
Clarence Davis, because he had boards for hands," said Hall of
Fame executive Ron Wolf, who worked for the Raiders at that
time. "But at that moment, at that time in the game, he had the
softest, surest hands in the history of the game."

Photograph by NEIL LEIFER

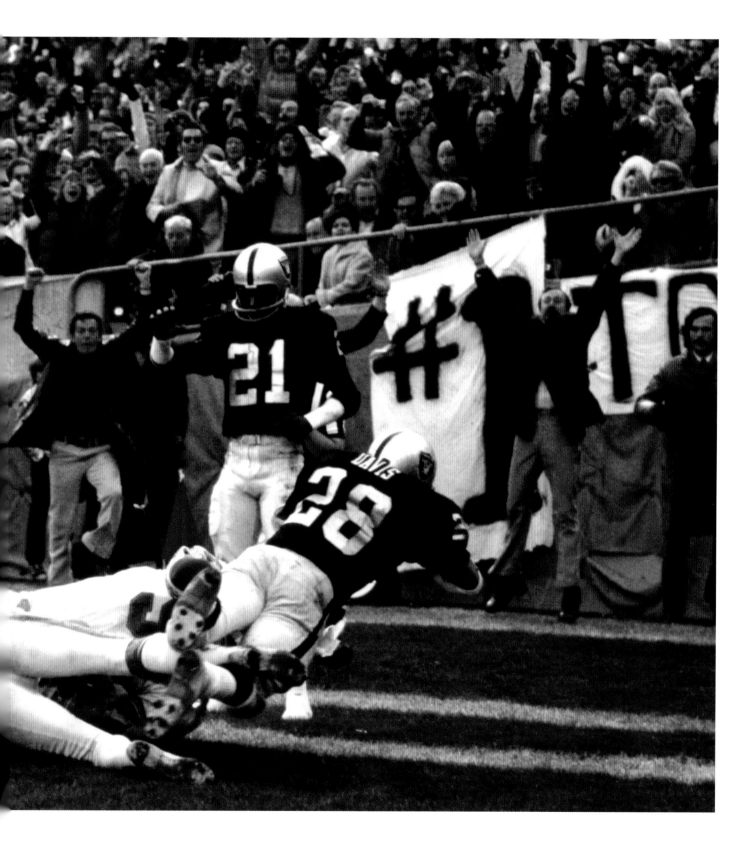

BIRTH OF A DYNASTY

MEMORIAL STADIUM, BALTIMORE | *December 19, 1976*

WHEN THE STEELERS became the NFL's team of the '70s, a dynasty that won four Super Bowls in a span of six years, the transformation from mediocrity to superiority was fairly swift. When Chuck Noll was hired as head coach in 1969, Pittsburgh hadn't been to the playoffs in more than 20 years. The Steelers went 12–30 in Noll's first three seasons but then—with young, emerging stars like Terry Bradshaw, Franco Harris and Joe Greene—Pittsburgh made the playoffs in 1972 and 1973. Despite losing to the Oakland Raiders in a 1973 divisional playoff game, the immediate future was bright. To be sure, Pittsburgh was a team to be reckoned with. But it was the 1974 NFL draft that put the Steelers over the top.

The draft is always an inexact science. Most teams would be happy to get four starting players out of a single class. In 1974, the Steelers drafted four players who would one day reach the Hall of Fame.

In the first round, with the 21st overall pick, Pittsburgh selected USC wide receiver Lynn Swann, who went on to be the MVP of Super Bowl X.

The second-round pick was Kent State linebacker Jack Lambert (pictured), one of the most menacing tacklers the NFL has ever seen. A quarterback in high school, some NFL scouts thought Lambert was too small to play linebacker at the pro level. They were wrong. Lambert made nine straight Pro Bowls and was the anchor of Pittsburgh's "Steel Curtain" defense.

The Steelers didn't have a third-round pick, but the first of their two fourth-round picks was another winner: Alabama A&M wide receiver John Stallworth. The Swann-Stallworth combination was one of the best receiving duos of all time. In Super Bowls XIII and XIV, Stallworth had a combined six receptions for 236 yards. He had a 75-yard touchdown in XIII and a 73-yard score in XIV.

Finally, in Round 5 of the 1974 draft, the Steelers selected Wisconsin center Mike Webster. "Iron Mike" was the anchor of the Steelers offense. A seven-time All-Pro, Webster started 150 consecutive games at one point. A member of the NFL's All-Decade Teams for both the '70s and '80s, Webster is widely considered the best center in NFL history.

Swann, Lambert, Stallworth and Webster. Pretty nice haul. It's no surprise that the Steelers won their first Super Bowl 11 months later. The dynasty was born.

Photograph by WALTER IOOSS JR.

JOHN MADDEN: FIRST, A COACH

ROSE BOWL STADIUM, PASADENA, CALIF. | *January 9, 1977*

JOHN MADDEN LED not one but *three* incredible lives, and he left an indelible mark on three different generations of football fans. The most recent generation recognizes Madden as the name behind perhaps the most popular video game in the history of video games. Before that, Madden revolutionized the sports broadcasting business—the first TV analyst to make it acceptable to get carried away after a big play, but then back up his excitement by explaining the action in a way that got the average football fan excited. Another aspect of Madden's TV legacy was that he didn't like to fly, and so he was driven from game to game in what became known as the "Madden Cruiser." Madden's popularity as a TV announcer made him America's No. 1 pitch man.

For the millions of Americans who knew John Madden as a TV and video game icon, it was easy to forget the man's first claim to fame. And it might not be surprising to think that a good percentage of people who know *Madden* the video game and Madden the TV guy don't even realize that he is a Hall of Fame football coach.

Here's what Richard Hoffer wrote for SI.com on December 28, 2021, the day Madden died:

> "John Madden's football career, suffering the unusual disadvantage of an increasingly interesting life, has long passed into irrelevance. He was one of the NFL's greatest coaches, sure, but his years with the Oakland Raiders were so long ago, and so comparatively few, that it's no longer possible to remember his shambling hulk on the sidelines, even if it was at a Super Bowl. Not when, in that athletic aftermath, he became one of our most unlikely celebrities, his mug on everything from magazine covers to video games, his cartoon commentary the soundtrack of our Sunday afternoons, his portfolio of endorsements an important part of the United States economy, his avuncular enthusiasm a reassuring respite every weekend.

> "Let's put it this way: Madden, who died Tuesday at age 85, was rightly enshrined in Pro Football's Hall of Fame, his 10-year turn with the Raiders producing seven division titles and a Super Bowl in 1977. His chauffeured ride, the famed Madden Cruiser, a strange and pointless artifact of his broadcasting career, has been installed there as well. It is no exaggeration to suggest that his bus is far more visited these days than his bust.

> "But before we recall the bus, the 'Doinks,' the Miller Lite commercials, his announcing run across all four networks (let alone his everlasting digital footprint on *Madden NFL*), let's pause to consider what made it all possible, that original long-ago stint with the Raiders. It was a wonderful stint, one of the best in NFL history. Elevated to head coach in 1969 at the age of 32, Madden so successfully enacted owner Al Davis's vision of 'orchestrated mayhem,' that the Raiders were probably as much feared as they were formidable."

Madden took over as head coach of the Raiders in 1969 and held the job for 10 seasons, leading the Raiders to victory in Super Bowl XI. Madden never had a losing season. His career record of 112–39–7 translates to an impressive winning percentage of .731.

Photograph by NEIL LEIFER

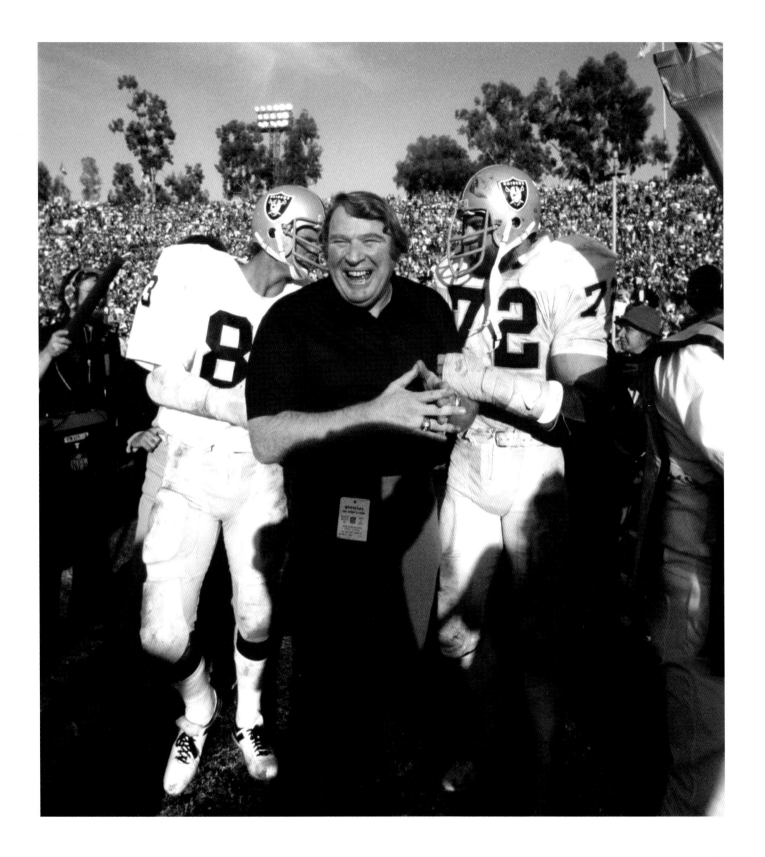

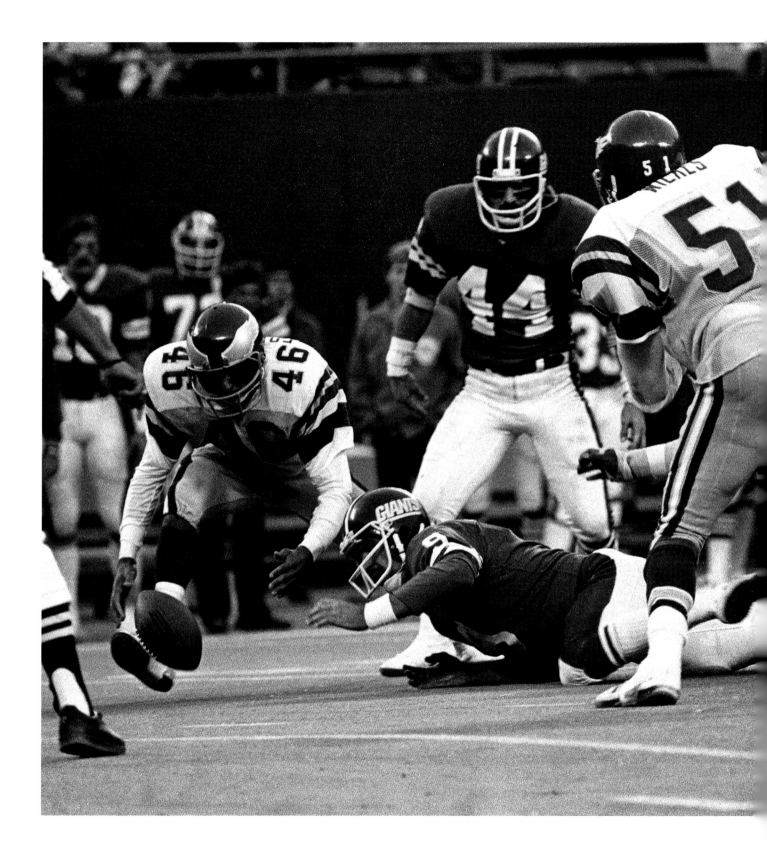

MORE THAN JUST A BLOOPER

GIANTS STADIUM, EAST RUTHERFORD, N.J. |
November 19, 1978

CBS PLAY-BY-PLAY ANNOUNCER Don Criqui was already reading the closing credits as a relatively inconsequential midseason game between the Philadelphia Eagles and New York Giants was nearing the end. Leading 17–12, the Giants had the ball and were just running out the clock, with Philly out of timeouts. Giants quarterback Joe Pisarcik needed just to take a step back and go to one knee. Instead, he inexplicably attempted a handoff. But he never had control of the ball, and it fell to the turf before fullback Larry Csonka could secure it. The football bounced perfectly into the waiting hands of second-year cornerback Herman Edwards, who raced 26 yards untouched for the game-winning score.

"I don't believe it!" Criqui exclaimed on the broadcast.

"The Miracle at the Meadowlands" remains one of the most-viewed bloopers in NFL history but it is much more than that. Pisarcik's fumble was the last straw for a once-proud franchise that had been languishing for more than a decade.

"It is far more significant than people think it is," said Criqui. "Looking back, in large measure it changed the whole structure of the National Football League in its most important market, New York."

As soon as the season ended, the Giants cleaned house. They fired the entire coaching staff and front office. Problem was, the root of the team's issues was co-owners Wellington Mara and nephew Tim Mara not seeing eye to eye. They couldn't agree on a new general manager—so the league stepped in and essentially forced them to hire Miami Dolphins personnel executive George Young. In short order, Young restructured the franchise and turned it into a winner. Among his many credits, he drafted Phil Simms and Lawrence Taylor and made Bill Parcells the head coach. The rest, as they say, is history.

Had Pisarcik's fumble not occurred, perhaps the Giants ownership would have been content with mediocrity and the changes would never have taken place. In other words, the most embarrassing play in team history is actually the best thing that could have happened.

Photograph by G. PAUL BURNETT/AP PHOTOS

WHAT ABOUT TERRY?

THREE RIVERS STADIUM, PITTSBURGH | *January 21, 1979*

THREE QUARTERBACKS HAVE won at least four Super Bowls. Two of them, Tom Brady (seven Super Bowls) and Joe Montana (four) are always mentioned in the conversation about the best quarterbacks of all time. Terry Bradshaw, while a member of the Pro Football Hall of Fame, is not in the G.O.A.T. conversation. But he is in the record books as the first quarterback with four Super Bowl rings.

Super Bowl XIII, in which the Pittsburgh Steelers defeated the Dallas Cowboys, 35–31, was Bradshaw's third NFL title and it produced the first of his back-to-back Super Bowl MVPs. He passed for 318 yards and four touchdowns—both Super Bowl records at the time.

Wrote Dan Jenkins in his Super Bowl XIII game story in the January 29, 1979, issue of SI:

"All game long, it was Bradshaw who was the dominant presence, who was mainly responsible for turning XIII into the best Super Bowl game of all as well as the highest-scoring. It was Bradshaw who took ferocious licks from a Dallas defense that sacked him four times. It was Bradshaw who kept playing with an injured shoulder. It was Bradshaw who kept finding (Lynn) Swann and

(John) Stallworth and tight end Randy Grossman just when he needed them."

Bradshaw led the NFL with 28 touchdown passes in 1978 and was the league's MVP. The Steelers dynasty of the '70s was built on a foundation of dominant defense, led by the likes of Joe Greene, Jack Lambert and Jack Ham. That's one reason Bradshaw isn't viewed on the same level as Brady or Montana. Another is that some questioned his intelligence. Bradshaw never let that get to him.

"Today I relaxed, felt good and had fun," Bradshaw said after Super Bowl XIII. "I had a little bit of a lackadaisical attitude. I didn't want to get uptight. I don't need anyone telling me how great or how smart I am, or how smart I'm not, I just tried to go out there and help win a football game."

Bradshaw certainly got the last laugh. Proving his Super Bowl XIII success was no fluke, he was third in the NFL in passing yards a year later and then was named MVP of Super Bowl XIV, throwing for 309 yards and two scores in the 31–19 win over the Rams. He announced his retirement in 1984, and has enjoyed great success in TV since then.

Photograph by NEIL LEIFER

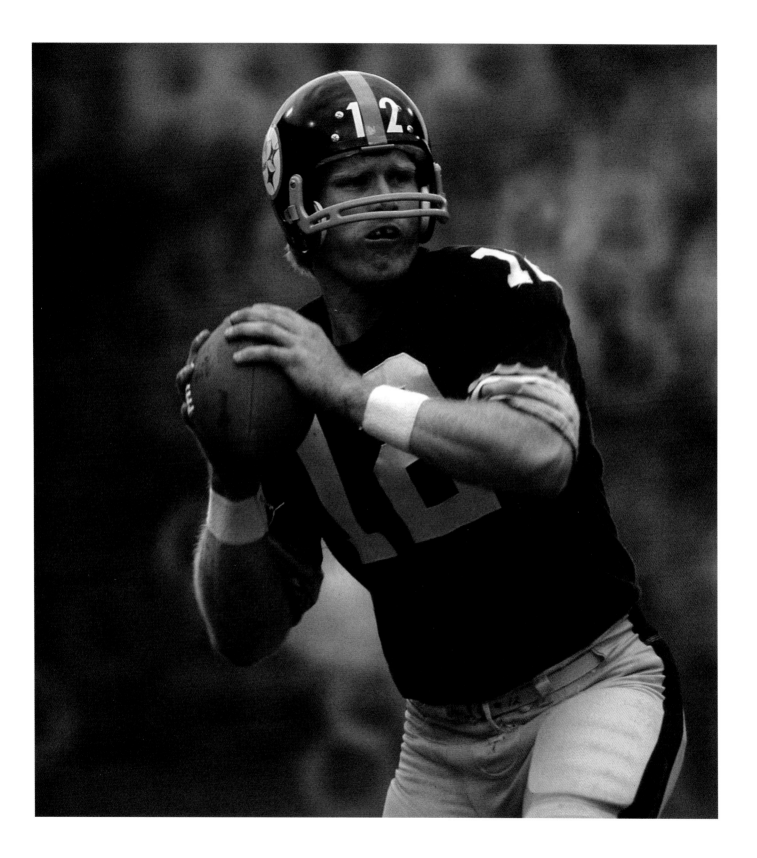

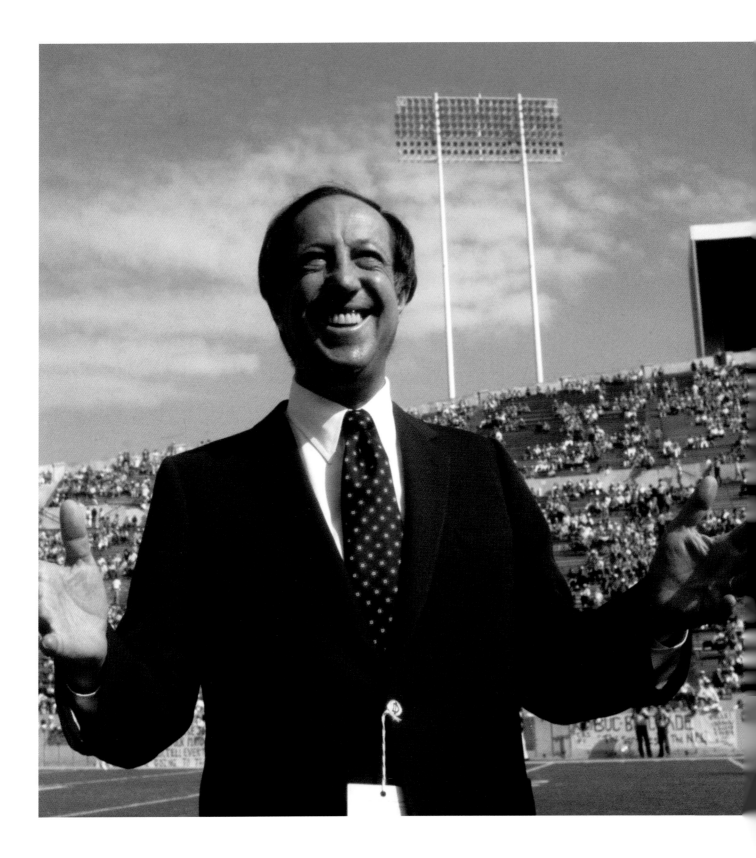

THE COMMISSIONER

TAMPA STADIUM, TAMPA | *December 29, 1979*

PETE ROZELLE BECAME commissioner of the NFL on January 26, 1960. Then 33 years old, the P.R. man who had only recently been named the general manager of the Los Angeles Rams was a compromise choice—elected on the 23rd ballot. Some team executives didn't even know who he was. But it didn't take long for everyone to know him. Rozelle presided over the league during its golden age. He negotiated the first mega-TV deals, helped broker the merger between the NFL and AFL, introduced the Super Bowl and was the man in control when the NFL became America's number one sport.

After 20 years on the job, here's what Frank Deford wrote about Rozelle in the January 21, 1980, issue of SI:

"But the owners who pay Rozelle are happy with his accomplishments, and the league, in its mellow and melliferous fettle, properly enjoys an elder statesman at the helm. As ever, Rozelle's own person mirrors his league. For the first time, minions in the Park Avenue offices (and, ye gods, even some journalists) grouse that the chief is not so accessible anymore. He is now a contented suburban squire—'This is really my first home'— remarried, to the lovely lady he met on the tennis courts. She is gracious and stylish, educated in England—The Queen Bee she is called—and they troop the league together, at once a royal couple presiding and giddy teen-agers holding hands.

"Rozelle, the once and future king, the always king, is what people expect in a commissioner and what leagues seek in one. He was, he says with a laugh, 'the child czar' when he fell from the heavens 20 years ago, and while he is no less the monarch today, he and his league are so interwoven that he seems to be able to rule as much by osmosis as with the silver tongue or the iron hand. At meetings, things just seem to bend to Rozelle's will, so much so, says Don Weiss, his top aide, 'that Pete not only knows what the answer will be before the question comes up, but he can make the owners think they arrived at the answer. A guy like Dan Rooney [president of the Steelers], who knows Pete well and knows how he works, has even gotten up sometimes and said, "Look, I know how this is going to end, so there's no sense in me fighting it, but I would just like to get this on the record."'

"Rozelle will serve the league at least until 1986, when his present contract will run out and he will be 60. But can he dare retire then? Will the league tolerate it? Surely, if Rozelle ever leaves the NFL, it will turn back into the Decatur Staleys and the Frankford Yellow Jackets, and Sundays will revert back to God, Monday nights to bowling."

Photograph by HEINZ KLUETMEIER

A GAME NO ONE SHOULD HAVE LOST

MIAMI ORANGE BOWL, MIAMI | *January 2, 1982*

THIS IS HOW John Underwood's recap of the Chargers-Dolphins playoff game following the 1981 season began in the January 11, 1982, issue of *Sports Illustrated*:

> "It is the one great irony of professional football that magnificent games such as San Diego's wonderful, woeful 41–38 overtime AFC playoff victory over Miami are almost always decided by the wrong guys. Decided not by heroic, bloodied men who play themselves to exhaustion and perform breathtaking feats, but by men in clean jerseys.… Men who cannot be coached, only traded. Men whose main objective in life, more often than not, is to avoid the crushing embarrassment of a shanked field goal in the last 30 seconds."

For the record, San Diego's Rolf Benirschke kicked a 29-yard field goal with 1:08 left in the first overtime to win it for the Chargers. But so much happened before that moment. There was San Diego's world-class offense jumping out to a 24–0 lead. There was Miami's comeback, spurred by backup quarterback Don Strock. There was Chargers tight end Kellen Winslow blocking the Miami field goal attempt that would have ended the game in regulation. Winslow caught 13 passes for a playoff record 166 yards. The epitome of a player leaving everything he had on the field, the future Hall of Fame tight end had to be carried off the field and into the locker room by his teammates.

Unfortunately for Winslow and the Chargers, that was as close as they would get to the Super Bowl. One week after winning in the Miami heat, San Diego lost to the Cincinnati Bengals in an AFC Championship Game played in arctic weather conditions.

Photograph by HEINZ KLUETMEIER

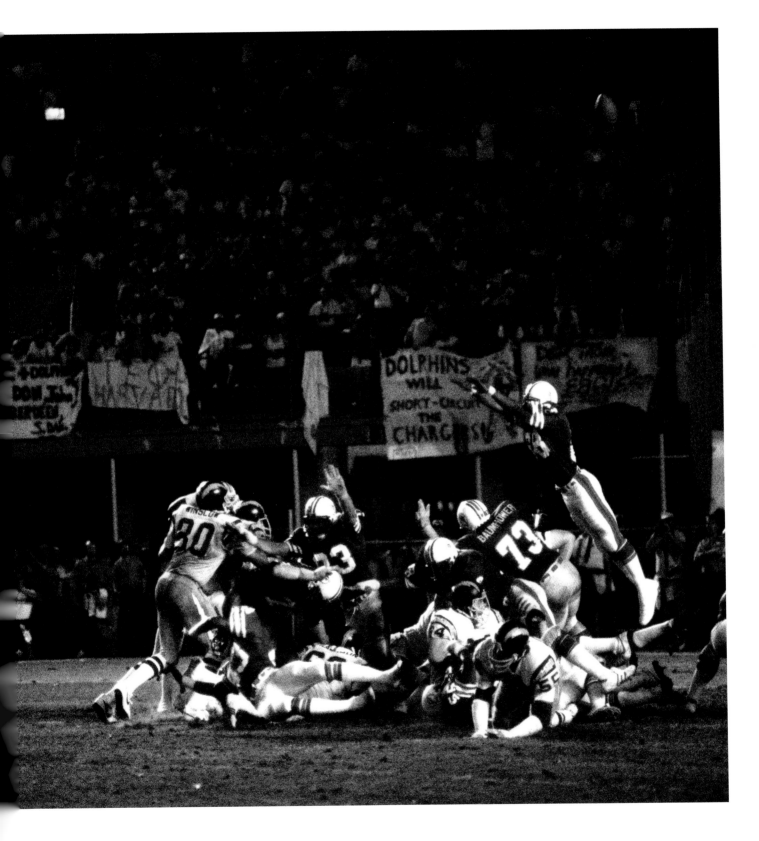

THE CATCH

CANDLESTICK PARK, SAN FRANCISCO | *January 10, 1982*

"It will be part of San Francisco's history; it will become a legend of this city, right up there with the Great Earthquake of 1906. The Drive. Eighty-nine yards to the Super Bowl, 89 yards at the end of a day that seemed hopeless. The Drive. In 10 years at least half a million people will claim to have been in Candlestick Park the day the 49ers drove the length of the field in 13 plays to beat Dallas 28–27 and win a trip to Super Bowl XVI. In 20 years the number of people who were there will be more than a million."

That's how Paul Zimmerman began his recap of the 1981 NFC Championship Game, which ran in the January 18, 1982, issue of SI. When 49ers receiver Dwight Clark lunged into the air and came down with the game-winning score with 51 seconds left, it marked a symbolic changing of the guard. San Francisco defeated the Bengals in Super Bowl XVI two weeks later—the first of four Super Bowls the 49ers won in a nine-year span. At the same time, it marked the end of the Dallas Cowboys' run of dominance. From 1970 to 1981, Dallas played in the conference championship game nine times, reaching the Super Bowl five times and winning twice. After this game, they failed to make the playoffs six times over the next eight seasons.

The game itself was a classic. There were five lead changes and neither team led by more than a touchdown. Bill Walsh's West Coast offense moved up and down the field with precision, led masterfully by the quarterback Walsh had drafted three years prior, Joe Montana.

Most people forget just how close the Cowboys came to erasing this unforgettable moment. Dallas reached the 49ers' 44-yard line with 38 seconds left, but fumbled on the next play to seal San Francisco's victory.

Photograph by WALTER IOOSS JR.

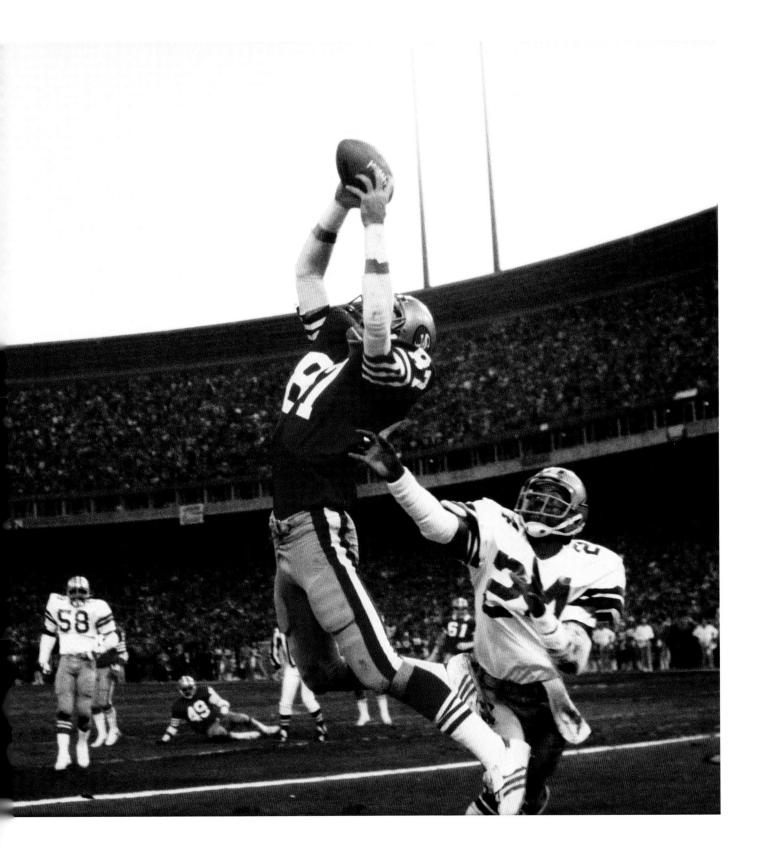

A HALL OF FAME HAUL

STANFORD UNIVERSITY, PALO ALTO, CALIF. | *August 1, 1982*

THE NFL DRAFT is seven rounds these days, and experts will agree that a team is lucky if its sixth- and seventh-round picks are good enough to become role players. And that makes the 1983 NFL draft all the more unbelievable. Here's just one case in point: In the eighth round of the 1983 draft, the Chicago Bears selected Tennessee State defensive end Richard Dent, who would go on to be Super Bowl XX MVP and a member of the Pro Football Hall of Fame.

Another example? The draft was 12 rounds in 1983, and it produced at least one Pro Bowl player from *every* round.

Of course, first-round picks get most of the attention every year, and 1983 was no exception. Of the 28 first-round picks, seven players—*25 percent of the first-rounders*—are immortalized in Canton. They are, in order of selection: John Elway (1-Colts), Eric Dickerson (2-Rams), Jimbo Covert (6-Bears), Bruce Matthews (9-Oilers), Jim Kelly (14-Bills), Dan Marino (27-Dolphins) and Darrell Green (28-Redskins).

Elway wasn't happy about being drafted by the Colts, and he threatened to play baseball instead if he wasn't traded. The Colts begrudgingly obliged and sent him to Denver in exchange for a package of players that included the Broncos' first-round pick, offensive tackle Chris Hinton. A seven-time Pro Bowl player himself, Hinton was one of several other first-rounders in 1983 who made their mark on the league. Other notable names: Seahawks running back Curt Warner, Vikings safety Joey Browner, Bears receiver Willie Gault and Cowboys defensive end Jim Jeffcoat.

The hits kept coming in Round 2, which produced seven Pro Bowl players, including 49ers running back Roger Craig, Rams receiver Henry Ellard, Giants defensive end Leonard Marshall and Bills linebacker Darryl Talley. The final pick of the third round was Washington's Pro Bowl defensive end Charles Mann. All in all, the 1983 draft produced 41 Pro Bowl players.

Photograph by DAVID MADISON/GETTY IMAGES

THE MAN IN BLACK

EL RANCHO TROPICANA, SANTA ROSA, CALIF. | *August 3, 1982*

MAYBE HE SMILES more around friends and family but Al Davis, in just about every public photograph taken of him, looks like he's about to break into an expletive-laced tirade. Over the course of his Hall of Fame career as a coach, league executive and team owner, Davis often had reason to be angry. That said, he had many occasions to celebrate—and many reasons to *be* celebrated.

In his 49 years associated with the Raiders—three as head coach (1963–65) and 46 as owner—the Raiders went to five Super Bowls, winning three times. Davis was never afraid to import players who might not have been perfect fits with other teams. As long as they demonstrated a "commitment to excellence."

A famous quote associated with Davis: "Just win, baby!" In addition to the wins on the football field, Davis also won his share of off-field battles. He sued the NFL for the right to relocate the Raiders from Oakland to Los Angeles, which he did in 1982. Davis eventually moved the Raiders back to Oakland. He died in 2011, nine years before his son moved the Raiders to Las Vegas, but he surely would have been proud of the way Mark Davis made the best deal possible for his franchise.

Another phrase Davis was fond of repeating was that he'd rather be feared than respected. And while he and his team have certainly been feared over the years, Davis is very much respected for some of his accomplishments. He became the first owner in the NFL's modern era to hire a Black head coach when he promoted Art Shell to the job in 1989. In 1997, Davis named Amy Trask the team's CEO, making her one of the highest-ranking women in professional sports.

"Mr. Davis was a coach, a commissioner and a Super Bowl champion," Richard Seymour, who played for the Raiders from 2009 to 2012, said in his 2022 Pro Football Hall of Fame induction speech. "But above all else, he was a great leader, because he welcomed and listened to every voice. It didn't matter if you were man, woman, Black, white, gay or straight. He believed that football was a game of values."

Photograph by PETER READ MILLER

THE INNOVATOR

PHILADELPHIA | *November 16, 1982*

SID GILLMAN TOOK over as head coach of the Los Angeles Rams in 1955, but it wasn't until 1960, when he became the first head coach of the Los Angeles Chargers of the fledgling American Football League, that he cemented his legacy. Gillman (pictured with Eagles head coach Dick Vermeil) was a tough coach, but he was also one of the key architects of the modern passing game.

Here's what Paul Zimmerman wrote for the January 13, 2003, issue of SI after the Hall of Fame coach passed away:

"It was a December night in 1966, and Sid Gillman's Chargers had just beaten the Jets 42–27. Gillman was having dinner, as he often did, in San Diego's leading sports restaurant, Pernicano's Casa di Baffi, with the owner, George Pernicano. 'I feel sorry for these New York guys,' Pernicano said, 'getting the hell beat out of them and then having that long flight home. I think I'll drive out to the airport and take them some pepperoni and cheese.' Gillman looked at Pernicano as if he were nuts. 'The hell with 'em,' he said.

"That was the Gillman I knew. Tough, uncompromising. When I saw him that year at a luncheon, he strode to the podium, frowning, checking his watch, his muscular neck cramped beneath his bow tie. 'Some see football as a game,' he said. 'You know what it is to me? It's blood!'

"His offense was beautiful: the deep strike to Lance Alworth, the swerving and swooping of his twin backs, Paul Lowe and Keith Lincoln. Yet there were brutal elements, too. The offense was built on the vertical attack—Alworth on the deep post, a tight end splitting the hash marks, Lowe or Lincoln pushing it down the seams. The theory was to punish the defense, and in the '63 AFL title game, Gillman beat the Boston Patriots 51–10. His was the true West Coast Offense (later adopted and modified by Don Coryell, Joe Gibbs and Ernie Zampese), the antithesis of Bill Walsh's horizontal approach.

"A few years ago I spent a week watching film with Gillman at his house, learning his theories. He was kind and gentle and very patient. One day I told him, 'You know when I first met you, you scared the hell out of me.' His wife, Esther, laughed. 'He scared a lot of people,' she said. 'Until they got to know him. Then he wasn't so bad.'"

Photograph by PETER MORGAN/AP PHOTOS

THE DIESEL DOMINATES

ROSE BOWL STADIUM, PASADENA, CALIF. | *January 30, 1983*

PRO FOOTBALL HALL of Fame running back John Riggins is known for many things. He's a colorful character who once sported a mohawk during his playing days. He had 1,000-yard rushing seasons for two different teams, the New York Jets and Washington Redskins. He even has two nicknames—"Riggo" and "Diesel." But when you say the name John Riggins, there is one enduring image that stands out: the Diesel bulldozing his way toward the winning touchdown against the Miami Dolphins in Super Bowl XVII.

As Paul Zimmerman described it in the February 7, 1983, issue of *Sports Illustrated*:

"What he had done on that long day's journey into night in Pasadena's Rose Bowl was grab modern NFL football by the scruff of the neck and toss it a few decades back into a simpler era—big guy running behind bigger guys blocking.

"First his numbers: 38 carries for 166 yards, one pass reception for 15. The entire Miami offense consisted of 47 plays for 176 yards. Both of the Riggins rushing figures were Super Bowl records; the carries set a personal mark."

Still, Washington was trailing Miami, 17–13, with nearly 11 minutes left in the game. The Redskins had crossed midfield but faced a fourth-and-inches at the Dolphins' 43-yard line. Head coach Joe Gibbs called a timeout, then decided to go for it, confident his bruising fullback could gain one yard.

From Zimmerman's story:

"The Skins called the same play they'd called before the timeout—70-Chip, Riggins off the left side, behind the short-yardage blocking back, a chunky, little 214-pounder named Otis Wonsley, and the 240-pound extra tight end, Clint Didier. It broke cleanly. The only Dolphin who had a shot at Riggins, cornerback Don McNeal, who had followed Didier in motion right, slipped as he reversed direction and could only attempt an arm tackle on Riggins. McNeal bounced off the Skins' fullback, and it was clear sailing for Riggins. At the end of the 43-yard run he was pulling away from safety Glenn Blackwood, a rather astounding show of speed by a 230-pounder on his 30th carry of the day."

At the age of 33, and on bad knees, Riggins carried the ball eight more times in the game, pounding the Dolphins defense and putting the game away.

Photograph by ANDY HAYT

A DARK DAY IN BALTIMORE

OWINGS MILLS, MD. | *March 28, 1984*

COLTS OWNER ROBERT IRSAY had been threatening for a while to move his team from Baltimore, where they had been a fixture since 1953. Still, it was a sudden gut punch the night of March 28, 1984, when he quietly packed the franchise into moving vans and migrated to Indianapolis under cover of darkness. Lifelong Colts fans were saddened, shocked and outraged all at once. *Sports Illustrated* writer Frank Deford, himself a Baltimore native, captured the moment in the April 9, 1984, issue:

"Baltimore … was the first place football mania really surfaced. It was 20 years ahead of old fancy-pants Washington, which still acts like it discovered enthusiasm. Impressionable youth that I was, I was so awed by Colt madness that I wrote my first novel about it. The plot had to do with how a guy who chanced upon some Colt season tickets got to be mayor. Then, one of my Baltimore contemporaries, Barry Levinson, brought out the movie *Diner*. Remember that? The girl Eddie wanted to marry had to pass a test about the Colts before he would walk down the aisle with her. People said, 'Boy, was that far out?' I said, 'No.' Having grown up in Baltimore, I thought it was very true to life. Besides, it was an easy test Eddie gave her. Sample question: What was the longest run from scrimmage by a Colt rookie in his first game?

Alan Ameche's 79-yarder on opening day in 1955, of course.

"Here's another Colt question: In what cities did the Colt franchise fail before it came to Baltimore? Answer: New York and Dallas. Imagine that, Baltimore supporting a football team when New York and Dallas couldn't! Look it up. And now, just because some egomaniacal carpetbagger named Irsay needs to cover his mistakes, the Colts leave Baltimore under cover of darkness. Of course, it's much easier now for the modern highwaymen who own sports franchises to use cities and throw them away. Thanks to the antitrust laws, they don't have to ask for anybody's permission; all they need is a credit card to get a moving van in.

"One last thing. If some future Eddie gives a test to his beloved, and the question is when did the Baltimore Colts die, the correct answer isn't 1984 but 1972, for that was when the NFL allowed a man like Irsay to buy a city's heart. The Baltimore Colts have been playing games all these years since then, but they've been brain dead."

Photograph by LLOYD PEARSON/AP PHOTOS

SWEETNESS

SOLDIER FIELD, CHICAGO | *October 7, 1984*

WALTER PAYTON WAS the NFL's all-time leading rusher when he died on November 1, 1999. Only 45 years old, Payton suffered from a rare liver disease. His rushing record was broken three years later by Emmitt Smith, but that in no way diminished Payton's incredible legacy. In his 13 seasons with the Chicago Bears, Payton rushed for 16,726 yards and added another 4,538 receiving yards. Nicknamed "Sweetness," Payton's soft voice belied his toughness.

Here's how Paul Zimmerman eulogized him in the November 8, 1999, issue of SI:

"He played football in a frenzy, attacking tacklers with a fury that almost seemed personal. He got stronger as the game went on. Defenses tired, he attacked them. In 1982, near the height of a remarkable career in which he rushed for more yards (16,726) than any man in history, I interviewed him at the Chicago Bears' training camp in Lake Forest, Ill. We were sitting in the lobby of the players' dorm. He had brought his motorcycle in and leaned it against a wall. Twilight was approaching but the lights in the lobby hadn't been turned on yet, and as we talked, he kept bouncing to his feet to emphasize some point—he couldn't sit still. His eyes sparkled in that half light, and I got this weird, unearthly feeling that there was a glow around him, that he was giving off sparks, that there was some kind of fire burning inside, lighting him up. It was the fire of pure energy. I'd never seen this before.

"He told me about his off-season workouts, how he'd run up and down the steep levees near his home in Mississippi, how he'd burn out anyone foolish enough to try to keep up with him. He played in 186 straight games to finish his 13-year NFL career. All of them played at a furious pace.

"Now, at 45, he's gone. It's hard to imagine."

Photograph by ANDY HAYT

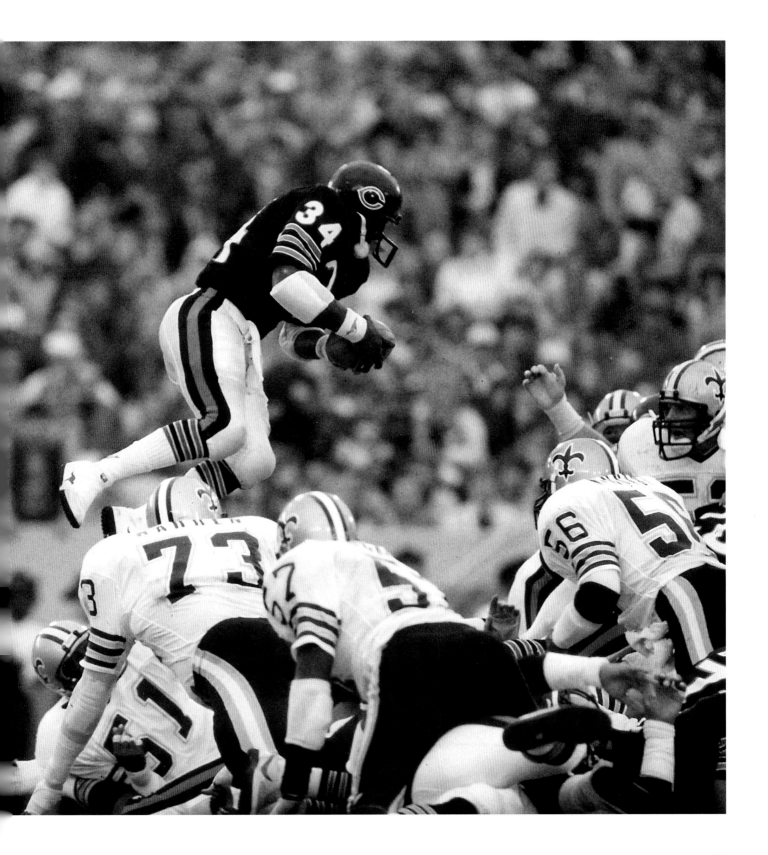

FUN IN THE SUN

ST. THOMAS UNIVERSITY, MIAMI | *November 26, 1984*

WHEN DAN MARINO burst onto the NFL scene in 1983, he was a larger-than-life figure, walking tall among the cadre of fellow quarterbacks around the league. Marino was the last of six quarterbacks to hear their names called in the first round of the 1983 draft—John Elway, Todd Blackledge, Jim Kelly, Tony Eason and Ken O'Brien all went ahead of him. But Marino was the first of that group to make his mark, and he played longer than all of them.

Before Marino got to the NFL, a quarterback had thrown for 4,000 in a season just five times—and Dan Fouts was responsible for three of those occurrences. Marino did it six times. With a lightning-quick release, Marino stood tall in the pocket and had an uncanny knack for finding the open receiver and getting rid of the ball just before the opposing pass rush could reach him.

After starting nine games as a rookie, Marino's 1984 season was one for the ages. He threw an NFL-record 48 touchdown passes (a mark that lasted 20 years before Peyton Manning broke it in 2004) and set another mark with 5,084 passing yards (which lasted 27 years before Drew Brees bested it in 2011).

When he retired after the 1999 season, Marino owned the all-time NFL records with 61,361 yards and 420 TD passes. Both marks were broken by Brett Favre in 2007 and have since been broken by Tom Brady.

While one of Marino's legacies is that he was the most prolific passer of his era, he is also thought of by many as the greatest quarterback to never win a championship. Marino's remarkable 1984 season helped Miami reach Super Bowl XIX, but the Dolphins lost that game to Joe Montana and the 49ers. No worries, most people thought. Marino was 23 years old. He'd be back. But while Marino made the playoffs in 10 of his 17 NFL seasons, he never made it back to the Super Bowl.

Photograph by JOHN IACONO

THE PUNKY QB

PHOTO SHOOT, CHICAGO | *September 1, 1985*

QUARTERBACK PLAY DEFINITELY isn't the first thing you think about when discussing the 1985 Chicago Bears, but starting quarterback Jim McMahon was most certainly a perfect fit for that oh-so-memorable team. Known as "the punky QB," McMahon was cocky, confident, unapologetic and, most of all, a winner.

McMahon passed for 2,392 yards and 15 touchdowns in 1985, his fourth season in Chicago after being a two-time All-American at BYU. Both stats were career highs for McMahon—nothing to write home about but good enough to earn him the only Pro Bowl nod of his 15-year career. And with the team around him, he really didn't have to do much to keep the train rolling.

The 1985 Bears were a true NFL juggernaut. Led by head coach Mike Ditka—himself an extremely confident and unapologetic winner—they started the season 12–0 and, with a defense that might have been the best in NFL history, it looked as if they might join the 1972 Miami Dolphins as the NFL's only undefeated teams. And that's why it was so fitting that, in the Week 13 Monday night game, Dan Marino and the Dolphins took matters into their own hands and defeated Chicago, 38–24.

Did we mention the Bears were a cocky bunch? One day after losing to the Dolphins, McMahon and several of his teammates released a music video they had recorded: "The Super Bowl Shuffle."

And the Bears backed up their bravado. With a defense that featured three future Hall of Famers (linebacker Mike Singletary and defensive linemen Richard Dent and Dan Hampton) and an offense fueled by Hall of Fame running back Walter Payton, the Bears bounced right back after the Miami loss. They held 11 regular-season opponents to 10 points or fewer. In the NFC playoffs, they outscored the Los Angeles Rams and New York Giants by a combined score of 45–0. They culminated one of the greatest single seasons in NFL history with a 46–10 drubbing of the New England Patriots in Super Bowl XX.

Photograph by PAUL NATKIN/GETTY IMAGES

BATTERING RAM

ANAHEIM STADIUM, ANAHEIM | *December 7, 1986*

WHEN THE LOS ANGELES RAMS selected SMU running back Eric Dickerson with the second overall pick in the 1983 NFL draft, it seemed the stars were aligned. The Rams had just hired John Robinson as their new head coach. While NFL defenses in the early 1980s were gearing up to stop the proliferation of more wide-open passing attacks, Robinson espoused the run-first philosophy that helped him develop great running backs as head coach at USC. So when the 6'3", 220-pound Dickerson burst onto the scene, he simply could not be stopped.

In four of his first six NFL seasons, Dickerson led the NFL in rushing yards. He smashed the rookie record with 1,808 yards in 1983. To prove that season was no fluke, he followed it with a season for the ages. In 1984, Dickerson set the NFL's single-season rushing record with 2,105 yards.

"He was so smooth," Robinson told SI before the start of the 1985 season. "That's the thing that surprised me. If you were blind, he could run right by you, and I don't think you'd know he was there unless you felt the wind. He's unique in that way. He is an extremely powerful runner, but he's so graceful it's really deceiving. He's the smoothest runner I've ever seen."

In 11 NFL seasons, Dickerson rushed for 13,259 yards (ninth on the all-time list) and 90 rushing touchdowns (tied for 13th). In addition to his rookie and single-season rushing records, Dickerson owns the mark for most rushing yards in a playoff game. He had 248 yards and two touchdowns (runs of 40 yards and 55 yards) in a 20–0 win over the Cowboys in a 1986 playoff game.

In that 1985 SI profile, Robinson gushed not only about Dickerson's speed and smoothness, but about his vision and toughness:

"I think you can be an average speed guy and be a great runner," said Robinson. "Courage and vision are the things. It all starts with the eyes. The great runner has to see and be able to communicate whatever he sees to his feet—to see something and get his body to move toward it or away from it. Eric sees things differently. And I think all great runners are tough guys. Payton, Simpson, Brown, Allen—they always take such a beating. The running back has to have as much courage as any person playing any sport. I've never seen Eric intimidated."

Photograph by ANDY HAYT

THE DRIVE

CLEVELAND STADIUM, CLEVELAND | *January 11, 1987*

THE FIRST TWO paragraphs from Rick Telander's game story in the January 19, 1987, issue of SI pretty much sum up the 1986 AFC Championship Game:

> "Did you sit there with a tail-wagging mongrel at your knee and kindly offer him a meaty bone, hold it barely in front of the pooch's eager snout and at the last instant, just after his head lunged forward but before his teeth clicked shut, pull the bone away? Have you? Just for fun?

> "Then you've been John Elway, the Denver Bronco quarterback who yanked the bone from the mouth of the Cleveland Dawgs, er, Browns, 23–20 in overtime, for the AFC Championship before 79,915 stunned fans in Cleveland Stadium on Sunday. No, let's clarify this metaphor. Elway didn't just pull victory from the Browns' mouth. He ripped the thing from halfway down their throat."

The Browns had just scored to take a 20–13 lead with 5:32 left. On its two previous fourth-quarter possessions, Denver had gone three-and-out both times. So when the Broncos' next possession started back at their own 2-yard line, a 98-yard game-tying scoring drive seemed unlikely.

But then Elway, in his fourth season, staged the first of what would be so many magical moments. He began moving Denver down the field and he would not be denied. Even facing a third-and-18 from the Cleveland 48, he completed a 20-yard pass to Mark Jackson to keep the drive alive. A few plays later, he hit Jackson for the 5-yard touchdown that tied the game.

At that point, a Denver victory in overtime seemed inevitable. On Denver's first possession in OT, Elway led Denver on a nine-play, 60-yard drive that resulted in Rich Karlis's game-winning 33-yard field goal, sending the Broncos to Super Bowl XXI.

Photograph by GEORGE GOJKOVICH/GETTY IMAGES

BO-DACIOUS

LOS ANGELES MEMORIAL COLISEUM, LOS ANGELES | *November 22, 1987*

WHEN BO JACKSON signed a five-year contract with the Los Angeles Raiders in 1987, he told reporters that football would be his "hobby." After all, he was already an outfielder for the Kansas City Royals, having made his major-league debut the previous September. As a rookie in 1987, Jackson hit 22 home runs for the Royals before reporting to the Raiders in time for their Week 8 game. The 1985 Heisman Trophy winner from Auburn immediately reminded everyone that he could easily have been the greatest running back of his generation. Jackson was equally devastating running around defenders or running over them. Five weeks into his NFL career, the Raiders played a Monday night game against the Seattle Seahawks. A massive TV audience tuned in to see the two-sport star. Jackson didn't disappoint, catching a touchdown pass and rushing for 221 yards and two more touchdowns. The first rushing TD was a 91-yard run in which he went untouched. The second was a short run in which he plowed over Seahawks linebacker Brian Bosworth, who had been crowing before the game about how he planned to shut down Jackson.

Jackson continued to play both sports. He made the All-Star Game in 1989 (taking home MVP honors) and then made his first Pro Bowl in 1990. But in a playoff game after the '90 season, Jackson suffered a hip injury that would end his football career. He played parts of three more baseball seasons, but was never the same in that sport, either.

When Jackson was trying to make a baseball comeback in 1992, SI's Steve Wulf wrote about him during spring training. He had seen enough of Bo the baseball player to write about that aspect. He reached out to SI NFL writer Peter King to get the football scouting report, and this is what King told him:

> "The best combination of power and speed ever to run in an NFL backfield. This is not just me saying this; this is every man in every NFL front office. The Buffalo Bills' personnel director, Bob Ferguson, said he has never graded a player higher than he graded Bo. Sam Wyche, when he coached the Bengals in 1990, said he was tempted to ask Bo for his autograph. Last year when Jimmy Irsay, the Indianapolis Colts' general manager, heard that Bo might not play football again, he said, 'It's like the music world without John Lennon.'"

Photograph by MIKE POWELL/GETTY IMAGES

THE FUMBLE

MILE HIGH STADIUM, DENVER | *January 17, 1988*

AFTER JOHN ELWAY broke the hearts of Cleveland fans in the 1986 AFC Championship Game, their team bounced back just fine in 1987. The Browns rolled to their third straight AFC Central title and once again had a date with Denver in the AFC title game. Would this be the day the Browns finally reached the Super Bowl?

From Rick Reilly's recap in the January 25, 1988, issue of SI:

"They say the one thing you learn from history is that you do not learn at all. It must be true, because history keeps rising up to clobber the Cleveland Browns. Three times in this decade the Browns have come within a minute of winning playoff games and three times that minute has turned into an entire off-season. First, there was the interception Brian Sipe served up to the Raiders in their divisional playoff game in 1980. Then there was John Elway's Sunday Drive for the AFC title a year ago. But who could have seen this one coming? This time, again within a few ticks of a Super Bowl berth, the Browns stayed highlight reel for highlight reel with Elway. And they held up under a din that threatened to crack the foundation of Mile High Stadium.

"What they didn't count on was an unknown cornerback with a hero complex.

"What they didn't count on was Jeremiah Castille, cut adrift by the Tampa Bay Buccaneers before this strange season began, sitting there on the Denver bench for much of the long afternoon and into the night. He had watched John Elway direct the Broncos to a 21–3 halftime lead, with poster-perfect passes and Fred Astaire feet. He had watched Bernie Kosar drag the Browns back to within a touchdown, 38–31, using shot-put heaves for passes and a running style that might suggest bunion problems. He had watched a parade of famous, rich men pass in front of him and didn't feel like he belonged with any of them."

As Reilly detailed, Castille came into the game after starting cornerback Steve Wilson was injured. Castille was on the field as Kosar marched the Browns down the field in quest of an overtime-forcing touchdown, just as Elway had done to Cleveland the year before.

On second-and-5 from the Denver 8-yard line with 1:12 to play, Cleveland's Earnest Byner took a handoff and cut to his left. With nothing but green in front of him, it appeared Byner would go in for his third touchdown of the game. Enter Castille, who got close enough to get one hand in and punch the ball free. Castille recovered the fumble at the three. Thanks to his heroics, Denver returned to the Super Bowl … and Cleveland returned home.

Photograph by MARK DUNCAN/AP PHOTOS

A QUARTER TO REMEMBER

JACK MURPHY STADIUM, SAN DIEGO | *January 31, 1988*

DOUG WILLIAMS CARVED his name into history when he became the first Black quarterback to win an NFL title in Super Bowl XXII. That's the headline, and it overshadows how the Washington Redskins overcame an early 10–0 deficit against Denver with an offensive explosion in the second quarter. SI's Paul Zimmerman, among others, had predicted a Broncos victory. As he recollected in this excerpt from a story in the January 2, 1989, issue, Zimmerman was not unhappy that Williams proved him wrong:

"The Redskins came into the Super Bowl ranked 24th against the pass. John Elway likes to work on teams with that kind of pass defense. But I kind of figured Redskins quarterback Doug Williams would have a big game. I was hoping he would have a big game. Williams is one of the nicest guys in the business. He proved that during the week before the NFC title game against the Vikings. It's no fun being around the Skins in the days before a big game. They go corporate on you. The rules were that the locker room was supposed to be open to the press for an hour each day. Fair enough, if you felt like interviewing a bunch of empty lockers. The Skins honored only the letter of the law. You would come in, and maybe there would be a couple of injured reserves sitting around, but everyone else had cleared out. You could hear them giggling behind the walls somewhere.

"Williams would have none of that nonsense. He was kind and gracious to anyone with a notebook or a tape recorder. He sat in the press area and answered the same questions all week, always with courtesy and good humor. He had known what the downside was like—he had been at Tampa Bay, and then with Oklahoma and Arizona in the USFL. I was just hoping he wouldn't get beaten too badly on Super Sunday.

"I clocked Herb Alpert doing the national anthem on the trumpet in 1:25.30. I was into hundredths; I'd just gotten a new stopwatch. I was trying to figure out the influence that ploddingly slow instrumental would have on the outcome of the game when Ricky Nattiel raced under an Elway pass for 56 yards and a touchdown. And then the Broncos drove for a field goal. And then they drove into field goal range again, but this time they were sacked out of it. On the Skins' next possession Williams twisted his left knee when he slipped on the grass of San Diego Jack Murphy Stadium. His backup, Jay Schroeder, replaced him. But when the second quarter started, Williams was back in there. I was thinking that I sure didn't want to see him quarterback a team that got blown out.

"O.K., we all know what happened in that second quarter. Thirty-five points and an orgy of yards for the Skins. Williams throwing bombs—four touchdowns of, in order, 80, 27, 50 and eight yards. Timmy Smith running to daylight, moonlight and into the next day on that counter play. It was adding-machine football. Eighteen plays, five minutes and 47 seconds of possession, 357 yards—all in the second quarter. Average gain per play: 19.8 yards. Average yards per minute: 61.7.

"Records had toppled like mad by the end of that 42–10 mismatch. The most notable were the Skins' 602 total yards and Smith's 204 on the ground. The Broncos made linebacker Ricky Hunley their scapegoat for the defensive collapse and shipped him off to Phoenix, where he's enjoying the sun and trying to forget. I understand; I'm still in shock."

Photograph by STEPHEN DUNN/GETTY IMAGES

THE FOG BOWL

SOLDIER FIELD, CHICAGO | *December 31, 1988*

THE FIRST 28 MINUTES of the 1988 divisional playoff game between the Philadelphia Eagles and Chicago Bears went just fine. The Bears had a 17–9 lead. They had kept the Eagles out of the end zone, but Philly quarterback Randall Cunningham was putting up good numbers and he certainly would be tough to handle as the game wore on. But as halftime drew near, Mother Nature threw both teams a curveball. A heavy fog rolled in off Lake Michigan and completely blanketed Chicago's Soldier Field. Visibility—for the players, coaches, fans, TV viewers, everybody—was a major challenge.

During halftime, referee Jim Tunney was on the phone with NFL officials in New York, and he considered declaring the game unplayable. But he did not. At one point in the second half, Bears defensive tackle Dan Hampton turned to a teammate standing next to him on the sideline and asked him what the score was. Hampton couldn't see the stadium scoreboard through the fog.

In Paul Zimmerman's game story in the January 9, 1989, issue of SI, he noted that a fan held up a sign that read, WHAT THE FOG IS GOING ON?

The Eagles did manage a field goal in the third quarter, closing to within 17–12. Cunningham ended up passing for 407 yards, but he was intercepted three times. Chicago kicked a fourth-quarter field goal that made the final score 20–12.

From Zimmerman's story:

"The underlying reason that the game wasn't suspended, of course, was TV. The idea of the network rearranging its programming schedule was just too awful to consider. As it happened, most of the people on the field agreed. Neither coach wanted the game suspended. 'The fog didn't beat us, the Bears did,' said Philly coach Buddy Ryan. The players didn't want it stopped, either, although Cunningham said his occasional long passes were pure guesswork. 'He put 'em up there, and the good Lord took them into the fog,' said Chicago quarterback Mike Tomczak, who admitted that his visibility was 'no more than 20 yards.'"

Photograph by HEINZ KLUETMEIER

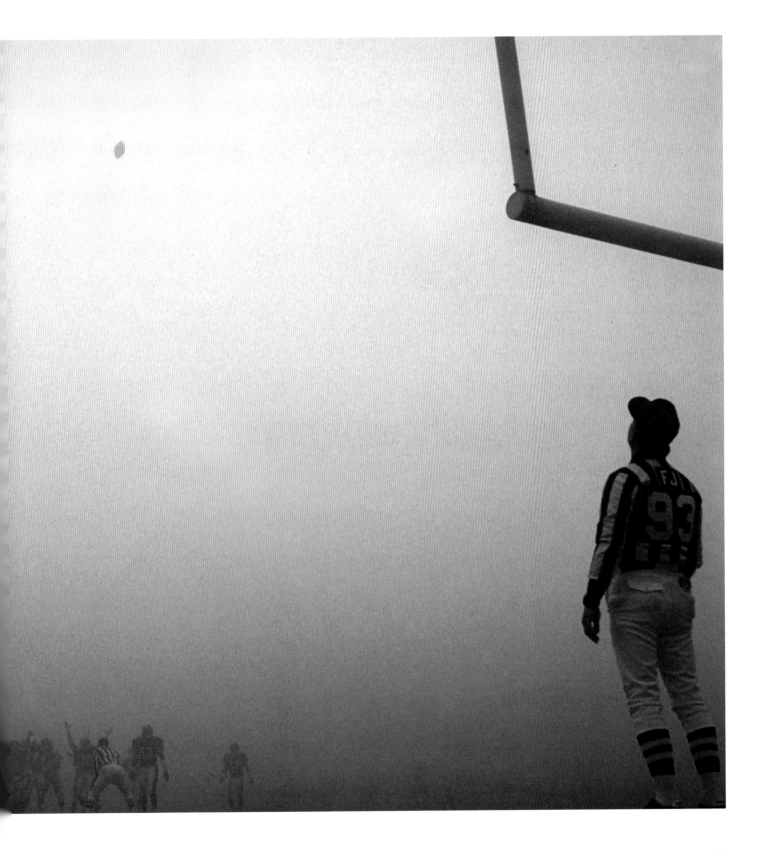

JOE COOL

JOE ROBBIE STADIUM, MIAMI | *January 22, 1989*

SAN FRANCISCO QUARTERBACK Joe Montana had built his NFL
legacy long before Super Bowl XXIII. He was on the throwing
end of "The Catch," which signaled the beginning of the 49ers'
dynasty in 1982, before becoming a two-time Super Bowl MVP
(XVI and XIX). He would win a third Super Bowl MVP in
XXIV—but it was his cool leadership at the end of Super Bowl
XXIII that stands near the top of his career achievements.

Another Hall of Famer, Jerry Rice, was the MVP of
San Francisco's 20–16 win over the Cincinnati Bengals at the end
of the 1988 season. Rice caught 11 passes for 215 yards and one
touchdown. But with the 49ers trailing 16–13 with 3:20 left,
it was Montana's magic that took over. San Francisco started its
next drive at its own 8-yard line. As the legend goes, teammates
recall getting into the huddle to start that drive, with the weight
of the Super Bowl squarely on their quarterback's shoulders, and
Montana stopping to tell them that he saw comedian John Candy
in the crowd. And then he proceeded to lead the 49ers on an
11-play, 92-yard drive that culminated with Montana's 10-yard
pass to John Taylor for the game-winning touchdown.

"We had them on their eight with three minutes to go,"
Bengals receiver Cris Collinsworth said after the game, "and
somebody came up to me and said, 'We got 'em now.' I said,
'Have you taken a look at who's quarterbacking the San Francisco
49ers?' That's what it comes down to. Joe Montana is not human.
I don't want to call him a god, but he's definitely somewhere in
between. I'm sure he did it in peewee football, in high school,
college and now in professional football. Every time he's had the
chips down and people counting him out, he's come back."

Photograph by BETTMANN

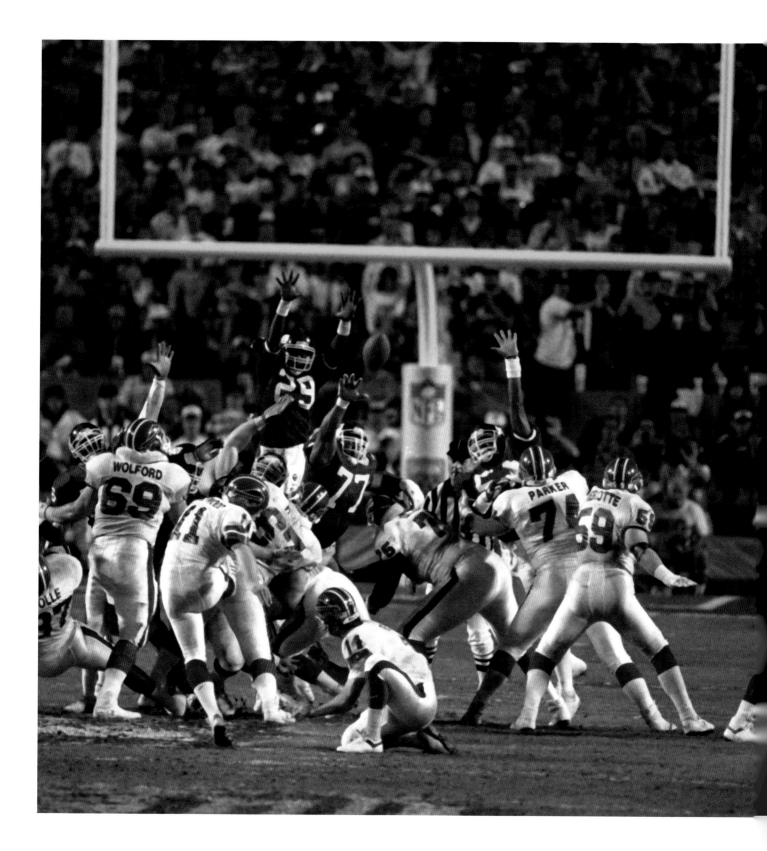

WIDE RIGHT

TAMPA STADIUM, TAMPA | *January 27, 1991*

SUPER BOWL XXV was old school vs. new school, ball control offense and hard-hitting defense vs. flash and dash. And it was a game for the ages. The New York Giants played with power and brute force. The Buffalo Bills featured the "K-Gun" pass-happy offense that could seemingly score at will. Which style would prevail? The game could have gone either way, and ultimately it came down to the final play.

"A game played under the shadow of war in the Mideast, in a stadium with the tightest security of any Super Bowl game, became a classic," wrote Paul Zimmerman in the February 4, 1991, issue of SI.

While the Bills offense featured a quartet of future Hall of Famers in quarterback Jim Kelly, running back Thurman Thomas and receivers Andre Reed and James Lofton, the Giants offense was led by backup quarterback Jeff Hostetler, filling in for the injured Phil Simms. Despite that stark contrast, it was the Giants who ended up with double the time of possession. While Hostetler did just enough, running back Ottis Anderson ran for 102 yards. When Buffalo did get the ball, the Giants defenders made sure to keep the play in front of them … and make sure the Bills players felt the brunt of every tackle.

"No other team ever hit me this hard," Reed said after the game. "You can't even compare this to anything I've ever been through. They bruised up my whole body."

Still, the Giants clung to only the thinnest of leads—20–19—in the closing minutes. Thanks in large part to the play of Thomas, who finished with 190 yards from scrimmage, Buffalo reached the Giants' 29-yard line with seconds left. Bills kicker Scott Norwood, with a chance to be the hero, saw his field goal attempt sail wide right. The Giants were champions.

"It came down to the last kick, and the Super Bowl is supposed to be played that way," said Kelly. "If you want to write a Super Bowl script, this is probably what you have to write. It came down to the last kick."

"Power wins football games," Giants head coach Bill Parcells repeated endlessly amidst the postgame locker room turmoil.

That was Parcells's overriding football philosophy. Someone asked him after the game if Super Bowl XXV had vindicated his system. "It's always been vindicated," he said. "It's the new stuff that had something to prove."

Photograph by PHIL SANDLIN/AP PHOTOS

A MAN OF VISION

TAMPA STADIUM, TAMPA | *January 27, 1991*

ED SABOL FOUNDED NFL Films in 1965, but it was his son, Steve Sabol (left), who transformed it into a storytelling juggernaut that elevated the game of football into something of American mythology. Steve Sabol's love of football was contagious. He died in 2012, eight years before he was enshrined in the Pro Football Hall of Fame. Peter King wrote this about Sabol after his death, in the October 1, 2012, issue of SI:

"I stuck out my hand each of the last two times I saw Steve Sabol, and both times he just shook his head and pulled me in close for a hug. The visionary behind NFL Films had been living with a brain tumor since March 2011, and he was bald from chemotherapy and radiation treatments. As we sat together in his office in southern New Jersey a month after his diagnosis, he said, 'So they talk about heaven, and I don't know what is waiting for me up there. But I can tell you this: Nothing will happen up there that can duplicate my life down here. Nothing. That life cannot be better than the one I've lived, the football life.'

"Tributes to Sabol, who died on Sept. 18 at age 69, have rightfully noted how ahead of his time he was. In 1966, when he was 24, he made the landmark documentary *They Call It Pro Football*, a film so moving, it made Vince Lombardi cry. Sabol's

decision to mike players during games, beginning in the '70s, humanized the NFL's players and coaches. His affection for the slo-mo spiral became the game's art-house shot. In '84, Sabol created the first X's-and-O's show, *Monday Night Matchup*, because he thought fans wanted more detail; now there are many such shows.

"What made Sabol great was his passion for detail. When he was filming a Packers practice one day in '67, he heard Lombardi gruffly order that a stray dog be taken off the field. Years later Sabol went on a long riff to author David Maraniss about the great voices of history and how Lombardi had one, and it helped him run his team.

"'Steve's genius,' former Vikings defensive end Jim Marshall, one of Sabol's early subjects, told me last week, 'was showing America what a football player really was like, what his life was like. I think that made America like football players, and like football.'

"No one over the past 50 years—no player, coach or commissioner—made America love it more than Sabol."

Photograph by AL MESSERSCHMIDT/AP PHOTOS

120

THE GAME-CHANGER

GIANTS STADIUM, EAST RUTHERFORD, N.J. | *December 21, 1991*

LAWRENCE TAYLOR WAS a force of nature on the football field. As the sport has evolved through the years, there have been changes to the game that have had a profound impact on the way it is played. Free substitutions … the 5-yard bump rule … the West Coast offense …

Lawrence Taylor.

When the New York Giants realized what a devastating defensive weapon they had in Taylor, they lined him up everywhere on the football field. Opposing offenses had no idea where he'd be coming from when the ball was snapped. They just knew he'd be coming. If it was a pass play, the quarterback was in imminent danger. If it was a run, Taylor would undoubtedly get there. A three-time NFL Defensive Player of the Year honoree, Taylor was the NFL's Most Valuable Player in 1986—he and fellow Hall of Famer Alan Page are the only defensive players to be named MVP.

Unlike Page, a defensive tackle with very specific responsibilities on the field, Taylor in many ways changed the way his position, linebacker, would be played. Taylor lined up as an outside linebacker in the Giants' 3-4 defense, but they moved him all over the place. Many of the edge rushers of today's game can thank the man they

call LT for being encouraged to freelance the way they do. Taylor finished his career with 132.5 sacks, but the Giants weren't shy about dropping LT into pass coverage. Teams would be bracing for Taylor's pass rush and then suddenly there he was, intercepting a pass. He did that nine times, returning two for touchdowns.

And Taylor didn't just change the way defense was played. In order to account for Taylor, the Redskins were the first team to start using two–tight end sets and they essentially created the H-back position with the sole intention of blocking Taylor.

LT was profiled by Jill Lieber in the January 26, 1987, issue of SI, just before Taylor and the Giants would defeat the Denver Broncos in Super Bowl XXI.

Bill Belichick, the Giants defensive coordinator at the time, had this to say: "What makes LT so great, what makes him so aggressive, is his total disregard for his body."

"It's hard to imagine the New York Giants reaching Super Bowl XXI without Lawrence Taylor," Lieber wrote, "the practically perfect linebacker."

Photograph by NEIL LEIFER

THE COMEBACK

RICH STADIUM, ORCHARD PARK, N.Y. | *January 3, 1993*

HERE'S HOW PETER KING set the stage for what was about to unfold in his recap of the 1992 AFC wild-card game for the January 11, 1993, issue of SI:

"So here were the Buffalo Bills, down 35–3 to the Houston Oilers with 28 minutes left in the AFC wild-card game at Rich Stadium on Sunday. It had been bad enough at halftime when, with his team trailing 28–3, coach Marv Levy had stared down his players and told them, 'Whatever happens, you guys have to live with yourselves after today.' But then to come out and have Oilers safety Bubba McDowell return an interception 58 yards for a touchdown.…

"With Houston having beaten Buffalo 27–3 in the regular-season finale, the Oilers had outscored the two-time defending AFC champion Bills 62–6 in the previous six quarters and two minutes. And now Buffalo was playing without quarterback Jim Kelly (knee sprain), running back Thurman Thomas (hip pointer) and linebacker Cornelius Bennett (hamstring pull). Sackmaster Bruce Smith (three cracked ribs) was on the field but having little impact.

"So you can understand why, after McDowell's touchdown, a few thousand fans started leaving cold, windy Rich Stadium. And why a couple of Houston TV guys up in the press box got on the phone to make nonrefundable plane reservations for the next round of the playoffs, in Pittsburgh. And why a league official consoled Buffalo media-relations director Scott Berchtold, telling him, 'Well, you guys had a nice run.'

"But suddenly … "

King proceeded to deliver a blow-by-blow recap of what is considered one of the most amazing comebacks in NFL history. Remarkably, it was orchestrated by Bills backup quarterback Frank Reich, who also led the greatest comeback victory in college football history, at the University of Maryland. Reich and the Bills actually took a 38–35 lead before Oilers quarterback Warren Moon led a last-ditch drive that culminated in a game-tying field goal with 12 seconds left in regulation.

The Oilers got the ball first in overtime, but after two completions Moon was intercepted when his intended target fell. After two short runs, Bills kicker Steve Christie kicked the game-winner.

Unlike other epic playoff games, in which the winners are so emotionally drained that they end up losing one week later, Buffalo stayed hot and won back-to-back road playoff games in Pittsburgh and Miami to earn their third consecutive trip to the Super Bowl. Unfortunately for the Bills, they ran into a buzzsaw in the Dallas Cowboys in Super Bowl XXVII and lost in the title game for the third straight season.

Photograph by CHUCK SOLOMON/AP PHOTOS

THE MINISTER OF DEFENSE

LAMBEAU FIELD, GREEN BAY, WISC. | *September 12, 1993*

REGGIE WHITE LEFT his mark on the NFL in so many ways. He was twice named Defensive Player of the Year—first in 1987 with the Philadelphia Eagles and then 11 years later with the Green Bay Packers. His 198 career sacks puts him second on the all-time list, just two behind Bruce Smith. Nicknamed the "Minister of Defense"—he was, after all, an ordained minister—White's intensity on the football field was impossible to contain.

Wrote Johnette Howard in the September 4, 1995, issue of SI:

"White's teammates know that his preaching about putting the team first isn't just talk. Despite the meat-grinder nature of the position he plays, until last season he had never missed a nonstrike NFL game. After an All-America senior season at Tennessee and a two-year stopover with the Memphis Showboats of the USFL, he came into the NFL in 1985 saying that he wanted to be the best defensive lineman ever, and more than a decade later, he's still rolling toward quarterbacks like a wave of lava, burying whatever is in his path. He burns to win. His example has been contagious."

White had already been to seven Pro Bowls in his eight seasons with the Eagles when it was time for him to seek a new contract. True NFL free agency was in its infancy back then, and White was the first real superstar to test the market. White initially said he wanted to sign with a Super Bowl contender, but he ended up with Green Bay—a team that had just four winning seasons in the previous 20 years. White said God told him to sign with the Packers. Whether or not that was true, some of the credit also goes to general manager Ron Wolf. A year earlier, Wolf had traded for quarterback Brett Favre from the Falcons. With Favre leading the offense and White anchoring the defense, Green Bay was an instant contender. By 1996, the Packers were NFL champions. In the Super Bowl XXXI victory over the New England Patriots, White had three sacks—still a Super Bowl record.

Photograph by JERRY REDFERN/AP PHOTOS

FLASH 80

CANDLESTICK PARK, SAN FRANCISCO | *January 15, 1995*

WHEN THE SAN Francisco 49ers stunned the Dallas Cowboys in the 1981 NFC Championship Game, it symbolically set both teams on separate paths. The 49ers won the Super Bowl twice in a four-year span. Dallas, meanwhile, saw an end to its dynastic run and was no longer the NFC's dominant team. Still, that change in fortunes could have been short-lived had it not been for the next time that San Francisco stunned the Cowboys. This time, it wasn't on the field but rather in the 1985 NFL draft. With the 17th pick in the first round, Dallas was all set to draft a record-setting wide receiver from Mississippi Valley State. But before they could, the 49ers traded their first-, second- and third-round picks to the New England Patriots in exchange for the 16th pick. That's how Jerry Rice became a 49er instead of a Cowboy.

Who knows what would have happened had history turned out differently. What we do know is that San Francisco head coach Bill Walsh was absolutely right in believing that Rice would thrive in his West Coast offense. Did he know Rice would become known as the greatest wide receiver in NFL history? Maybe not, but Walsh still deserved credit for drafting him.

Rice wasn't the fastest receiver, but he was an extraordinary route runner with great hands. And when Joe Montana or Steve Young hit him in stride, Rice was a threat to score from anywhere on the field. In addition to helping the 49ers win three more Super Bowls (he was MVP in Super Bowl XXIII), Rice rewrote the record books.

Rice led the league in receiving yards and receiving touchdowns six times each. When he retired in 2005, he owned the NFL's all-time records for receptions (1,549), receiving yards (22,895), receiving touchdowns (197), total touchdowns (208) and all-purpose yards (23,546). Despite the proliferation of the passing game over the last 20 years, those all-time records still stand—and no active receiver is close to reaching them.

Perhaps Rice's most impressive record is one that has since been broken. In 1987, Rice set a new mark with 22 receiving touchdowns. The record lasted 20 years before fellow Hall of Fame receiver Randy Moss caught 24 touchdowns in 2007. Of course, Moss set the record in 16 games. Because 1987 was a strike-shortened season, Rice caught his 22 touchdowns in only 12 games.

Photograph by PETER READ MILLER/AP PHOTOS

CHIEF DEFENDER

MILE HIGH STADIUM, DENVER | *October 22, 1995*

DERRICK THOMAS WAS a shooting star across the NFL universe. His career lasted 11 years, a good run by most standards. It just felt too short because it was cut off abruptly and tragically when Thomas died following a car accident one month after the 1999 season had ended. Before his death, Thomas was an unstoppable force for the Kansas City Chiefs, a sack machine. The linebacker from the University of Alabama was the Defensive Rookie of the Year in 1989 when he recorded 10 sacks; he came back the next year with *20*. Thomas averaged 11.5 sacks per year. His 126.5 career sacks ranked 11th on the all-time list when he died, and there's no telling where he'd be on that list had he lived. Thomas had turned 33 a month before his passing. He had 41.5 sacks in the four years prior to his death, so he certainly wasn't slowing down.

Thomas remains the Chiefs' all-time leader in sacks, safeties (3), forced fumbles (41), fumble recoveries (19) and defensive touchdowns (4). His most impressive performance came on November 11, 1990, in a Week 10 home game vs. the Seattle Seahawks. That was Thomas's brilliant second season with the Chiefs, and seven of his 20 sacks came in that one game.

Photograph by ALLEN KEE/GETTY IMAGES

SLIDING DOORS

CITRUS BOWL, ORLANDO | *May 20, 1998*

WHO SHOULD THE Colts take with the first pick of the 1998 NFL draft, Peyton Manning or Ryan Leaf? In hindsight, it's one of the dumbest questions ever posed. The numbers tell you all you need to know: Manning threw for 71,940 yards and 539 touchdown passes in 17 NFL seasons, winning two Super Bowls along the way. Leaf's career lasted all of three seasons in which he compiled 3,666 yards and 14 TD passes.

But the amazing thing is that, in the weeks leading up to the '98 draft, many experts considered it a toss-up as to which of these quarterbacks would be taken first overall. Manning, son of NFL veteran Archie Manning, was a consensus All-American who started all four seasons at Tennessee, setting school and SEC records along the way. Leaf burst onto the national scene as a junior, passing for 3,968 yards and 34 touchdowns while leading Washington State to the Rose Bowl. When talk began that he might challenge Manning for the first overall pick in the draft, Leaf opted to forego his senior season.

Perhaps the first sign that this shouldn't have been such a neck-and-neck race was at the 1998 NFL Combine, when Leaf weighed in at 261 pounds—20 pounds over his playing weight. As Peter King wrote in SI's 1998 NFL draft preview:

> "Leaf admits that he 'hit the banquet circuit a little hard and ordered too much room service late at night.' Maybe his ballooning to 261 pounds reflected nothing more than a kid loving life and celebrating his newfound celebrity. But maybe it was a red flag."

In King's draft preview, he conducted a film study with six veteran NFL personnel experts. It wasn't unanimous, but most agreed that Manning was the better of the two quarterbacks. Nobody was saying Leaf wouldn't or shouldn't be the second player drafted, though Jerry Angelo, one of King's blue-ribbon panelists, was dubious after Leaf's weigh-in.

"Here's what could be the biggest day of your life, the day you're going to expose yourself to your future employers for the first time, and you show up out of shape and overweight. To me, that's a signal," Angelo said. "The quarterback has to be the CEO of your team. You have to trust him. I'd have some hard questions if that happened and we were going to pick him."

Sure enough, Leaf was drafted second overall by the San Diego Chargers and he immediately created friction. Leaf alienated his teammates, fought with the media and was injured often. The combination led him to be out of football long before anyone had imagined.

Photograph by CLIFF WELCH/ICON SMI

MAN ON A MISSION

RAYMOND JAMES STADIUM, TAMPA | *November 1, 1998*

THERE'S A GOOD reason former Minnesota Vikings defensive tackle John Randle often looked as if he had a chip on his shoulder. That's what happens when you think you're good enough to play in the NFL but no team drafts you. The 1990 draft was 12 rounds, with 331 players hearing their names called. John Randle was not one of them.

Randle had earned Little All-America honors at Div. II Texas A&M–Kingsville and his brother, Ervin, played eight years in the NFL. But Randle was 6'1" and 244 pounds—a few inches shorter and at least 50 pounds lighter than the prototypical defensive tackles of the era. Scouts just didn't think Randle had the size to make it in the NFL.

As it turned out, Randle wasn't just good enough. He was better than most. With an unstoppable motor and cat-like quickness for an interior defensive lineman, Randle became one of the most feared pass rushers in the league. The Vikings favored a smaller, more nimble defensive line, so they took a chance on Randle. He played sparingly as a rookie in 1990. He started eight games in 1991 and recorded 9.5 sacks. In each of the next eight seasons, he wouldn't notch fewer than 10. After the 1998 season, the Vikings signed Randle to a contract making him the highest-paid defensive player in NFL history. He also developed a reputation as one of the most notorious trash-talkers in the league. But he was always able to back up his words with actions.

"John is the toughest player I play," said Packers QB Brett Favre, who had to face him twice a year. "On artificial turf, he's unblockable."

Randle retired after the 2003 season with 137.5 career sacks, sixth on the all-time list. In 2010, he was elected to the Pro Football Hall of Fame.

Photograph by WALTER IOOSS JR.

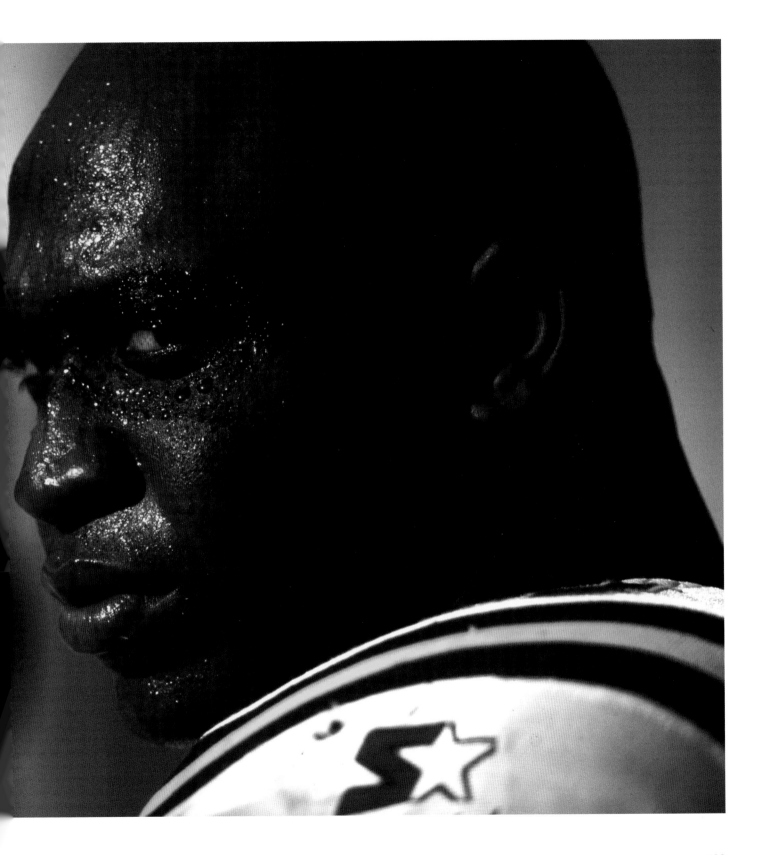

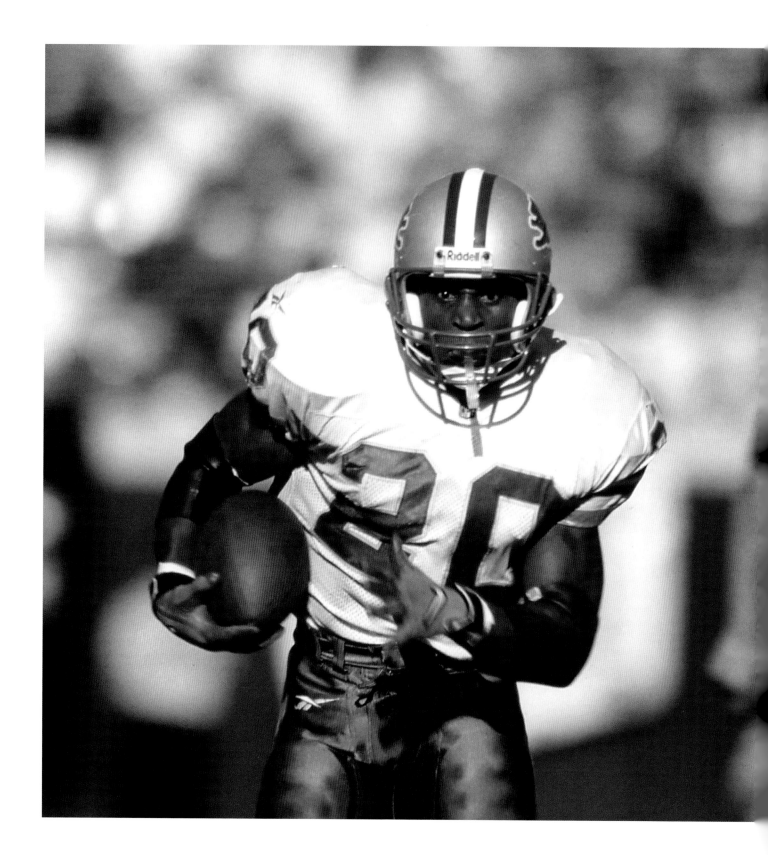

THE LION KING

VETERANS STADIUM, PHILADELPHIA | *November 8, 1998*

AS THE CLOCK wound down in the final game of his rookie season, Barry Sanders was relaxing on the Detroit Lions sideline. Sanders's team was up 31–10 thanks in part to his three touchdowns, and it was time for the backups to finish it off. But then Lions head coach Wayne Fontes got word from upstairs: The NFL's leading rusher, Christian Okoye, was done for the day, and Sanders needed 11 more yards to pass Okoye and win the 1989 NFL rushing title. Fontes passed that news to his star running back and told him he could go in when Detroit went back on offense.

"No," said Sanders. "Let the other guy play."

Typical Barry Sanders.

The debate as to who is the greatest running back in NFL history doesn't always come down to career numbers. Emmitt Smith's all-time rushing record may never be broken, but his longevity and ability to stay healthy for so many seasons was as critical to his success as his talent. Injuries and wear and tear kept the likes of Gale Sayers and Earl Campbell from putting up those kinds of numbers. Sanders, as brilliant as any running back to ever play, may be the one player who could easily have smashed the all-time rushing record … if he had wanted to.

Walter Payton was still the all-time leading rusher when Sanders stunned the NFL world and retired just before the start of the 1999 season. Sanders had rushed for 1,491 yards in 1998—and now needed 1,458 more yards to pass Payton. Some speculated that the shy and humble Sanders was uncomfortable with the idea of taking such an important honor away from the iconic and universally loved Payton. Whatever the reason, it certainly had nothing to do with a lack of production. Sanders, so quick and explosive, was just 31 when he stepped away. Over the last five years of his career, he averaged more than 100 yards per game. At that pace, he would have topped 20,000 rushing yards before turning 35. Smith's seemingly unbreakable record stands at 18,355.

Photograph by MITCHELL B. REIBEL/AP PHOTOS

SURF'S UP

HOME OF JIM BROWN, HOLLYWOOD HILLS, CALIF. | *July 15, 1999*

WALTER IOOSS JR. took this photo of running backs Jim Brown and Ricky Williams for a feature in the August 30, 1999, issue of SI in which Hall of Famers were introduced to up-and-coming NFL stars. Brown was the NFL's all-time rushing leader when he retired in 1965 and, though 10 players have since passed his mark of 12,312 yards, many still consider him the greatest running back in NFL history. Williams, when this photo was taken, was the NCAA's all-time rushing leader (he's second now) and the Saints traded all of their 1999 draft picks to move up and take him with the fifth overall pick in that year's draft.

From SI's "Fun in the Sun" story:

"Williams knows full well that he's in the company of greatness. Though he never saw Brown play, Williams understands the standard by which his career will be judged. 'A lot of players come into the NFL and think they're the greatest thing ever, but I have respect for what came before,' he says. 'I know linebackers are faster now and defenses are more specialized, but the game is essentially the same as it always was. Toughness is the most important quality for any running back, and Jim Brown was amazing. He used to carry people on his back.'

"Williams seems mesmerized by Brown, who among other things talks about Muhammad Ali, Malcolm X, the pool parties that he hosts for members of inner-city gangs, his role opposite Al Pacino in the upcoming Oliver Stone film *Any Given Sunday* and—how's this for incongruous?—his close friendships with Louis Farrakhan and Bob Knight. When Brown gives his views on some of the NFL's other legendary running backs, Williams is impressed by the degree of insight. 'This kid hasn't proved he's a great runner at the pro level yet,' Brown says, putting his hand on Williams's shoulder, 'but I give him respect for what he did in college, and I welcome him into the fraternity. He reminds me of Earl Campbell, and people were scared to death of that man. There's room for all kinds of greatness.'"

Williams didn't quite live up to his Hall of Fame potential, but he certainly showed flashes. After rushing for 1,000 yards twice in his three seasons with the Saints, Williams was traded to the Dolphins. In 2002, he led the NFL with 1,853 rushing yards. A vocal proponent of marijuana, Williams failed several drug tests and was suspended for the 2006 season. He never matched his 2002 success, but he ended his career after the 2011 season with 10,009 rushing yards.

Photograph by WALTER IOOSS JR.

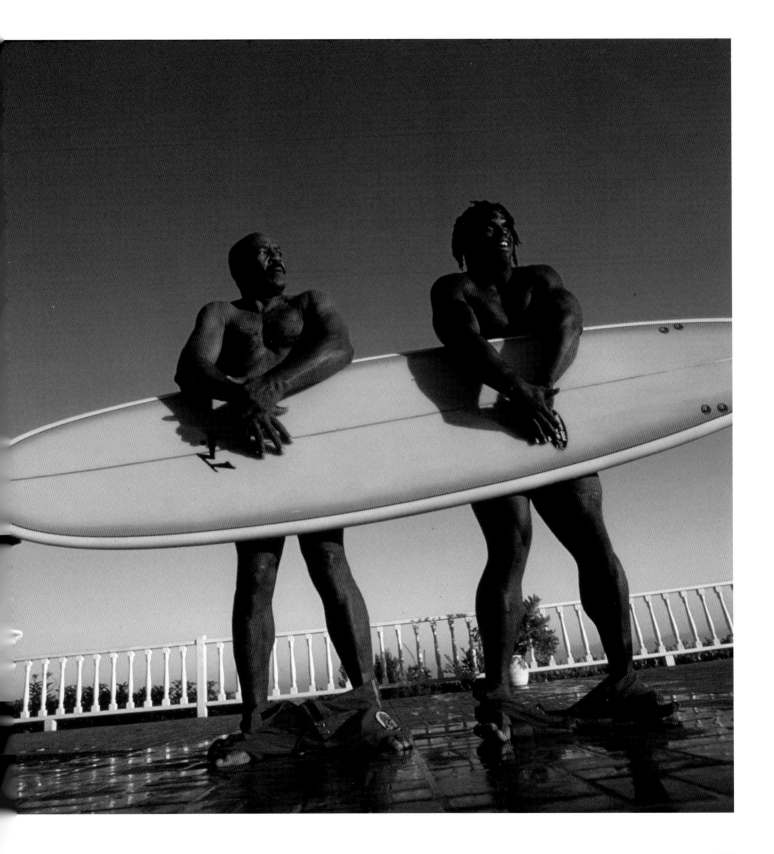

2000 to 2022

The New Millennium

THE MUSIC CITY MIRACLE

ADELPHIA COLISEUM, NASHVILLE | *January 8, 2000*

KEVIN DYSON RACING down the sideline with a wall of blockers, about to score a playoff game-winning touchdown, looks easy. In fact, the hard part had already been done. It was a play deservedly known as the Music City Miracle.

Michael Silver's story in the January 17, 2000, issue of *Sports Illustrated* begins with a description of the scene as Tennessee Titans head coach Jeff Fisher is gathered with his family on the night of January 8, watching a replay of the team's playoff victory over the Buffalo Bills earlier that day:

> "What unfolded before them, in living color, was the 21st century's first classic sports highlight, the NFL's most electric ending since Franco Harris's Immaculate Reception in 1972: Kevin Dyson dashing down the sideline with the pulse-tweaking kickoff return that gave the Titans a 22–16 AFC wild-card playoff victory over the Buffalo Bills."

Buffalo had kicked a field goal to take a 16–15 lead in the game with just 16 seconds left. Like most coaches, Fisher had a particular play saved for desperation moments like this, plays the team would practice all season and hope they never needed. The play was called "Home Run Throwback," and the Titans ran it at the end of every Saturday special teams practice that season. Still, the chances of it actually working in a live game, especially when the Bills knew all they needed was a stop to advance, seemed remote.

Tennessee's Lorenzo Neal fielded the kickoff near the right hashmark at the 25-yard line. He quickly handed the ball off to tight end Frank Wycheck. This wasn't an official pass, but it was certainly the most important throw of Wycheck's life. After getting the ball from Neal, he took two steps to his right and then chucked the ball across the field to Dyson, who went untouched on the 75-yard touchdown.

Two ironies regarding Dyson. First: The Titans receiver had never been part of the team that practiced Home Run Throwback all season. The return man was supposed to be Derrick Mason, but Mason was injured earlier in the game. Dyson was called on, even though he had never returned an NFL kickoff before. Second: The Titans played in Super Bowl XXXIV just four weeks later, and Dyson nearly scored the game-tying touchdown as time expired—only to be tackled at the 1-yard line.

Photograph by BOB ROSATO

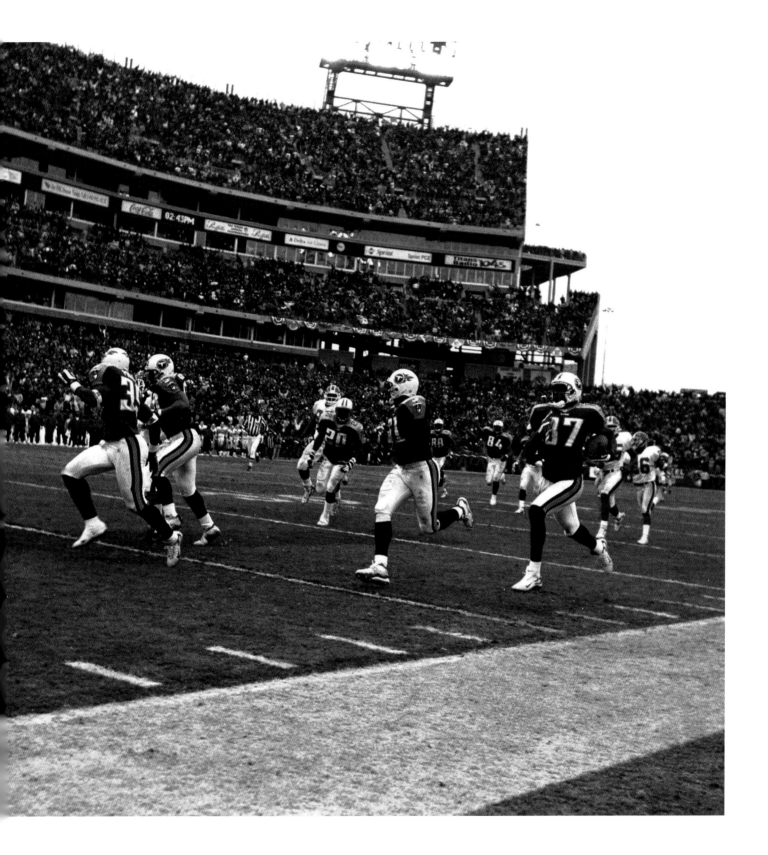

A FANTASY SEASON

3COM PARK, SAN FRANCISCO | *October 29, 2000*

WHEN YOU THINK of "all-purpose" running backs, players who can strike fear into a defense as both a runner and receiver, few compare to Marshall Faulk. Playing his first five NFL seasons with the Indianapolis Colts, Faulk had already established himself as a Pro Bowl back. He was traded to the St. Louis Cardinals in 1999, and his first three seasons with the new team were nothing short of brilliant. From 1999 to 2001, Faulk averaged 153.75 yards from scrimmage per game.

Coinciding with Faulk's stellar stretch was the meteoric rise in popularity of fantasy football. Greater internet access in the United States and advancements in web technology made it more convenient to play fantasy football. With millions of fans participating—earning points based on players' yardage and touchdown totals in real NFL games—Faulk emerged as the first true fantasy football superstar.

In 2000, a year after helping the Rams win Super Bowl XXXIV, Faulk had a season for the ages: In just 14 games, he rushed for 1,359 yards and a league-leading 18 touchdowns. He added 81 receptions for 830 yards and another eight touchdowns receiving. It's safe to say most fantasy managers that had Faulk on their team probably did well.

Wrote SI's senior fantasy writer Michael Fabiano:

"Faulk scored an incredible 459.9 fantasy points in the 2000 season, and he did it in just 14 games. So while that total ranks third all-time among running backs in a single season, Faulk's 32.9 fantasy points per game average remains the high-water mark at the position. The fact that he had such a tremendous season right around the time when fantasy football was starting to gain popularity shouldn't be understated. Faulk was the consensus No. 1 overall pick for several years, in fact, and his stats helped fuel that initial push for fantasy to become mainstream."

When Faulk came into the NFL in 1994, it was estimated that between 1 and 3 million people played fantasy sports, according to the Fantasy Sports & Gaming Association. By 2003, that number was up to 15.2 million. In 2017, it was estimated that more than 46 million play fantasy football. And they're all hoping to draft the next Marshall Faulk.

Photograph by PETER READ MILLER

ONE YARD SHY

GEORGIA DOME, ATLANTA | *January 30, 2000*

THIS IS THE enduring image of Super Bowl XXXIV: Rams linebacker Mike Jones making the Super Bowl–saving tackle, dropping Titans receiver Kevin Dyson at the 1-yard line on the final play of the game. That's right, a defensive play is the highlight for a Rams team that was known as "The Greatest Show on Turf." In fact, the game-saving tackle overshadowed what may be one of the greatest offensive plays in Super Bowl history— Kurt Warner's 73-yard touchdown pass to Isaac Bruce with 1:54 left to play.

SI's Paul Zimmerman captured the moment in the February 7, 2000, issue:

"The Rams have turned the most cherished coaching maxims on their ear. *Establish the run. Avoid mistakes. Take what they give you.* Uh-uh. 'We make them take what we give them,' Marshall Faulk, St. Louis's brilliant running back, said after the Rams' hair-raising 23–16 Super Bowl win over the Titans.

"*Establish the pass. Be bold. Push the ball down-field.* That's the credo of the NFL's new showcase team. That's the philosophy that enabled Kurt Warner to throw for a Super Bowl–record 414 yards, 73 of them on his last pass, the game-winner to Isaac Bruce.

"The guy responsible for this strategy is Mike Martz, St. Louis's 48-year-old offensive coordinator. He came to the Rams this season well versed in the true West Coast offense, which had first fascinated him in the late 1960s when he was a San Diego high schooler and Chargers coach Sid Gillman ran that dazzling, down-the-field attack. The scheme filtered down to Don Coryell and his disciples, two of whom Martz worked under, Ernie Zampese with the L.A. Rams and Norv Turner with the Redskins.

"But before St. Louis bought into the strategy, Martz had to do a selling job to coach Dick Vermeil, who clung to the old maxims. Get the ball downfield, he told Vermeil. Pass first, then run. Vermeil wasn't so sure. He called the Elias Sports Bureau, which keeps the official statistics for the NFL, and got a pass-frequency printout. The results were startling. Two of the four teams that had played in the conference championship games last January had passed more than they'd run in the first quarter throughout the season, as had six of the other eight playoff clubs. Of the 18 teams that had missed the postseason, six had relied on the rush in the opening period. 'Go run your offense,' Vermeil told Martz.

"That's what the Rams did on Sunday. Their pass-run overload was 13 to 6 in the first quarter and 45 to 13 by game's end. The last pass, Warner's bomb to Bruce, defied logic. The St. Louis defense had been on the field for 20 of the previous 23 plays and was tiring badly. A little more than two minutes were left, and the score was 16–16. A long scoring drive was called for. Rest the defense, eat the clock so that Tennessee would have only seconds remaining if it got the ball back. Nope. Martz remembered that the Rams had almost lost the NFC title game to the Buccaneers after he had turned conservative. He had an attack-first philosophy, and he would live or die by it. 'We had a shot,' said Martz afterward, 'so we took it.'

"After its quick touchdown St. Louis watched in agony as the Titans marched downfield. 'Tennessee played with great courage,' Rams tight end Ernie Conwell said, 'but it took courage for Mike to call that play, too. It's been the character of this team all year. The big play. Today it won a Super Bowl for us.'"

Photograph by JOHN BIEVER

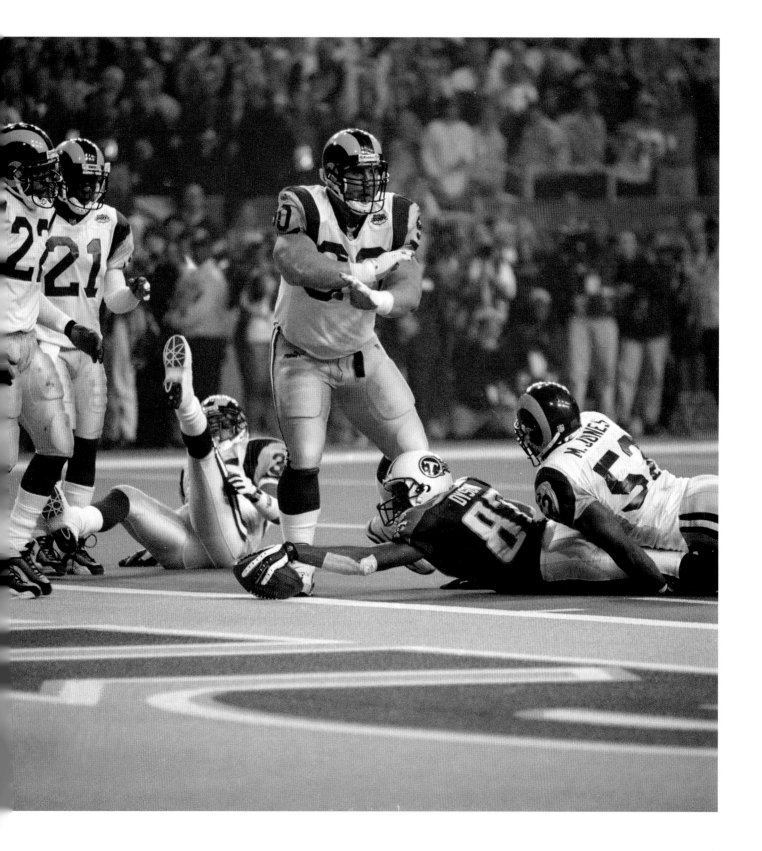

THE HOGS

PHOTO SHOOT, BALTIMORE | *June 15, 2001*

DON'T BE FOOLED by this photo. The famous nickname given to Washington's offensive line of the 1980s had nothing to do with motorcycles. For the July 2–9, 2001, "Where Are They Now?" issue of SI, Albert Chen offered this origin story of the Hogs:

> "During the Redskins' 1981 minicamp, Washington offensive line coach Joe Bugel took one look at his herd of linemen and yelled, 'O.K., you hogs, let's go down in the bullpen and hit those sleds.' Bugel used the moniker to unite the group. T-shirts were made, and any Hog caught not wearing his to practice owed Bugel five dollars. By the following season this collection of fine swine had become the most feared (and renowned) offensive line in the NFL, helping lead the Skins to their first Super Bowl title. Says George Starke, 'We made offensive linemen famous.'"

Walker Iooss Jr. took this picture of the original Hogs (from left): George Starke, Mark May, Jeff Bostic, Russ Grimm and Joe Jacoby. Washington fans in the early '80s fully embraced their new heroes, with many of them showing up for games wearing old-fashioned dresses and pig noses.

"We weren't the prettiest," May said in the SI story. "We drank beer, had big bellies, but we worked hard, and people liked that."

In the 10-year span from 1982 to 1991, Washington won three Super Bowls and played in a fourth. Not all five of the original Hogs were there for that entire run, and a few other Pro Bowl linemen kept the Hogs tradition going along the way. Grimm, Bostic and Jacoby were part of all three Super Bowl winners. Don Warren, an excellent blocking tight end and an honorary member of the Hogs, also won three titles. May, Raleigh McKenzie and Ed Simmons were Hogs with two Super Bowl wins to their credit. Other notable Hogs included Jim Lachey and Mark Schlereth.

Some have argued over the years that the Hogs didn't get enough credit in the form of honors and accolades. While Jacoby has come close a few times, Grimm is the only one of the group to be elected to the Pro Football Hall of Fame. "He was the prototypical Hog," May said of Grimm, a four-time All-Pro. "He had the body of a hog, and he was the most vocal."

Photograph by WALTER IOOSS JR.

'WE WILL CARRY ON'

ARROWHEAD STADIUM, KANSAS CITY, MO. | *September 23, 2001*

IN RETROSPECT, PERHAPS it was obvious that the NFL should have canceled its games five days after the most horrific and destructive terrorist attack on American soil. Indeed, Week 2 of the 2001 NFL season was postponed following the attacks that took down the World Trade Center and damaged the Pentagon on September 11, 2001. But it wasn't a unanimous decision. League owners were split, many of them saying the terrorists win if games are canceled. Some reminded NFL commissioner Paul Tagliabue that his predecessor, Pete Rozelle, made the tough call to play games the weekend after John F. Kennedy was killed.

"This is not the Kennedy assassination. This is not Pearl Harbor," Tagliabue said to the owners on a conference call the night of September 12. "It's worse."

In the September 24 issue of SI that year, Peter King chronicled Tagliabue's experience in the days following 9/11. On Thursday morning, two days after the attack, at 4:45 a.m., Tagliabue sat at the kitchen table of his Upper East Side apartment and drafted the following statement on a legal pad:

"This week we have witnessed despicable acts. Within our NFL family, loved ones are missing. Such events try our hearts and souls. These events and experiences will deeply affect all of us—not just for now but for years, lifetimes, generations. As a nation and as individuals, we will respond in many ways on many fronts. Supporting, respecting, grieving, learning, becoming closer, more resolute, stronger. We will carry on—not move on and forget—but carry on.… We will not play NFL games this weekend."

There was much more to do, of course. Tagliabue enlisted a group of security experts to make sure NFL stadiums would be safe when games resumed. The Week 2 games were moved to the end of the season, pushing the playoffs back a week. Sounds easy, but in order to reschedule the Super Bowl, the league had to negotiate with the National Auto Dealers Association, which had the Louisiana Superdome—and thousands of New Orleans hotel rooms—booked that weekend. Eventually, they made it happen.

"I think it's been lost by history what a big role Tagliabue had in leading the NFL through a crisis period," retired Pro Football Hall of Fame vice president Joe Horrigan told SI in 2014. "I have always believed the actions he took following the attacks were critical not only for the NFL, but for America. The nation looked to its political leaders for strength and a sense of security. But we also looked to the private sector to help re-establish the all-important sense of normalcy that was taken from us all. I think his course of action became the template for crisis management in sports, and business."

Photograph by ELSA/ALLSPORT

THE SACK KING

GIANTS STADIUM, EAST RUTHERFORD, N.J. | *January 6, 2002*

BEFORE HE BECAME the co-host of *Good Morning America* and *$100,000 Pyramid*, Michael Strahan was a feared NFL pass rusher. Don't be fooled by the warm, gap-toothed smile. In 15 seasons as a defensive end for the New York Giants, Strahan racked up 141.5 sacks, sixth on the all-time list. Strahan ended the 2001 season with 22.5 sacks, breaking the single-season record that Mark Gastineau had owned for 17 years. (T.J. Watt of the Steelers tied Strahan's record in 2021.)

As Strahan was closing in on the season record, Peter King spoke to him for the December 17, 2001, issue of *Sports Illustrated*. "The quarterback and defensive end are the two highest-paid positions in football—did you know that?" Strahan said. "The defensive end can be as disruptive as a quarterback can be productive."

More from King's story:

> "Strahan needs six sacks in his last four games to break Gastineau's record, and it won't come easily. 'Here's what people don't realize,' he says. 'I'm lining up against a guy they think I should handle, so I should get a sack or two. They don't realize I'm playing against that running back too on some plays, and that tight end, and that guard. I'm playing against a coach who's going to do everything he can to keep me away from his quarterback.'"

When he broke the record in the regular-season finale against the Packers, some observers wondered how hard the opposing quarterback actually tried to stay away from Strahan.

Green Bay had the ball with less than three minutes left. They didn't have to pass, because they were nursing a comfortable lead. A running play was called from the sideline, but Packers quarterback Brett Favre—a good friend of Strahan's—faked the handoff and casually rolled to his left, Strahan's side. Because the offensive line was in run-block mode, Strahan was untouched. Favre safely dropped to the turf as Strahan reached him to record the easiest sack of his career—and the record-breaker.

Photograph by EZRA SHAW/GETTY IMAGES

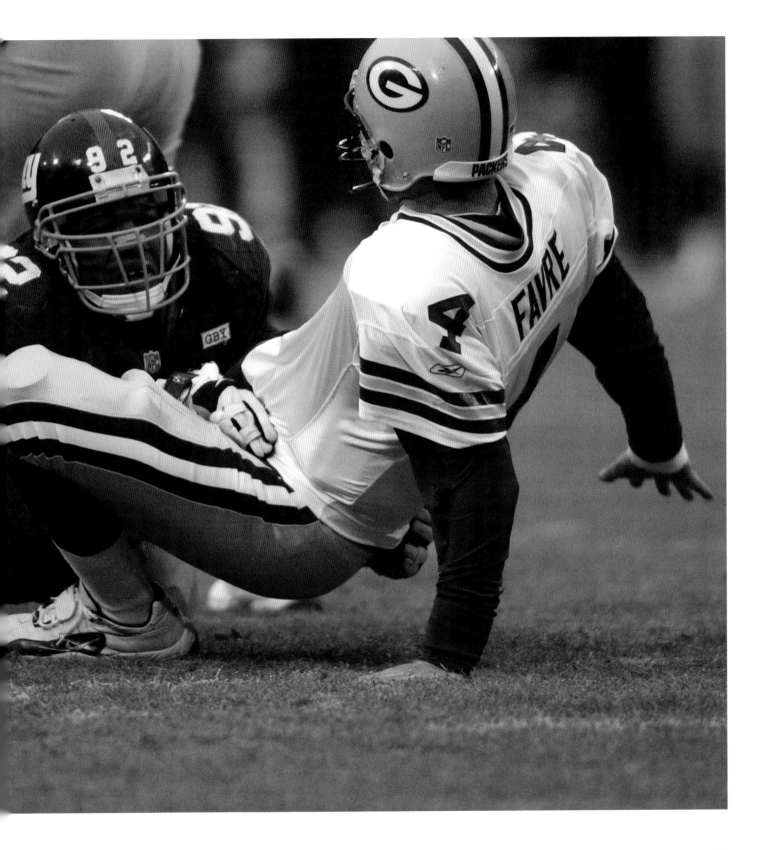

BIRTH OF THE G.O.A.T.

LOUISIANA SUPERDOME, NEW ORLEANS | *February 3, 2002*

THIS MAY BE the last photograph ever taken of Tom Brady with such a look of utter shock on his face. Because after Brady and the Patriots shocked the world by defeating the St. Louis Rams in Super Bowl XXXVI, it turns out a dynasty had begun. The Patriots were a heavy underdog in this game. They haven't been an underdog too many times since.

From Michael Silver's game recap in the February 11, 2002, issue of SI:

"Take a knee, Bill Belichick thought. Play it safe, kill the clock and don't put your young quarterback in a position to blow the Super Bowl. This was one option that Belichick, the cerebral coach of the New England Patriots, considered on Sunday night as the Louisiana Superdome shook with energy and the roof seemed ready to cave in on his team.

"Then, with 81 seconds left and the Patriots locked in a 17–17 tie with the resurgent St. Louis Rams, Belichick's head deferred to his heart. Although his tired team had squandered a 14-point, fourth-quarter lead, Belichick decided that kneeling was for wimps. Instead his underdog Patriots and their undaunted 24-year-old quarterback, Tom Brady, would deliver one of the most thrilling finishes the sport has known."

Tom Brady—now known universally as the G.O.A.T.—was an unheralded backup quarterback when the 2001 NFL season began. He was forced into action when starter Drew Bledsoe was injured, and a legend was born. Brady led New England to the Super Bowl and was near perfect in executing that final drive, leading to Adam Vinatieri's game-winning field goal as time expired.

"With a quarterback like Brady, going for the win is not that dangerous," Belichick explained after the game, "because he's not going to make a mistake."

After being named Super Bowl MVP, Brady was offered the coveted trip to Disney World to celebrate. At the team's postgame party, the quarterback asked his coach for permission to miss the team flight home.

From Silver's story: "Belichick gave him a perplexed look, and there was a clumsy stretch of dead air. 'Of course you can go,' Belichick said. 'How many times do you win the Super Bowl?'"

Little did Belichick or Brady know, it would be the first of many.

Photograph by HEINZ KLUETMEIER

THE TONE-SETTER

PHOTO SHOOT, BALTIMORE | *October 6, 2002*

WALTER IOOSS JR. took this portrait of Hall of Fame linebacker Ray Lewis for the "Faces of the NFL" issue of *Sports Illustrated* that ran in 2002. If Lewis looks particularly intimidating, there's a good reason. That's exactly the image he wanted ingrained in the minds and hearts of any offensive player against whom he competed.

As the accompanying text to Iooss's portrait explained:

> "The intimidating presence of the All-Pro middle linebacker haunts opposing running backs. 'I think they look for me, one way or another,' Lewis says. 'They might not see me, but they know I'm coming. I love making that first lick, which I call a tone-setter.'"

Lewis set the tone the moment he entered the NFL in 1996. Even though some scouts thought that Lewis, at 6'1", might be too short to be an impact linebacker, the Baltimore Ravens took him late in the first round of the draft. Their faith paid off. Lewis led the NFL in tackles for loss as a rookie. A year later, he led the league in tackles—the first of three seasons he accomplished that feat.

Lewis was the heart and soul of what became a dominating defense in the late '90s and early 2000s, with the apex coming in 2000 when the Ravens won Super Bowl XXXV. In the regular season, Baltimore held 11 of 16 opponents to 10 points or less—including four shutouts. Lewis was named NFL Defensive Player of the Year. (He would win it again in 2003.) The Ravens allowed a total of 23 points in their four postseason games. The only playoff game that was ever in doubt was the divisional matchup against Tennessee. Trailing by one score, the Titans were driving midway through the fourth quarter when Lewis intercepted a Steve McNair pass and returned it 50 yards for the game-clinching touchdown.

In Super Bowl XXXV, Lewis had five tackles and four passes defensed in the 34–7 victory over the Giants, earning Super Bowl MVP honors. Twelve years later, at age 37, Lewis capped his legendary career with a victory in Super Bowl XLVII.

Photograph by WALTER IOOSS JR.

THE RECORD-BREAKER

PHOTO SHOOT, DALLAS | *October 15, 2002*

EMMITT SMITH WAS 33 years old when this photo was taken for the December 9, 2002, "Faces of the NFL" issue of *Sports Illustrated*. Smith was closing in on the end of his 13th and final season with the Dallas Cowboys. (He would play two more with the Arizona Cardinals before retiring.) He was also closing in on the NFL's all-time rushing record, which Walter Payton had owned for 18 years.

At 33, Smith was nowhere near as dominant a runner as he had been in his younger days. From 1991 to 1995, Smith *averaged* more than 1,600 yards a season. He finished 2002 with 975 yards, snapping an 11-year streak with at least 1,000 yards. Through the first seven games of that season, he never had more than 82 yards in any game. He went into the October 27 home game vs. Seattle needing 93 yards to break Payton's record. The Cowboys' next two games were on the road, and he wanted to make history at home.

Here's is an excerpt from S.L. Price's story in the November 4 issue of SI that year:

"More than speed or power or balance, awareness has been his greatest asset. He's always been able to read the men shifting in front of him, anticipate where and when a hole would open, when to make that famous cutback. So it was: On first-and-10 at Dallas's 27-yard line Smith churned for three yards. On second down he took the ball from rookie quarterback Chad Hutchinson, cut left, found a seam, stumbled over a defender's arm, placed his right hand on the turf, kept his balance and kept on chugging until he had caught Payton and passed him by. Then Smith bounced to his feet, face alight, knowing without being told that the record was his. The game stopped, he saw his mother's face and wept, kissed his wife, Pat, and their three kids, hugged former teammate Daryl Johnston and wept again. After a five-minute break, he returned to the game, capping the Cowboys' drive with a one-yard burst that extended his NFL record for rushing TDs to 150. He finished the day with a season-high 109 yards on 24 carries, including six of at least 10 yards."

Smith had one more 100-yard game that season, rushing for 144 yards on a Thanksgiving Day win against rival Washington. In the "Faces of the NFL" issue shortly thereafter, Smith addressed his age:

"Why should I be amazed?" he said afterward through his Cheshire-cat grin. "I know what I can do. This is my job. I don't feel old at all."

Smith finished his Hall of Fame career with 18,355 yards, still the all-time mark.

Photograph by WALTER IOOSS JR.

MASTER AND COMMANDER

HOME OF BILL BELICHICK, MASSACHUSETTS | *December 4, 2002*

HAD BILL BELICHICK not stepped out from under the shadow of legendary head coach Bill Parcells, he still would have been known as a brilliant defensive coordinator who played a key role in helping the New York Giants win two Super Bowls. And if his only head coaching stint was the five years he led the Cleveland Browns, that wouldn't be bad. He took the Browns to the playoffs in 1994—and they've only made the postseason twice in the more than 20 years since Belichick's departure.

Of course, those stops are now mere blips on the Belichick résumé (along with the time he was named head coach of the New York Jets but stepped down from that gig after 24 hours). He became head coach of the New England Patriots in 2000 and has since become one of the most successful coaches in NFL history. He is the only coach to win six Super Bowls.

After his second title, a 32–29 win over the Carolina Panthers in Super Bowl XXXVIII, Peter King profiled the coach for the August 9, 2004, issue of SI. The story began with Belichick's mother showing King the cerebral coach's childhood bedroom:

"The contents of the room provide a window into the mind of Bill Belichick. They tell us that the hottest coach in the NFL is well-educated and uncluttered in his thinking. Through a roller-coaster coaching ride that has included a trying stint with the Cleveland Browns in the 1990s and a Captain Queeg-like performance in walking away from the New York Jets 24 hours after being promoted to head coach in January 2000, Belichick has in many respects remained unaltered. 'I don't think he's changed from his Cleveland days,' says good friend Jim Brown, the Hall of Fame running back, who remains close to the Browns' organization. 'He's acquired some life experiences, but he's exactly the same man I knew 10 years ago.'

"As a coach, however, Belichick has continually educated himself, never allowing himself or his team to become too predictable. Less than a month after the Patriots beat the Carolina Panthers to claim their second Lombardi Trophy last February, he flew to Baton Rouge and spent two days drawing up schemes with his former defensive coordinator in Cleveland, LSU coach Nick Saban. For the second straight year he traveled to the Florida Keys to pick the brain of fellow two-time Super Bowl winner Jimmy Johnson. During a vacation on Nantucket before training camp, he listened to audiotapes of a book by retired Navy captain D. Michael Abrashoff called *It's Your Ship: Management Techniques from the Best Damn Ship in the Navy*. He also found time for one of the *Harry Potter* tomes. Hey, even a guy as intense as Belichick has to have fun once in a while."

Photograph by DAMIAN STROHMEYER

THE BIG TUNA

ALAMODOME, SAN ANTONIO | *August 4, 2003*

WHICH IS THE most impressive Bill Parcells achievement? He won two Super Bowls as head coach of the New York Giants, a franchise that was dormant for decades before he took over. He led a second team to the Super Bowl when he got the New England Patriots there in 1996. He coached the New York Jets to the AFC Championship Game in 1998; the Jets hadn't gotten that far the previous 16 seasons and wouldn't get back for another 10 years after Parcells left. In 2003, Parcells took over a Dallas Cowboys team that had missed the playoffs for three straight seasons; he got them to the postseason twice in four years. He's the only coach in NFL history to take four different teams to the playoffs, and in each case he got them there in his first or second season on the job. Want one more? His coaching tree includes three assistants—Bill Belichick, Sean Payton and Tom Coughlin—who have won Super Bowls as head coaches themselves.

Players loved playing for Parcells, no matter how hard he was on them. When Parcells retired in 2007, Peter King wrote about him in the January 29 issue of SI and recounted how Payton credited Parcells with making him tougher. "I told him if he was afraid of confrontation, he was going to have a problem being a head coach," said Parcells.

Parcells was also the master of motivational mind games, King wrote:

> "Giants linebacker Lawrence Taylor struggled against Rams tackle Irv Pankey, so before the teams' 1989 playoff game Parcells handed Taylor an airline ticket and told him to fly to New Orleans and give the return ticket to Saints linebacker Pat Swilling. 'He's the only guy who can handle Pankey. You can't,' Parcells said. Taylor played angry, beating Pankey for two sacks. 'It's amazing how deep he was able to get into your head,' Cowboys QB Tony Romo said."

Photograph by BOB ROSATO

AN UNLIKELY CHAMPION

PHOTO SHOOT, ST. LOUIS | *August 21, 2003*

THE COVER OF the October 18, 1999, issue of SI summed up the Kurt Warner story completely: "Who IS This Guy? From out of nowhere, the Rams' Kurt Warner takes the NFL by storm."

At that point, the amazing Kurt Warner story was in its infancy. He was 28 years old at the time, but only four starts into an NFL career that seemed entirely unlikely. After an unspectacular college career at Northern Iowa, Warner signed with the Packers in 1994 but was cut before the end of training camp. He then returned to Iowa, where he worked stocking shelves at a grocery story. Not willing to give up on his football dream, Warner then signed with the Iowa Barnstormers of the Arena Football League. Three years later, the St. Louis Rams gave him a shot, allocating him to the Amsterdam Admirals of the NFL Europe league. In the 1998 NFL season, Warner was the Rams' third-string quarterback, throwing a total of 11 passes in very limited action.

He entered 1999 as a backup to Trent Green, but when Green suffered a season-ending injury in the preseason, Warner finally got a real chance to play. Still, few people had any expectations for the one-time stock boy. One person who did was Rams head coach Dick Vermeil.

"Kurt is going to play better than any of the Number 1 draft picks at quarterback this year," Vermeil told *Sports Illustrated* just before the start of the season.

And he was right. When the Warner cover story was written, the Rams were 4–0, the only undefeated team in the league, and Warner had 14 touchdown passes in those four games. By season's end, Warner had thrown a league-leading 41 TD passes and was named MVP. He led St. Louis to victory in Super Bowl XXXIV a few weeks later and was the MVP of that game, passing for 414 yards and two scores.

The strong-armed Warner would see his Cinderella story last 12 years in the NFL. He was the league MVP again in 2001 and helped the Arizona Cardinals reach the NFL title game in 2008. Warner passed for 377 yards and three touchdowns in Super Bowl XLIII, but the Steelers pulled out a win in the closing seconds.

Warner isn't the only undrafted player to be enshrined in the Pro Football Hall of Fame, but his rise to fame may have been the most unlikely.

Photograph by WALTER IOOSS JR.

THE BLACK HOLE

NETWORK ASSOCIATES COLISEUM, OAKLAND |
October 24, 2004

WHETHER THEY ARE from Oakland, Los Angeles, Las Vegas or points unknown, fans of the Raiders are cut from a slightly different cloth. Since the early days of the franchise, the Raiders have always embraced the image of rag-tag renegades, blue-collar bullies who lived up to their team's name. The legend grew in 1974, when NFL Films president Steve Sabol penned the poem "The Autumn Wind" and the iconic voice of NFL Films narrator John Facenda recited it for the team's highlight video at the end of that season:

> "The Autumn Wind is a pirate.
> Blustering in from sea,
> With a rollicking song, he sweeps along,
> Swaggering boisterously.
> His face is weather beaten.
> He wears a hooded sash,
> With a silver hat about his head,
> And a bristling black mustache.
> He growls as he storms the country,
> A villain big and bold.
> And the trees all shake and quiver and quake,
> As he robs them of their gold.
> The Autumn Wind is a Raider,
> Pillaging just for fun.
> He'll knock you 'round and upside down,
> And laugh when he's conquered and won."

Just as the Raiders players embraced their reputation, the fans—Raider Nation—embraced their team's nasty image. Especially when the Raiders were in Oakland, fans of the visiting team knew to avoid certain areas of the parking lot before games. Most of the Raiders fans, though, despite the menacing face paint and spiked shoulder pads that gave the appearance of extras from a *Mad Max* movie, were really just true fans.

"The passion is indescribable," former Raiders CEO Amy Trask told the *Los Angeles Times* in 2020. "It is a sincere, strong, incredible passion. I can't explain the why—I think it's more appropriate for the fans to speak to that—but the passion is tremendous and it is global."

Photograph by WALTER IOOSS JR.

THE GUNSLINGER

LAMBEAU FIELD, GREEN BAY, WISC. | *October 30, 2006*

WHEN BRETT FAVRE retired in 2011, he owned the NFL's all-time records for most passing yards (71,836) and most touchdowns thrown (508). Peyton Manning, Drew Brees and Tom Brady have all since passed him in both categories but that by no means diminishes his legacy. Favre, a Super Bowl champion and three-time MVP, played with as much fire and passion as anyone. He still owns the record for most consecutive NFL games started, 321, which is all the more impressive considering some of the obstacles he's faced.

In the November 8, 2004, issue of SI, Peter King offered a picture of both Favre's obstacles and his passion:

> "How much more anguish can Brett Favre take? In the span of 10 months his healthy-as-a-mule father, Irv, dropped dead of a heart attack at 58; his brother-in-law Casey Tynes, 24, was killed when he crashed an ATV on the Favre estate in Mississippi; and his wife, Deanna (Casey's sister), learned she had breast cancer. Favre found out about Deanna's cancer on Oct. 14, eight days after Tynes died. (Deanna underwent a lumpectomy and is expected to recover after chemotherapy.)

> "The record shows that when he's faced with adversity, Favre continues to perform. He won the first of his three MVP awards while addicted to a painkiller nine years ago. He threw for 399 yards 26 hours after learning of his father's death last December. And since his wife's cancer was discovered, he's piloted the reeling Packers back into the NFC playoff race, completing 68% of his throws in three wins.

> "Irv Favre would acknowledge that athletic failure was possible, but that didn't make it acceptable. 'My dad wouldn't have stood for any excuses,' Favre told SI last January. 'In tough times, players play.'"

Photograph by WALTER IOOSS JR.

THE MEASURE OF A MAN

UNIVERSITY OF PHOENIX STADIUM, GLENDALE, ARIZ. | *November 12, 2006*

ON APRIL 22, 2004, two days before that year's NFL draft, the league office on Park Avenue was buzzing. Team officials, top college prospects and other assorted guests were visiting NFL headquarters throughout the day and league officials were busily preparing for an exciting weekend. Suddenly, a pall fell over the building. News quickly spread: Pat Tillman—the Arizona Cardinals safety who turned down a $3.6 million contract offer following the 2001 season because he was so affected by the 9/11 attacks that he wanted to enlist in the Army—had been killed in Afghanistan.

The following is an excerpt from Gary Smith's profile in the September 11, 2006, issue of SI:

"Pat just had that way, with colonels and coaches and Nobel Prize winners, too, of slicing through rank and reputation, of turning every encounter into nothing more or less than two human beings talking. Hell, the guy introduced himself to strangers simply as 'Pat,' and if they asked what he did before strapping it on for Uncle Sam, he'd say he studied some back at Arizona State and quickly ask about *them*, never mentioning the summa cum laude or the Pac-10 defensive player of the year award, and certainly not the NFL. And still, something about him made you walk away wanting to learn more, laugh more, run more, give more.

"Who else showed up in a college assistant coach's office at 1 a.m., asking what he thought of Mormonism with such zest that both ended up reading the Book of Mormon so they could discuss it in detail? Who else in the NFL or the U.S. Army took a book everywhere, even on 10-minute errands, read *The Communist Manifesto*, *Mein Kampf*, the Bible and the Koran, so he could carve out his own convictions … then bought you the book and picked a philosophical fight just to flush out some viewpoint that might push him to revise his, push him to *evolve*? Gays, for instance. By the last few years of his life, his narrow view of them as an adolescent had so altered that he would argue they were the most evolved form of man.

"Most people, [Pat's father] Russ felt, are just pieces of everybody else, off on some mimic's mission all their lives. It's as if there's a padlock on who they really are and just a few figure out the combination and then the whole damn thing pops open, the treasure of possibility becomes theirs. That was Pat, so … so … hell, even his mom, Mary, when she tried to get her arms around him, would just end up throwing them in the air. He was the most respectful gutter mouth you ever met, the politest man ever to reach across a restaurant table and dunk his sticky hands into your glass of water. So playful and so serious, so transparent and so mysterious, so kind and so frightening, so loud and so silent … so *juxtaposed*, Mary would say. So at ease with himself that he could meet you wherever you were."

This memorial statue of Tillman was dedicated in 2006 and remains outside of the renamed State Farm Stadium.

Photograph by ROBERT LABERGE/GETTY IMAGES

PRINCE RULES

DOLPHIN STADIUM, MIAMI GARDENS, FLA. | *February 4, 2007*

SUPER BOWL XLI wasn't a particularly memorable game, but it was notable for a few reasons. When the Colts defeated the Bears, 29–17, at Dolphin Stadium in Florida, Tony Dungy became the first Black head coach to win the Super Bowl. It was also the first NFL title for Hall of Fame quarterback Peyton Manning. But for many of the 74,000-plus in attendance, the highlight of the evening was likely the halftime performance by the late musical icon, Prince.

Super Bowl halftime shows have morphed through the years—starting with the benign innocence of marching bands, becoming worldwide events when Michael Jackson electrified the Rose Bowl crowd in 1993, and then appealing to an older demographic with classic rockers as a direct response to Janet Jackson's controversial "wardrobe malfunction" during the Super Bowl XXXVIII halftime debacle.

Super Bowl halftime shows are now analyzed and critiqued as much as the game itself. When the reviews came in for Prince's Super Bowl XLI show, they were stellar.

It was a magical 12-minute set. For the record, Prince opened with his 1984 hit, "Let's Go Crazy." He followed that with "Baby I'm a Star," which rolled into a cover of Credence Clearwater Revival's "Proud Mary." With the 100-member Florida A&M University Marching Band providing a driving drum beat throughout, Prince went into a mashup of Bob Dylan's "All Along the Watchtower" and the Foo Fighters' "The Best of You," in which he showcased his dazzling guitar chops.

The rain had been coming down throughout the game and into halftime, but skies truly opened and it became a classic Florida downpour—just as Prince broke into his apropos finale, "Purple Rain." Despite the deluge, mesmerized fans could not leave their seats, and the heavy rains could not muffle the screaming crowd. The show was so memorable that The Ringer, years later, published an oral history of the show and the events leading up to it.

Said Charles Coplin, then the NFL's head of programming who served as executive producer of the halftime show, "I remember just my phone started blowing up. Like, 'OMG, this is the greatest thing I've ever seen.' I just had all these people, friends, colleagues, people in the business, just really losing their minds on my texts. And that's when I knew that this thing was really maybe even better than we thought it was gonna be."

Photograph by JED JACOBSOHN/GETTY IMAGES

THE TEACHER

MOUNT WASHINGTON, PITTSBURGH | *May 11, 2007*

MIKE TOMLIN LOOKS remarkably calm for a man who had been
handed such a daunting responsibility at the time this photo was
taken. For 38 years, from 1969 to 2006, the Pittsburgh Steelers
had just two head coaches. Both men had great success.
Chuck Noll led the team from 1969 to 1991, winning four
Super Bowls. Bill Cowher took over in 1992. His teams finished
in first place eight times, getting to the Super Bowl in his fourth
season and winning it all in 2005, his second-to-last season.

Tomlin was about to turn 35 when the Steelers hired him in
2007 to replace Cowher. This is what Peter King wrote in the
May 21, 2007, issue of SI:

> "Steelers chairman Dan Rooney hired Tomlin for the same
> reason that Tony Dungy, then the Tampa Bay coach, hired
> him six years ago. They looked past his age—something
> a few college programs couldn't get beyond—and saw
> another Noll, a teacher. 'He can make anyone understand
> what he's teaching,' Dungy says. 'That's the essence of
> what a coach needs to do at any level.'

> "Well, there are a lot of teachers in the coaching ranks, but
> how many of them get to pilot one of the NFL's flagship
> franchises just 15 months after it has won the Super Bowl?
> The first black coach in the Steelers' 74-year history, Tomlin
> wasn't hired because of the Rooney Rule (the NFL stipulation
> that requires teams to interview minorities for coaching
> vacancies). Tomlin got the job because of these traits: He
> welcomes change and does not shy from confrontation; he
> gets players to perform at a higher level than they had been
> before he coached them; and he has great determination to
> win, which can be described as about midway between Noll's
> quiet hatred of losing and Cowher's spitting fury in the face of
> defeat. 'I am a sick competitor,' Tomlin says."

To say that Tomlin has successfully followed in the footsteps of
Noll and Cowher would be an understatement. Tomlin's Steelers won
Super Bowl XLIII after the 2008 season and reached the big game
again two years later (losing to Green Bay). Amazingly, Tomlin never
had a losing season through his first 15 years as head coach.

Photograph by AL TIELEMANS

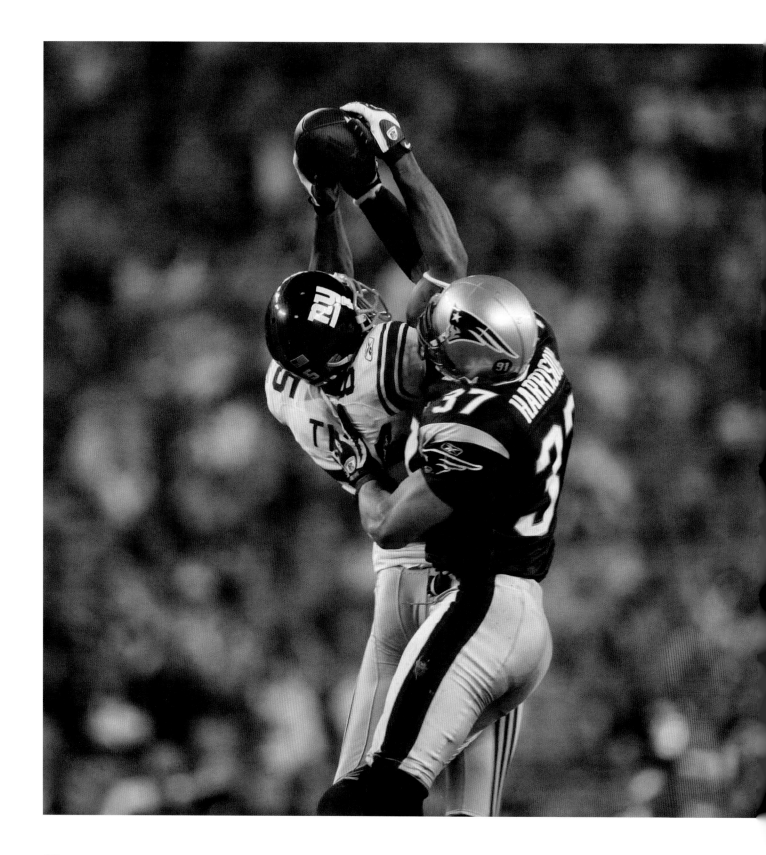

THE HELMET CATCH

UNIVERSITY OF PHOENIX STADIUM, GLENDALE, ARIZ. | *February 3, 2008*

THE 2007 NEW ENGLAND PATRIOTS were an unstoppable force. With Tom Brady and Randy Moss leading the record-breaking offense and a defense that featured the likes of Tedy Bruschi, Mike Vrabel, Junior Seau, Richard Seymour and Rodney Harrison, Bill Belichick's squad tore through the regular season and rarely came close to losing a game. They set an NFL record for points scored, averaging 37 points per game, and their average margin of victory was 20 points. Once they reached Super Bowl XLII, all that stood between the Patriots and perfection was the New York Giants, a team that went 4–4 in the second half of the season and made it to the big game as a wild card. New England was listed as a 12-point favorite. Seemingly, it would take a miracle for the Giants to win this game.

Wrote Tim Layden in his game recap for the February 11, 2008, issue of SI:

"The Super Bowl would be either a coronation or a colossal upset; it would not simply be an NFL title game. The Patriots had spent the entirety of their 16-0 regular season, including a riveting 38–35 win over the Giants on December 29, and their run through the AFC playoffs denying their pursuit of history, but that larger task defined the game. Some of the New England players even admitted it. 'You have to finish,' Seau said in midweek. 'You have to finish, or it doesn't count to be in that "great" group.'"

Michael Strahan and the Giants defense were up for the challenge. A Patriots team that hadn't scored fewer than 20 points in a game all year was trailing 10–7 in the fourth quarter. But then Brady capped an 80-yard drive with a 6-yard TD pass to Moss that gave New England a 14–10 lead with 2:42 remaining. One hundred and sixty-two seconds to perfection.

Then came the miracle, a play that etched Eli Manning and David Tyree into NFL history. As Layden detailed:

"The Giants took six plays to move from their 17-yard line to their 44, where, on third-and-five, Manning took a shotgun snap and carved a place in football lore. Quickly swarmed in a collapsing pocket, he was grabbed by the Patriots' Jarvis Green, a 6'3", 285-pound defensive end. For an instant Manning disappeared, presumed sacked. Somehow, though, he pulled away from the scrum. … Once free, Manning squared himself and lobbed a pass into the middle of the field toward Tyree, who had stopped after running a post pattern. A fifth-year wideout best known for his special teams work, Tyree scarcely fit the hero's mold—he had caught only four passes in the regular season and one in the playoffs. But Manning likes Tyree. After a disastrous Friday practice in which Tyree had dropped a half-dozen passes, Manning went up to the receiver and told him, 'You forget about this. You're a gamer. I know you are.'

"With the Super Bowl in the balance, Tyree rose high and outfought Patriots veteran strong safety Rodney Harrison, clutching the ball against his own helmet. 'Harrison is a dirty cheap-shot artist and also a heck of a football player,' said Tyree. 'But once that ball was in the air, it was mine, mine, mine, like a little kid.'"

The 32-yard gain took the ball to the New England 24-yard line. Four plays later, with 39 seconds left, Manning hit Plaxico Burress for a 13-yard touchdown. Giants 17, Patriots 14. Miracle attained.

Photograph by DAMIAN STROHMEYER

THE 100-YARD DASH

RAYMOND JAMES STADIUM, TAMPA | *February 1, 2009*

SUPER BOWL XLIII was memorable for many reasons, not least of which was the game-winning touchdown pass thrown by Ben Roethlisberger, which fell into the outstretched hands of Santonio Holmes with 35 seconds left to play, as the Steelers receiver barely kept his toes down in the back corner of the end zone.

The touchdown was the culmination of a very entertaining game between Pittsburgh and the Arizona Cardinals. And considering the Steelers could not stop the Cardinals' passing combination of Kurt Warner and Larry Fitzgerald in the fourth quarter, that made what happened at the end of the first half all the more important.

The Cardinals trailed Pittsburgh, 10–7, but they reached the Steelers' 1-yard line with seconds left in the second quarter. Arizona called a play in which Warner would look to veteran receiver Anquan Boldin. And that's when James Harrison turned in what is likely the most remarkable defensive play in Super Bowl history.

Here's how Damon Hack described it in his Super Bowl recap for SI:

> "With Arizona on the Pittsburgh one and 18 seconds remaining, Harrison dropped into coverage rather than coming on the rush and stepped right into the path of Warner's pass to Boldin. Taking off down the right sideline, he dodged Warner, Fitzgerald, Breaston, Gandy, tight end Leonard Pope, guard Reggie Wells and the churning legs of his own teammates. When Fitzgerald and Breaston finally caught Harrison short of the goal line, the linebacker did a somersault over Fitzgerald, landing on his head to score the touchdown. For several long moments Harrison lay on his back, palms up, toes pointing skyward. Tomlin headed for the end zone, where he helped Harrison to his feet and walked him off the field, an arm draped over the linebacker's shoulder. 'It was tiring,' Harrison said of his historic run, 'but it was all worth it.'"

Photograph by JOHN BIEVER

NEW ORLEANS' SAINT

TAD GORMLEY STADIUM, NEW ORLEANS | *May 19, 2010*

DREW BREES GREW up in Dallas, was a college football hero in West Lafayette, Ind., and then became a pro football player when he was drafted to play in San Diego. But there is only one place with which Drew Brees will forever be associated: New Orleans.

Here is a passage from Tim Layden's story in the December 6, 2010, issue of *Sports Illustrated*, in which Brees was named SI's Sportsman of the Year:

"On the night of Feb. 7, 2010, Drew Brees led the New Orleans Saints to the first Super Bowl championship in the franchise's star-crossed history, a 31–17 victory over the Indianapolis Colts in Miami. He completed 32 of 39 passes for 228 yards and two touchdowns, did not throw an interception and was named the game's most valuable player. For Brees it was the culmination of a four-year climb to a place among the best quarterbacks in football, and for the Saints the crowning moment in a 44-year romance with their home. For that city, nearly lost to a terrible storm, it was a critical step on a very long and ongoing path to recovery. 'I needed New Orleans just as much as New Orleans needed me,' says Brees. 'People in New Orleans needed somebody to care about them. And it was the one place that cared about me.'"

Brees had five solid seasons with the Chargers to start his NFL career, but San Diego preferred to make 2004 first-round pick Philip Rivers its starting quarterback. Brees was a free agent, but he was coming off shoulder surgery. The Saints, who had just two winning seasons in the previous 13 years, were one of the only teams interested in signing him. Worse yet, the city of New Orleans was in shambles, still reeling from the devastation caused a year earlier by Hurricane Katrina.

Brees played an instrumental role in rebuilding both the city and the franchise. The fact that Brees and his family lived in New Orleans—not in the suburbs—was a huge symbol of his place in the city's heart.

In addition to making the Saints a perennial contender and being named Super Bowl XLIV MVP, Brees posted some of the most prolific passing numbers in NFL history. From 2006 to 2017, he never passed for fewer than 4,300 yards in a season—topping 5,000 yards four times. He retired after the 2020 season with 80,358 yards and 571 TD passes. Both numbers are second all time behind Tom Brady.

Photograph by WALTER IOOSS JR.

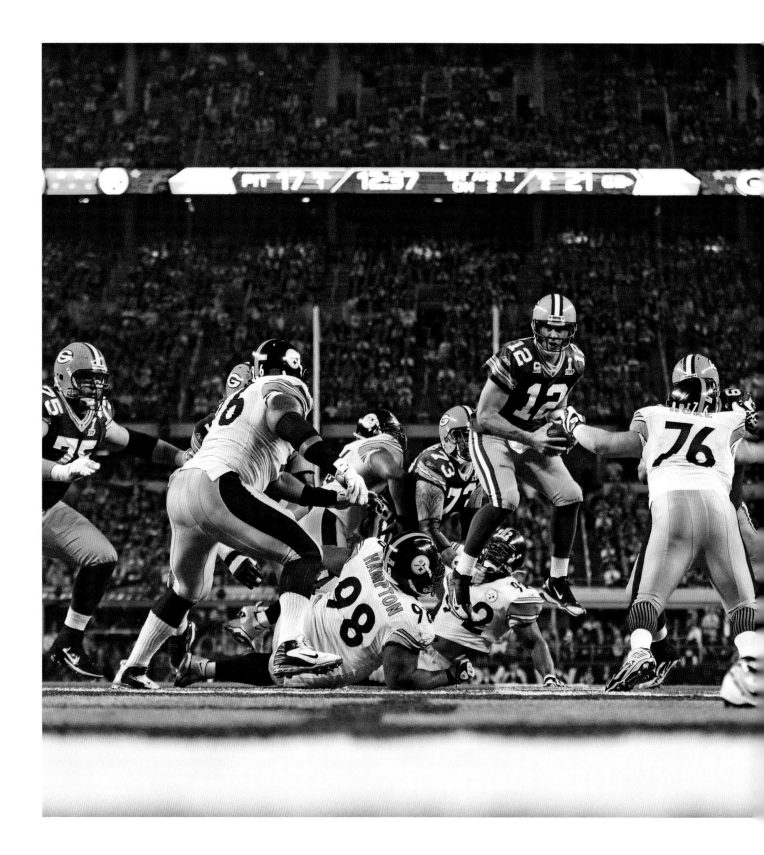

THE AIR APPARENT

COWBOYS STADIUM, ARLINGTON, TEX. | *February 6, 2011*

GREEN BAY FANS aren't used to losing, so they got a little panicky when the Packers lost two of their first three games to start the 2014 season. That's when their quarterback took to the airwaves to send a message:

"Five letters here just for everybody out there in Packer-land: R-E-L-A-X," Rodgers said on a local sports radio station. "Relax. We're going to be O.K."

Of course they were. With Rodgers leading the way, Green Bay finished 12–4 that season and reached the NFC title game (losing in overtime at Seattle). Rodgers won the second of his four NFL Most Valuable Player awards. The first had come three years earlier—the season after he was MVP of Super Bowl XLV, throwing for 304 yards and three touchdowns in a 31–25 win over Pittsburgh.

Rodgers was expected to be a high NFL draft pick in 2005, but he ended up sliding all the way to the Packers at No. 24. He couldn't wait to make everyone pay for passing on him. Alas, Rodgers had to wait. The Packers already had a future Hall of Fame QB in Brett Favre. Favre would play another three seasons in Green Bay before Rodgers got his chance. Despite the pressure of stepping in for a living legend, Rodgers made it look easy.

"What's most telling is the number of teammates ... who admit they steal glances at the jumbotron to catch Rodgers's highlights in real time," Greg Bishop wrote in a September 21, 2015, profile of Rodgers in SI. "They're still surprised by the QB, despite the MVPs and the volume of eye-popping statistics."

Photograph by PETER READ MILLER

ONE OF A KIND

GILLETTE STADIUM, FOXBOROUGH, MA. | *August 1, 2012*

ROB GRONKOWSKI WAS a larger-than-life figure both on and off the football field. Off the field, "Gronk" was all smiles—dancing shirtless on the beach or at a nightclub, he never met a party he didn't like. On the field, Gronkowski was still usually smiling … but he was working harder than most people think. And it's his combination of size, speed and smarts that made him one of the greatest tight ends in NFL history.

At 6'6" and 265 pounds, Gronkowski's signature end-zone spike of the football was an imposing sight— and it was one that occurred often. In 11 NFL seasons, Gronkowski caught 92 touchdown passes, third on the all-time list for tight ends. Antonio Gates, who is first on that list with 116 touchdowns, played 93 more games than Gronkowski. Tony Gonzalez, second on the list with 111, played 127 more games. Gronkowski often played with or missed time because of injuries—which is also a reason why he retired (for the second time) at age 33.

Gronkowski's career totals also include 621 receptions for 9,286 yards (fifth all-time among tight ends). And he's got four Super Bowl rings to his credit: XLIX, LI and LIII with the Patriots, LV with the Buccaneers.

What made Gronk so great? Because he was so athletically gifted, he was very much like another wide receiver for the offense. But unlike other modern-day tight ends who are more receivers than blockers, Gronkowski could be a punishing blocker. Opposing defenses had to keep that in mind.

"It's tough to cover the guy no matter where they put him," veteran coach Rex Ryan told SI in a September 19, 2016, story. "They can put him at the outside position, they can put him in the slot, they can put him flexed or on the line of scrimmage, they move him all over the place, so you have to be dialed in on where he is. And you know he's a guy that can run, but his size is probably the most imposing thing. And the other thing is he's a guy that will flat go get the football. So you definitely have to be mindful of where he's at."

Photograph by WALTER IOOSS JR.

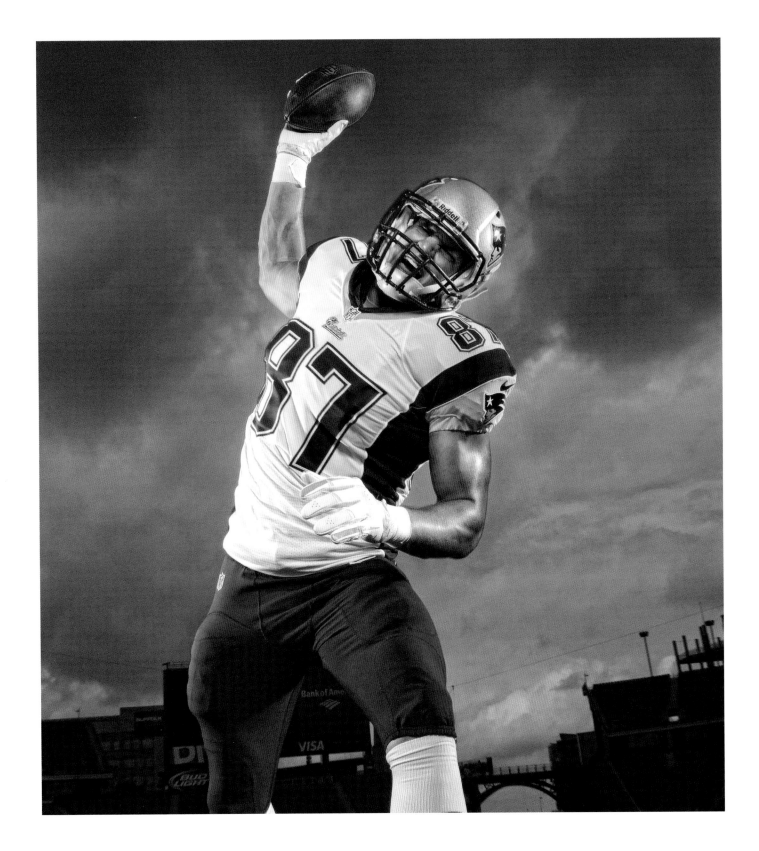

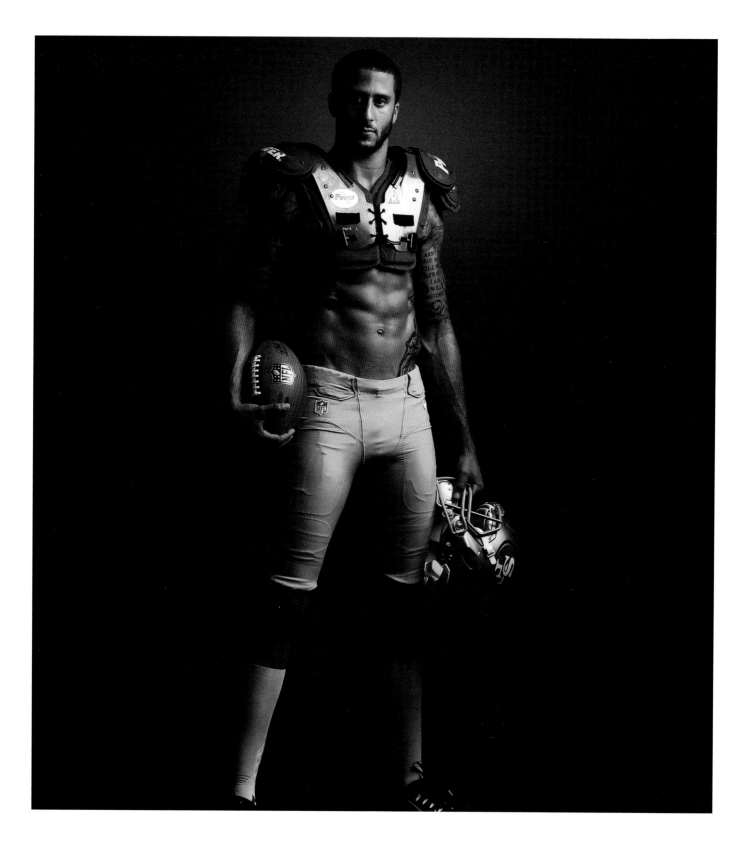

THE ACTIVIST

PHOTO SHOOT, LOS ANGELES | *July 10, 2014*

FOR ALL THE attention Colin Kaepernick has earned for things he's done (or not done, depending on how one views it) outside of live action on the football field, his football accomplishments are worth talking about. Kaepernick became the San Francisco 49ers' starting quarterback midway through the 2012 season and led them to a first-place finish in the NFC West. In his first career playoff start, Kaepernick amassed 444 total yards, with two passing touchdowns and two rushing touchdowns in a 45–31 victory over Green Bay. His 181 yards rushing in that game remains an NFL single-game record for a quarterback. A few weeks later, Kaepernick started in Super Bowl XLVII, in which the 49ers lost to the Baltimore Ravens, 34–31. In the losing effort, Kaepernick passed for 302 yards and one touchdown— making him one of just 15 quarterbacks in NFL history who have passed for at least 300 yards in a Super Bowl.

Of course, Colin Kaepernick's legacy in the NFL is not what he accomplished on the football field. It was his decision to kneel during the playing of the national anthem to protest police violence and racial injustice.

Before the 49ers' third preseason game in the summer of 2016, Kaepernick was seen sitting during the national anthem. When asked about this by NFL.com's Steve Wyche after the game, Kaepernick responded: "I am not going to stand up to show pride in a flag for a country that oppresses black people and people of color. To me, this is bigger than football and it would be selfish on my part to look the other way. There are bodies in the street and people getting paid leave and getting away with murder."

After a conversation that week with former NFL player and U.S. military veteran Nate Boyer, Kaepernick believed he would be showing proper respect for former and current military members by kneeling during the anthem rather than sitting. Many people applauded Kaepernick's message, but many others were still enraged. The situation quickly became a political firestorm for the NFL.

The 49ers had an all-new coaching staff in 2017, and they told Kaepernick they planned to go in another direction. Kaepernick opted out of his contract to become a free agent, but he had no takers. He was a pariah.

Kaepernick would file a lawsuit against the NFL, alleging that teams were colluding to keep him out of the game. The lawsuit was settled for an undisclosed sum. In 2020, NFL commissioner Roger Goodell publicly apologized to Kaepernick for not supporting him when the controversy began.

Photograph by ROBERT BECK

BY A NOSE

METLIFE STADIUM, EAST RUTHERFORD, N.J. |
November 23, 2014

IT'S HARD TO ignore Odell Beckham Jr. With his colorful hair and numerous tattoos, Beckham turned heads during his first three spectacular seasons with the New York Giants. But it was the ridiculous one-handed touchdown catch he made in a Sunday night game in 2014 that got him truly noticed. The Giants actually lost to Dallas that night, but all anyone could talk about was Beckham's catch, in which he extended his body completely and somehow held onto the nose of the football as he fell backward in the end zone.

Here's how Austin Murphy described the scene in the September 7, 2015, issue of SI, recapping Beckham's rookie season:

> "The airborne rookie levitated like a magic carpet, his right arm suddenly elastic, it seemed, as he snagged the spheroid, which somehow lodged in the crescent formed by thumb and forefinger. Dude made the play with three digits, max, all the while being mugged by Cowboys cornerback Brandon Carr, who was flagged for interference, and who quickly wearied of discussing the Catch, later griping to reporters, 'I'm not going to keep talking about one play,' sensing, correctly, that he and this young Giant were now linked and would remain so, through the decades, as Ralph Branca is to Bobby Thomson."

The story went on to explain that the play shook Beckham's world like a snow globe: "'It all just came on so fast'—the dinner invite from LeBron James; the text exchanges with Michael Jordan; the chance to hang out with both his fútbol namesake, David Beckham, and his fellow Big Apple fashion plate, Anna Wintour."

The club-hopping Beckham and New York City seemed like a perfect fit, but he was traded to Cleveland after the 2018 season, where he played for two and a half seasons before wearing out his welcome. He did sign with the Rams midway through the 2021 season and was an important piece of their championship squad, catching a touchdown pass in Super Bowl LVI.

Photograph by AL BELLO/GETTY IMAGES

THE GAME-SAVER

UNIVERSITY OF PHOENIX STADIUM, GLENDALE, ARIZ. |
February 1, 2015

MALCOLM BUTLER BEGAN his NFL career as an undrafted free agent from tiny West Alabama. He was signed by the New England Patriots and made the roster as a rookie in 2014. Just a few months later, Butler found himself a presenter at the Grammys and the owner of a Chevy pickup truck that was gifted to him by Tom Brady.

The truck was Brady's reward for being named MVP of Super Bowl XLIX after the Patriots defeated the Seattle Seahawks, 28–24. It was the third of Brady's five Super Bowl MVPs, and certainly he was deserving. Brady passed for 328 yards and four touchdowns, the last of which gave New England the lead with just over two minutes to play. But the Patriots wouldn't have won the game had it not been for Butler, the team's third-string cornerback.

Butler entered the game in the second half to replace a struggling Kyle Arrington as the Patriots' nickel back, and he took advantage of the opportunity. He had already broken up a couple of passes and made three tackles before Seattle's final, fateful drive. Trailing by four, Seahawks quarterback Russell Wilson drove his team down the field, reaching the Patriots' 1-yard line with 26 seconds left. Everybody expected the next play to be a handoff to bruising running back Marshawn Lynch, who already had 102 rushing yards and one touchdown in the game. As the Seahawks lined up, however, Butler recognized the formation and anticipated a pass. Seattle receiver Ricardo Lockette ran a crossing pattern right at the goal line. Butler muscled his way in front of Lockette as Wilson got off his pass. The cornerback came down with the interception to seal the win for New England.

"It didn't seem like the moment was too big for him," Patriots cornerback Logan Ryan said after the game. "I don't even think he realized how big it was."

To his credit, Butler was more than a one-hit wonder. He played four seasons in New England, making the Pro Bowl in his second season and leading the team with four interceptions in 2016, when the Patriots went on to win Super Bowl LI.

Photograph by FOCUS ON SPORT/GETTY IMAGES

ALL'S WELL THAT ENDS WELL

LEVI'S STADIUM, SANTA CLARA, CALIF. | *February 7, 2016*

IN PERHAPS THE greatest of NFL ironies, Peyton Manning—one of the most prolific passers in NFL history—put up some of the most mediocre numbers of his career in his final game … and walked away a champion.

In 2013, his second season with the Denver Broncos, Manning set NFL single-season records with 5,477 yards and 55 touchdown passes. But Manning and the Broncos lost to the Seahawks in Super Bowl XLVIII. Two years later, Manning literally limped his way to the finish line. A foot injury forced him to miss six games—aside from sitting out the 2011 season, it was the first time in his illustrious 17-year career that he did not start all 16 games—but he made it back for the postseason and Denver earned a trip to Super Bowl 50 to face the Carolina Panthers.

Manning's performance was the definition of "blah," not that he cared. Denver's defense got the job done in a 24–10 victory. Manning retired as a two-time Super Bowl champion. (He passed for 247 yards and a score nine years earlier and was the game's MVP when the Colts defeated the Bears in Super Bowl XLI.)

Here's an excerpt from Greg Bishop's recap in the February 15, 2016, issue of SI:

"The game he played against the Panthers well represented his season: a meager 13 of 23 completions, 141 passing yards, an interception and two fumbles (one lost), and only one third-down conversion in 14 attempts. Denver's 194 offensive yards were the fewest by any team ever to win a Super Bowl. But those weren't the numbers that mattered.

"What mattered was 39, Manning's age, which makes him the oldest starting passer to win the Big Game [a record since broken by Tom Brady]. What mattered was two, as in the number of franchises he has led to championships, an NFL first. What mattered was 200, as in his NFL victory total, vaulting him past Brett Favre for the most ever by a quarterback [also since surpassed by Brady]. 'This game was like this season,' Manning said. 'It tested our toughness, our resilience and our unselfishness.'"

Photograph by RONALD MARTINEZ/GETTY IMAGES

A SUPER SECOND HALF

NRG STADIUM, HOUSTON | *February 5, 2017*

WHEN JAMES WHITE scored his third touchdown of Super Bowl LI, New England Patriots players celebrated their overtime victory. After the first 50 Super Bowls were decided in regulation, this was the first and still only time the Super Bowl has required an extra period. Yet, Super Bowl LI is remembered more for how the teams got to overtime. From Greg Bishop's game recap in the February 13, 2017, issue of SI:

> "The greatest comeback in Super Bowl history began with the Patriots down 25 points, their offense discombobulated and their defense getting shredded like a stack of old credit card statements. More than a few New Englanders headed early for the exits, while reports from Washington indicated that President Donald Trump, noted Patriots supporter, had already turned the game off.

> "In his owner's suite (Robert) Kraft looked at his son, Jonathan, and asked, knowing full well the answer, 'You think Tommy has given up?'

> "'No f------ way,' Jonathan replied."

Indeed, Tommy had not given up. As surprising as it was that Tom Brady and the Patriots could only muster three points in the game's first two and a half quarters, in retrospect nobody can be shocked about what ensued. And yet it was shocking. Brady passed for 466 yards (a Super Bowl record he would break a year later). After White scored his second touchdown of the game, this one with 57 seconds left in regulation, Brady hit Danny Amendola for the game-tying 2-point conversion.

At that point, the Falcons defense was so gassed it never stood a chance. Brady and the Patriots marched down the field on the opening drive of OT to win it. Adding to the historic nature of the game, it was Brady's fourth Super Bowl MVP award, breaking a tie with Joe Montana, and it was head coach Bill Belichick's fifth Super Bowl win, breaking a tie with Chuck Noll.

Photograph by SIMON BRUTY

THE HUMANITARIAN

PHOTO SHOOT, HOUSTON | *November 20, 2017*

WHEN DEFENSIVE END J.J. Watt sets his sight on something, there's no stopping him. And that's usually bad news for quarterbacks, since the 6'5", 290-pound Watt is a freight train of a pass rusher. In his first 11 NFL seasons, he amassed 102 sacks and was named NFL Defensive Player of the Year three times.

Watt's dogged determination is not reserved for the football field. He has been just as successful in his philanthropic endeavors. And just as he has won awards for his playing prowess, he has also been lauded for his charity work. In 2017, Watt was named the NFL's Walter Payton Man of the Year as well as *Sports Illustrated*'s Sportsperson of the Year.

The focus of Watt's philanthropic efforts that year was to provide relief after the city of Houston was devastated by Hurricane Harvey. Watt began with an emotional video that he put out on his very popular social media channels—he has 5.6 million followers on Twitter and 4.2 million on Instagram. Watt announced that he was donating $100,000 and hoping to raise another $100,000 through donations. But after Watt's video went viral and national media outlets picked it up, $100,000 was like pocket money. Stars like Jimmy Fallon, Ellen DeGeneres, Tom Brady and Drake were among thousands who responded to the campaign. When the smoke cleared, Watt had raised an incredible $37 million.

"During a time like that, you learn so much about how the world is bigger than just the bubble you live in," said Watt, who played his first 10 NFL seasons with the Houston Texans, which is why the Hurricane Harvey damage hit so close to home. "We always see these events on TV—a storm in Puerto Rico or Hurricane Katrina—and you feel terrible. You want to help. But there's an entirely new level of heightened awareness when it's your city, when you actually see the houses. It's real. That will change you forever. That's what we experienced. It's an angle I didn't even really contemplate fully until now."

Photograph by ROBERT BECK

PHILLY SPECIAL

U.S. BANK STADIUM, MINNEAPOLIS | *February 4, 2018*

SPORTS ILLUSTRATED'S SUPER Bowl LII game story, in the February 12, 2018, issue, began 19 months before the game was played, following the path of Nick Foles. The then-unemployed quarterback was mulling retirement, thinking about becoming a high school pastor and possibly joining his father in the restaurant business. Then he got a surprise call from Andy Reid, inviting him to be the Chiefs' backup. In 2017, he returned to the Eagles, the team that had originally drafted him. And when MVP candidate Carson Wentz suffered a season-ending knee injury in Week 14, Philadelphia's hopes were planted firmly on the shoulders of Foles. The career backup proved up to the task. After beating the Falcons and Vikings in the playoffs, the Eagles met the New England Patriots in Super Bowl LII at Minnesota's U.S. Bank Stadium.

On his way to leading the Eagles to their first Super Bowl victory and earning MVP honors, Foles was at the center of what is one of the most memorable plays in NFL history: the Philly Special.

Clinging to a 15–12 lead just before halftime, the Eagles faced a fourth-and-goal at the New England 1-yard line. Rather than play it safe and kick the field goal, head coach Doug Pederson opted to go for it. Foles lined up in the shotgun, but then moved off to the right. A direct snap went to running back Corey Clement, who pitched the ball to tight end Trey Burton. Rolling to his right, Burton tossed the ball to a wide-open Foles for the touchdown. Thus, Foles is the only quarterback in NFL history to *catch* a touchdown pass in the Super Bowl.

Of course, as easy as the Eagles made that play look, nothing comes easy against the Patriots. Tom Brady passed for a Super Bowl–record 505 yards and New England came back and took a fourth-quarter lead. Not to be outdone, Foles—who passed for 373 yards and three scores—led a 75-yard drive and threw an 11-yard TD pass to Zach Ertz that gave the Eagles the lead for good with 2:21 left.

Photograph by DAVID E. KLUTHO

TOTALLY OBSTINATE

PHOTO SHOOT. LOS ANGELES | *August 20, 2018*

IN MODERN NFL history, there have been several pass-catchers to have earned the label "diva receiver." From Keyshawn Johnson imploring quarterbacks to give him the damn ball to Chad Johnson changing his last name to Ochocinco, some star receivers are just cut from a different cloth. But the player whose photo appears in the dictionary next to "diva receiver" might be Terrell Owens.

Whether feuding with his quarterback, his coach or the media, Owens always seemed to be causing friction. That goes a long way toward explaining why a player who was so good ended up with five different teams in a 15-year career. The 49ers, who drafted Owens in 1996, traded him in 2004 even though he had averaged more than 1,300 receiving yards and nearly 13 touchdowns over the previous four seasons.

Owens finished his NFL career with 1,078 receptions (eighth on the all-time list), 15,934 yards (third) and 153 receiving touchdowns (third). Despite those all-time great numbers, Owens wasn't elected to the Pro Football Hall of Fame until his third year on the ballot. Everyone understood it was Owens's off-field behavior and reputation for being a locker-room distraction that kept him from induction sooner. Still, Owens always thought of himself as being unfairly treated, something Greg Bishop wrote about in the December 3, 2018, issue of *Sports Illustrated*:

> "Owens has a few ideas about what might have created these perceptions, and he rattles them off from a notes file in his brain: 1) his division of locker rooms from San Francisco to Philadelphia during a five-team, 15-season odyssey of an NFL career; 2) his outspoken nature outside of those locker rooms; 3) his 'harmless' touchdown celebrations; 4) even his playing on a broken right leg and torn ankle ligament in Super Bowl XXXIX, where he caught, incredibly, nine passes for 122 yards in the Eagles' loss to the Patriots. Huh? Owens says his heroics in that game were framed as selfish, though a fact check suggests he contrived that framing himself. He looks at a performance for which he earned universal praise and still, somehow, perceives that he was slighted."

True to his reputation of holding a grudge, Owens became the first living Hall of Fame player to not be present in Canton, Ohio, for his enshrinement ceremony.

Photograph by KOHJIRO KINNO

THE PRODIGY

ARROWHEAD STADIUM, KANSAS CITY, MO. | *December 9, 2018*

PATRICK MAHOMES WAS the 10th player taken in the first round of the 2017 NFL draft. The Kansas City Chiefs knew he was good, but they never really considered throwing him into action that first year. Mahomes backed up Alex Smith as a rookie, but he couldn't be held back for long. Even though Smith played well for the AFC West champs in 2017, Kansas City traded Smith to Washington shortly after the season ended. They were ready to usher in the Patrick Mahomes Era.

And Mahomes did not disappoint. In his first full season as a starting NFL quarterback, he joined Peyton Manning as the only players in league history to pass for 5,000 yards and 50 touchdowns in one season. Mahomes was the regular-season MVP that season. A year later, he would be the Super Bowl MVP. With pass-happy offensive coach Andy Reid working with a quarterback who demonstrated a dazzling ability to see the field and make every throw imaginable, the sky was the limit.

And "every throw imaginable" is not an exaggeration. As he did in this 2018 game against the Ravens, Mahomes has been known to flash a no-look pass that would make Magic Johnson proud.

Robert Klemko wrote about Mahomes in the October 22, 2018, issue of SI:

"In his first year as a starter he is at the center of a pyrotechnic offense, utilizing a trend-setting quick-passing game to get the ball in the hands of playmakers and throwing deep balls on a dime 40 to 60 yards downfield. The Chiefs are 5–1 and are the league's highest-scoring team, and Mahomes seems to make history on a weekly basis. His 13 touchdown passes in the first three games of the season were an NFL record, and his five straight 300-yard passing games are a Chiefs franchise mark. Going back to last December, Mahomes has more passing yards (2,149) after seven career starts than any other QB in NFL history.

"Even in losing efforts, Mahomes is winning. He came up short in a Week 6 Sunday-night shootout against the Patriots (who won 43–40), but he threw for a season-high 352 yards and lost only after Tom Brady drove New England to a winning field goal on the final play. Afterwards, Brady sprinted across the field to be the first to congratulate Mahomes, who was in kindergarten when TB12 took his first NFL snap.

"'It was nothing we didn't already know,' tight end Travis Kelce said afterward, nodding in the direction of Kansas City's second-year QB."

Photograph by PETER AIKEN/GETTY IMAGES

SUPER MEN

VARIOUS LOCATIONS | *December 20, 2019*

WHEN SUPER BOWL LIV was played at Hard Rock Stadium on February 2, 2020, it marked the 11th time the game had been played in the Miami metropolitan area—more than any other city. That was a good excuse for SI to organize this composite photo of the living MVPs from Super Bowls played in Miami. From left to right: Jerry Rice (49ers, SB XXIII), Steve Young (49ers, SB XXIX), Peyton Manning (Colts, SB XLI), Drew Brees (Saints, SB XLIV), Joe Namath (Jets, SB III), Lynn Swann (Steelers, SB X), Terry Bradshaw (Steelers, SB XIII), Chuck Howley (Cowboys, SB V) and John Elway (Broncos, SB XXXIII).

Bart Starr, Super Bowl II MVP for the Packers (not to mention MVP of Super Bowl I in Los Angeles), died just six months before this photo was created. Like Starr, seven of nine players in this photo are Hall of Famers (and Brees will join them when he's eligible).

The least recognizable of these MVPs is Howley. The Cowboys linebacker had two interceptions in Super Bowl V, but the Baltimore Colts kicked the game-winning field goal in the closing seconds of the game. Howley is still the only player from the losing team to be Super Bowl MVP.

For the record, Patrick Mahomes became the most recent member of Miami's Super Bowl MVP fraternity when the Chiefs defeated the 49ers a little over a month after this photo was created.

Photograph by KOHJIRO KINNO, DAVID E. KLUTHO, JEFFERY A. SALTER, GREG NELSON AND JAMIE SCHWABEROW

BLOWN AWAY

PHOTO SHOOT, COSTA MESA, CALIF. | *March 2, 2021*

THE MOST TALKED-ABOUT body part for most NFL quarterbacks is his throwing arm. For some dual-threat quarterbacks, it might be their legs. The first overall pick in the 2021 NFL draft has a cannon for an arm and speed to outrun most linebackers, but his distinguishing feature is something else. Try this for fun: Google the phrase "long-haired quarterback." The first thing you'll see, in extra-large type, is "William Trevor Lawrence."

Of course, the legend of Trevor Lawrence and his hair had time to grow before reaching the NFL. He caught the football world's attention as a 19-year-old freshman at Clemson University, where he was handed the starting job five games into the 2018 season. Lawrence led the Tigers through an undefeated regular season and then he was the Offensive MVP of the National Championship Game, an upset victory over No. 1 Alabama. Lawrence was the first freshman quarterback to start for a national champion in 33 years.

In addition to the coverage he received in the traditional sports media, *GQ* ran a story on its website with this headline: "Clemson QB Trevor Lawrence's Hair Is Almost Better Than His National Championship." As the story explained, "Lawrence's long layered blond tresses are the stuff of shampoo brand executives' dreams. He is Fabio if Fabio could drop a 60-yard dime against college football's most perennially feared defense."

Lawrence led Clemson to undefeated regular seasons in 2019 and '20, but lost in the college football playoffs both years. Still, when he announced he was turning pro after his junior year, Lawrence had compiled an incredible record of 34–2 as the starting quarterback. He threw for 90 touchdowns and ran for 18 more, with just 17 interceptions.

When this photo was taken a little less than two months before the 2021 NFL draft, there was no doubt that Lawrence would be the first player chosen. Lawrence would be taking his talents, and his hair, to Jacksonville.

Photograph by KOHJIRO KINNO

THE COMEBACK KID

HOME OF ALEX SMITH, KAILUA-KONA, HI. | *March 25, 2021*

WHEN THE SAN FRANCISCO 49ERS made Alex Smith the first overall pick of the 2005 draft, the star quarterback from Utah surely had no idea what a roller-coaster of an NFL career he was about to begin. Ups and downs on the football field helped him become resilient … but who knew his desire to play would nearly kill him?

A revolving door of head coaches and offensive coordinators in San Francisco contributed to his slow development. In his seventh season with the 49ers, Smith made his postseason debut—and outdueled Drew Brees in an upset win over the Saints. A year later, Smith missed playing time with a concussion and second-year QB Colin Kaepernick came in and played great. Envisioning a future with Kaepernick, the 49ers traded Smith to the Chiefs before the 2013 season.

Smith had five solid years in Kansas City, capped by a 2017 season in which he had career highs of 4,042 yards, 26 touchdown passes and a 104.7 passer rating. Problem was, the Chiefs' first-round pick in 2017 was a kid named Patrick Mahomes. Smith was credited with helping the rookie learn and grow, but head coach Andy Reid knew Mahomes would be the starting quarterback in 2018.

Smith was traded to Washington for the 2018 season, but he never had a chance to do much on the field. On November 18 against the Texans, Smith was sacked and broke his right leg. More specifically, he suffered a spiral and compound fracture of his tibia and fibula. It appeared to be a career-ending injury … only it was worse than that. After surgery, Smith developed a bacterial infection that resulted in sepsis, a life-threatening condition. Smith had to undergo 17 more surgeries over the next nine months. Doctors were very close to amputating his leg, but they somehow managed to avoid that. Smith spent the entire 2019 season trying to work his way back. Miraculously, he returned to the field in 2020 and played in eight games for Washington. The results were average, but more than enough to unanimously earn Comeback Player of the Year honors.

Having overcome the greatest obstacle that could have been thrown his way, Smith retired after the 2020 season.

Photograph by JORDAN MURPH

THE START OF SOMETHING BIG

GREAT LAKES SCIENCE CENTER, CLEVELAND |
April 29, 2021

THE NATIONAL FOOTBALL LEAGUE began holding its "annual player selection meeting"—better known to the masses as the NFL draft—back in 1936. Considering how massively popular the draft has become, some may find it hard to believe that the draft wasn't televised until 1980. And why would it be? The draft, as its formal title suggested, was nothing more than a business meeting in which the teams were divvying up their new assets. Then along came ESPN, this new cable network with the crazy idea of broadcasting sports 24 hours a day, and a need to find programming to fill the time.

Pete Rozelle, NFL commissioner at the time, was befuddled when he got the request to televise the 1980 draft. But he was also a former P.R. man who recognized potential when he saw it. Rozelle, after all, was the brilliant visionary who guided the transformation of the Super Bowl from a mere championship game to an international spectacle.

And so it was Rozelle who found a way—even though the NFL owners initially voted against the idea of televising the draft—to allow ESPN to plant a crew at a desk just outside the ballroom of the New York Sheraton hotel, where the draft was taking place.

Needless to say, it was a good idea. ESPN's coverage of the draft has mushroomed since then and the NFL has turned the draft into a three-day event that cities across the country bid for the right to host—just like they do for the Super Bowl. With millions of fans watching and hundreds of thousands attending each year, the draft has easily become the most popular sporting event that doesn't actually involve the playing of a game.

Photograph by GREGORY SHAMUS/GETTY IMAGES

GOOD JUDGMENT

MERCEDES-BENZ STADIUM, ATLANTA | *November 18, 2021*

IN A JUNE 15, 2017, story on SI.com, NFL writer Albert Breer included a small note near the end of his column about the league making a subtle change to the title of one of its officiating positions. The "head linesman," a position first created in 1965, would now be called the "down judge." Why the change? Because the league's newest head linesman was not a man.

Two years earlier, before the start of the 2015 season, Sarah Thomas was hired as the first full-time female official in NFL history. By that time, she had already been breaking ground for women in the profession for several years. Thomas was 26 years old when she officiated her first varsity high school football game in 1999. In 2006, former NFL referee Gerry Austin hired her to become a Conference USA official. A year later, she became the first woman to officiate a major college football game when she worked a contest between Memphis and Jacksonville State.

"She came highly recommended by two NFL scouts," said Austin, who refereed Super Bowls XXXI and XXXV. "She has a good presence and demeanor. I feel like she has the ability and courage to make a call, and the guts to not make one, too."

Thomas continued to break ground on the college level—she was the first woman to officiate a bowl game and the first to work a game in the Big Ten Conference. After working minicamps for several NFL teams, she finally got the call to be a full-time NFL official.

"I don't feel that it's been harder for me because I'm a female," Thomas told ABC News in 2013. "I think that we are just out here working as officials…. I think just on our credentials, just as officials, I think that's what moves us along, not because of our gender or our race."

Photograph by RICH VON BIBERSTEIN

CALIFORNIA LOVE

PHOTO SHOOT, CALABASAS, CALIF. | *February 26, 2022*

AARON DONALD WOULD have gone down as an all-time great even if the Los Angeles Rams didn't win the Super Bowl after the 2021 season. After all, the hulking defensive tackle already had three NFL Defensive Player of the Year awards under his belt. In eight NFL seasons, he was named first-team All-Pro seven times. And typical of a player as dominant as Donald can be, he shined on the sport's greatest stage.

Just as no offensive lineman can stop his bull rush, Donald would not be denied in his title shot. It was Rams receiver Cooper Kupp who earned Super Bowl LVI MVP honors after scoring the go-ahead touchdown (his second of the game) with 1:25 left to play, but it was Donald who sealed the victory. The Cincinnati Bengals quickly crossed midfield on the ensuing possession. On a third-and-1 play, Bengals running back Samaje Perine appeared to have an easy first down, but Donald somehow brought him down at the line of scrimmage. On fourth-and-1, Donald harrassed Bengals quarterback Joe Burrow into an incompletion to clinch the win.

"I'm still living in the moment," Donald told SI in the days that followed the Super Bowl. He ripped his shirt off at the team's celebration parade. He appeared on late-night talk shows. He took his family and friends out for elaborate dinners.

But amid all the euphoria, Rams fans were worried about rumors that Donald was going to retire. Donald was just 30 years old, coming off his fifth straight season with 10 or more sacks (a league-leading 20.5 in 2018). He finished the 2021 season with 98 career sacks and was poised to climb higher up the leaderboard with a few more seasons of play.

But the rumors were real. Donald didn't deny that he was considering walking away on top so that he could spend more time with his family.

Which is why, when he ultimately signed a new contract and declared that he'd be returning to the Rams, the team's fans were as jubilant as Donald is in this photo.

Photograph by KOHJIRO KINNO

THE FUTURE IS NOW

LUCAS OIL STADIUM, INDIANAPOLIS | *March 6, 2022*

THE EVOLUTION OF college scouting is fascinating. In the early days of the NFL draft, the only things teams knew about most college prospects were things they read in a college preview magazine or maybe something they heard from a college coach. Eventually, teams built up scouting departments to gather as much information as they could on players from even the smallest schools. And it still wasn't enough.

Perhaps the most important information that teams couldn't get from watching games was a player's medical history. So a group called National Football Scouting Inc. held the first National Invitational Camp in 1982. Three years later, two other scouting companies joined forces with the NFS to conduct what became known as the National Scouting Combine. Not only were medical tests conducted on the top college prospects, but teams administered mental and psychological testing, ran players through the 40-yard dash and other athletic drills, and spent time getting to know these future NFL players.

Like the NFL draft itself, the Combine began as nothing more than a private league meeting. It moved to Indianapolis in 1987 and has remained there ever since. Through the 1990s, aside from college prospects and league and team officials, maybe a small handful of NFL media would make the trip to Indy—mainly to sit in the lobby of the hotel where NFL coaches and general managers were staying and see if they could land a few interviews.

Then along came the NFL Network in 2004, and suddenly it became clear that die-hard NFL fans want to see college prospects running the 40-yard dash and how many times they can bench press 225 pounds. They wanted to learn all they could about every prospect—even though it was February and the draft was almost three months away.

In 2022, NFL Network broadcast more than 50 hours of live coverage from the NFL Combine.

Photograph by JUSTIN CASTERLINE/GETTY IMAGES

Sports Illustrated

THE STORY OF

Football

IN 100 PHOTOGRAPHS

———

No part of this publication may be reproduced, stored in a retrieval system, or transmitted in any form by any means, electronic, mechanical, photocopying, or otherwise, without the prior written permission of the publisher, Triumph Books LLC, 814 North Franklin Street, Chicago, Illinois 60610.

Library of Congress Cataloging-in-Publication Data available upon request.

This book is available in quantity at special discounts for your group or organization. For further information, contact:

Triumph Books LLC
814 North Franklin Street,
Chicago, Illinois 60610
(312) 337-0747
www.triumphbooks.com

Printed in U.S.A.
ISBN: 978-1-63727-296-1